DOUBLE TAKE

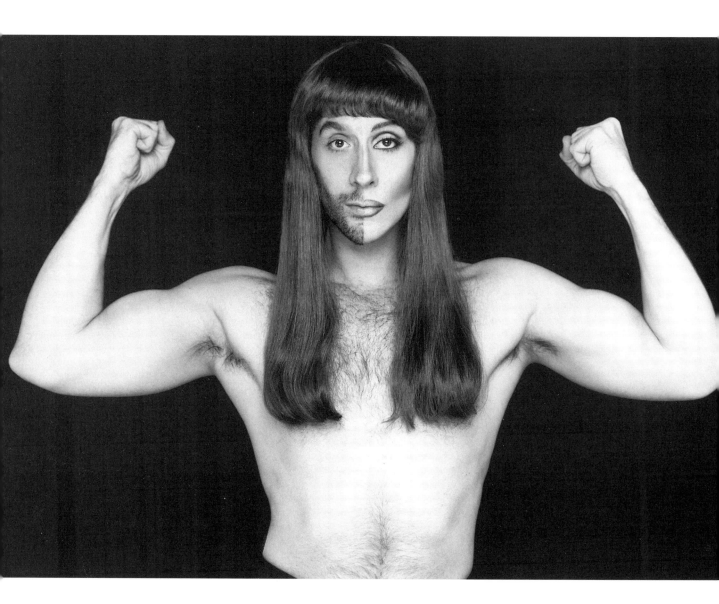

DOUBLE TAKE

DEVON CASS WITH JOHN FILIMON

To Tom
Thanks so much for being
a part of my dream. I appreciate
you so much. 3/25/99

ReganBooks

An Imprint of HarperPerennial
A Division of HarperCollins *Publishers*

HarperCollins Publishers, Inc.
10 East 53rd Street
New York, NY 10022.

HarperCollins books may be purchased for educational, business, or sales promotional use. For information please write:

Special Markets Department
HarperCollins Publishers, Inc.
10 East 53rd Street
New York, NY 10022.

FIRST EDITION

Designed by
Greg Simpson / Ephemera Inc.

Library of Congress
Cataloging-in-Publication Data
Cass, Devon.
Double take / Devon Cass with
John Filimon. – First Edition.
ISBN 0-06-098806-1
1. Impersonation. 2. Celebrities—United States—
Miscellanea. 3. Cosmetics—Handbooks,
manuals, etc. I. Filimon, John. II. Title
PN2071.I47C37 1997
791—dc21 97-14913
98 99 00 01 02 ❖/RRD
10 9 8 7 6 5 4 3 2 1

DEVON LEBOUFF BAWDEN

To my namesake, Devon Lebouff
Bawden, whose passing taught me
the importance of a day, and
inspired me to believe in tomorrow.
You're gone too soon, but you
will live in my heart eternally.
This book is our legacy.

CON TENTS

COLOR PHOTO INSERT, featuring half-face makeup for Diana
Ross, Barbra Streisand, Madonna, Marilyn Monroe, Michael
Jackson, Liza Minnelli, and Cher, follows page 160.

ACKNOWLEDGMENTS

This book, a dream of mine for eight years, was a labor of love that could not have been done alone. I was overwhelmed by the number of people who gave me their time, skills, and resources, as well as their emotional support, to complete this project. I'd like to thank Mark Payne for introducing me to this art form when I was 17, making me aware of a dream.

Special thanks go to Barbara Shapokas. Her countless hours at the computer created the perfect "dummy" that perfectly expressed my concept and helped to land a publisher within two months. Her emotional support and wonderful words of wisdom also guided me in the right direction. I think of her as a second mom, and words will never be able to express my gratitude. I love you!

Thanks also to Aaron Morishita, for the exorbitant amount of time spent scanning each and every photograph for the "dummy." You are truly an incredible and giving person.

I'll never forget the enthusiasm or the incredible creative imput of Dance Rizzo, my dearest friend for twenty-nine years. Dance has always been there for me. She has one hundred percent belief in my talent. Dance, you are such a giving and beautiful person. Every year I grow to understand more the gift of friendship God has blessed me with. You are unconditional laughter, understanding, compassion, and the light I look toward when I'm lost. For that, I will always love you.

John Filimon, I thank you for the undeniable support and creative input to make my dream become a reality. I'm so glad we came together at the witching hour. I never had to question your effort. You understood my vision and beautifully conveyed in words what I feel in my soul.

Suzy Creamcheese encouraged me as a child to pursue an artistic profession, and introduced me to a sense of style and high standards that have been instrumental through all my years of success.

Joseph Manuella, your incredible contribution and devotion to the search for the very best look-alikes for this book will always be remembered.

I would also like to thank Elaine Chez for her contribution in providing great subjects for the book as well as for lending me her costumes that are exact replicas of those Marilyn Monroe wore, not to mention her accessories and the Jackie O. suit. You're wonderful. Thanks!

Kathy Raff's expertise with wigs helped to create the precise look I wanted for each person. You're awesome!

Chuck Jones, I thank you for the use of your magnificent Elizabeth Taylor dress, and for your constant support of my photography.

I thank Kenny Burrows for looking like Claudette, but most of all for the hours spent shooting me as Cher exactly the way I envisioned her, as well as for helping on the Devon's Recommendations section.

Scott Cooper, your contributions to the book during the final days of the project were invaluable.

David Brewer, for lending me his tux and tails for

the Marlene Dietrich shoot and hand delivering it to my door. You're very generous.

Michele Mitchells lent me the Joan Collins jewelry. Thanks!

Boris Agular's detailed eye and hours of assistance helped to re-create the Madonna "Vogue" shot.

Kate MaCaulley's support made me believe that this book was possible even when some people had doubts.

I thank Joe Smith, at Modern Age, for his patience and beautiful reproductions, and Laura Molta, for her hours of transcribing interviews and moral support.

I thank Elizabeth Rutledge, for her invaluable friendship and support, for putting up with my working late nights and for helping with the Grace Jones outfit.

I thank Jane Payne for styling the RuPaul wig at the last minute.

Genaro Cruz, who was always there for design input when needed.

Special thanks to David Ball, Frank Chmielewski, and Steve Huang.

Mavis Jennings has been one of my best friends for eight years now. He's been amazingly supportive. The week I got a publisher, he threw me a surprise party spelling out congratulations on fourteen pages of newspaper taped across his entire studio apartment. It's moments like these that reveal the splendor of true friendship and giving, and for that I will always love you.

I thank my agent, Susan Gleason, for her knowledge of the publishing world and for introducing this book to ReganBooks. Also, for all her support.

Thanks to Kristin Kiser of ReganBooks, for her motivational attitude and love of this book.

Robbin Colgrove, for letting me disassemble her home in Houston to use as my studio for the RuPaul shoot, and for the use of her RuPaul-like earrings. You are so generous.

John Ekizian and Alene Boyle at HarperCollins/ReganBooks, for their last-minute insights on the book.

Richard Nardini, for his new friendship and support in the months that it took me to complete this project. I look forward to more crazy times.

Mr. Patrick Coakley, my media instructor at the High School for the Performing and Visual Arts. He allowed me to audition and accepted me to the school that changed my life, and gave me the encouragement I needed to follow my dreams.

Special thanks to my family. My mother, Cherie Bowen, for having me and loving me unconditionally, always supporting my every decision. My brother, Shawn, for his love and support. My sister, Raegan, who was my first and most beautiful subject when I was thirteen and she was only a year old. The day you were born my first prayer was answered, a prayer that started me on my path to what I have become today. Thank you also for giving birth to Erlinda Valencia. She is a blessing who reintroduces the joy to my heart that I felt when you were born. My grandma Nan King, for always being there in tough times and helping me to continue my dreams. To my grandfather Charles King, for his love and acceptance. And to Uncle Ricky, for all his love. Because of the incredible foundation you all have given me, I walk this earth with a sense of pride and integrity, and I only wish all people could walk in my shoes to feel what a beautiful life I am living. I love you all.

To God, for answering all of my prayers and continually reflecting his brilliance in me. I am truly blessed!

And finally to the late Jerome Perles, a man who believed so much in me and this project. He was instrumental in getting this book published. Although he lived to see my dream fulfilled, he unfortunately passed away before it went to print. I am eternally grateful for his shared vision in this endeavor.

INTRO DUCTION

mage! It's a powerful concept, and every celebrity has one. Some change their image many times over, while others like to live with the same one. Regardless, it's image that helps unknowns get known and keeps established stars at the top.

This book is about image. It's about how to have fun making yourself over into the image of someone else. Once accomplished, it's my hope that you'll come to know, in some small way, the wonderful feeling of celebrity, if only for a short time.

I began taking photos when I was thirteen years old. A few years later, I became fascinated with the idea of celebrity impersonation. It's illusion, a magic trick that involves several art forms, including hairstyling, perfecting makeup, creating just the right lighting, and then capturing that fabulous image on camera. Once you take the impersonation out of the photography studio, it's all that and more. It's walking, talking, gesturing, singing, or lip-synching.

After years of perfecting each and every craft I just mentioned, I felt uniquely qualified to put together this book. As an art form, celebrity impersonation is finally coming into its own. In fact, it's perpetuating new industries. TV talk shows prove that people love to watch look-alikes and female impersonators. Just look at RuPaul, who has a successful singing career

and her own television show.

This book is about two things: the fun of making yourself over into another person and how you can utilize the techniques here when applying your everyday makeup. It just has to be softer and prettier. I was inspired to do the book because I saw many celebrity impersonators who were overdone, even harsh, and I knew they could be better. Technical, theatrical makeup works for the stage, but not close-up, and especially not on television, where the camera "never blinks" but sees every

flaw. When I first started doing celebrity transformations, there were plenty of things to overcome. It felt like I was performing surgery when painting one person's face on someone else. I had to be precise. Any woman who's ever tried to put on liquid eyeliner knows what I'm talking about. Once I got it right, it was easy to repeat time and again. I got it right mostly by doing it on myself, perfect-

ing my own impersonation of Cher.

I was meant to do this book. Even before my fascination with illusion began, I remember drawing those beautiful faces that graced the covers and inside pages of fashion magazines. I'd work to get the mouth, the eyes, and even the eyeballs just right, and now I find it ironic that I take an image of a celebrity from a magazine or a CD cover and draw it on a living canvas. It's a constant challenge. It's also fascinating and fun. In some ways I think my work here is even more rewarding than if I'd been photographing the actual celebrity.

This book will take you on a journey to the land of illusion, making it easy to transform yourself into one of your favorite celebrities. These photographs are your road map. The step-by-step makeup instructions are easy to follow. Look into the mirror, and also deep inside yourself, to find the celebrity that fits you best. We all

have this star quality inside us. Sometimes it's the shape of the nose, the laugh, a flirtatious smile, or luminous eyes, or the sassy sense of humor that will make the celebrity within apparent. Every section in this book starts with a few words from me about what *I* saw when I looked at the people who became my photographic

subjects. Sometimes the likeness was easy to see, other times it came out only with makeup and "attitude lessons." Either way, everyone was thrilled with the results, and eager to share their thoughts and feelings about their transformations with me and John Filimon, who interviewed them after the experience. These talented, unique individuals understand the fun, excitement, and creativity that go into celebrity impersonations.

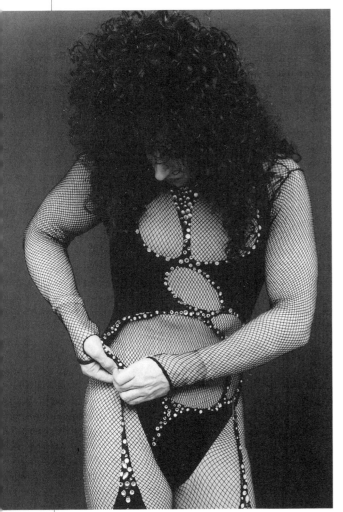

It's my hope that you, too, will understand everything that goes

into the process. Have fun playing with the half-face pictures throughout, covering one side then the other, realizing that even if the impersonator captures the celebrity's soul, without the makeup and hair the illusion is broken. Look closely at the living

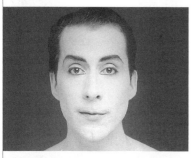

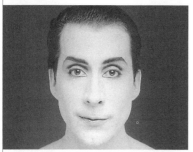

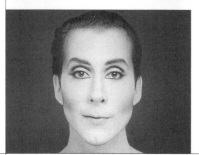

mannequins, the poses they strike and their facial structure. You'll see that even if you don't have that structure, a wig and the right makeup can be enough to transform you. The suggested songs, expressions, and quotes are here to help you do a better impersonation of the celebrity you choose. These are the most identifiable elements to help you produce the closest impression possible. You may like another song or saying, but if people don't recognize it, it won't work.

This book has been a learning experience for me as well. I've grown in many ways and learned new tricks about makeup, hair, costuming, and photography that help me in my everyday work. I also learned patience, even when I was so tired I wanted to cry. But it all came together and I'm proud of the work here.

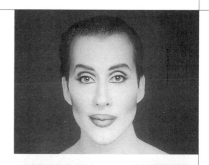

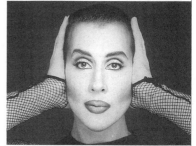

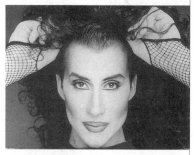

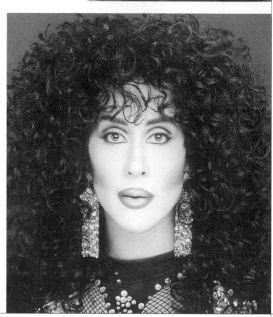

DEVON'S RECOMMENDATIONS

MAX FACTOR panstick is creamy, goes on easily and evenly, but isn't oily. For men, to cover a five o'clock shadow, apply a thicker coating. There's a great color selection too.

FASHION FAIR is great cover-up for people of color, and perfect for character work. Always choose the same color foundation and powder because they come in matching shades.

COTY, L'ORÉAL, MATTIQUE, AND COVER GIRL all make great powders. Choose the color of powder that best fits your base tone. I prefer a compact powder rather than the loose type because loose powder is harder to control.

MAC lipstick and lip liner pencils go on smoothly and stay on. There's also a great color diversity.

MAC eye shadow for professional impersonators is a little more expensive, but it's worth it.

MAC blush distributes evenly and there's a great color range.

BOBBY BROWN makeup brushes. Expensive but worth it.

When it comes to **BRUSHES,** I prefer **SABLE.**

WET & WILD cosmetics are great for people just starting out. They do the job but are less expensive.

L'ORÉAL eyebrow pencils go on easily and don't run.

L'ORÉAL eyeliner doesn't flake when it dries. The brush has an excellent point that makes it easy to draw fine lines.

L'ORÉAL mascara has a voluminous brush that allows for even coverage and minimal caking.

L'ORÉAL Color Endure lipstick—color lasts all night.

DUO CLEAR eyelash glue is great for the novice. If you mess up it dries clear.

RAVE HAIRSPRAY AND PAUL MITCHELL sculpting spray hold very well but both are light in consistency and gentle to natural hair and wigs. They leave very little residue.

TOOLS OF THE TRADE

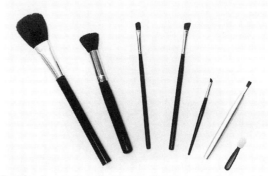

BRUSHES

Most brush sets contain brushes similar to those pictured here. However, some brush sets vary. Use your own best judgment as to what brush is similar to the brush shown in the makeup steps to create the desired effect.

- blush brush (medium size)
- contour brush
- eye shadow brush
- beveled shading eye shadow brush
- beveled eyebrow brush
- lip brush
- sponge applicator

TRIANGULAR SPONGES

These are best for applying foundation to hard-to-reach places.

CUTICLE STICK

- wood or preferably plastic

POWDER PUFFS

ACCESSORY CHECKLIST

- bobby pins (small, medium, and large—to match hair color)
- combs
- brushes
- tweezers
- hairspray
- wig cap
- fingernail glue
- spirit gum
- spirit gum remover
- glue stick
- fabric glue or glue gun
- nail polish remover
- press-on nails
- safety pins
- spray water bottle
- duct tape
- stockings (fishnets, sheers, opaques—to match skin color)
- Danskin body stockings (fishnets, opaques—to match skin color)
- electric razor
- twin-blade razor
- shaving cream
- depilatory

MAKEUP CHECKLIST
(Use suggested colors)

- foundation
- panstick (This is best for character work.)
- powder (in desired colors, but translucent works with all colors)
- eye shadow
- blush
- contour
- lipstick
- gloss
- eyeliner pencil
- liquid eyeliner
- false eyelashes
- eyelash glue
- mascara
- eyebrow pencil
- lip liner pencil

HELPFUL HINTS

These tips are meant to make your entrance into the world of look-alike celebrity impersonation easy.

SHAVING DEMONSTRATION

KENNY BURROWS
CLAUDETTE COLBERT

For anyone who needs to remove hair, shaving is one alternative.

Basic shaving cream and a twin-blade razor will accomplish the job nicely, as shown. Of course, you can also use an electric razor if it gives you the closeness you need.

Another option is to use a depilatory. It's an easy way to remove hair without razor burn if you have sensitive skin. Follow the directions on any leading brand, which you can pur-

chase at a pharmacy or grocery store. Remember, never use a depilatory on your face. Shaving is still the best option for men.

A third option is body waxing. It can "ouch" a little, and can cause breakouts and blemishes, but it has the advantage of keeping hair off for longer periods of time, and breakouts can be covered with foundation.

A final option is none of the above. You can wear a body stocking to hide unwanted hair.

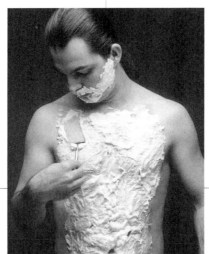

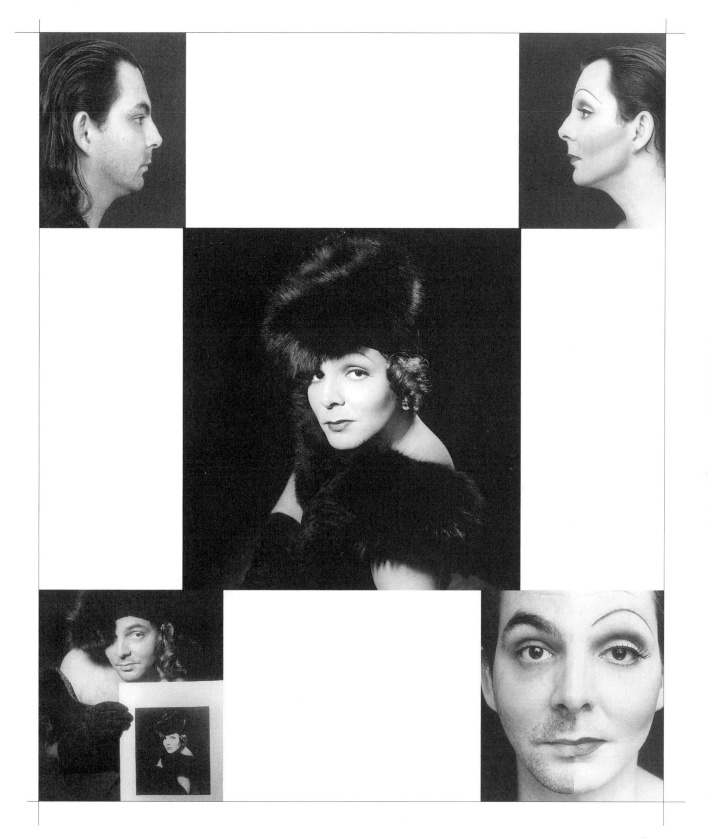

MAKEUP TIPS

Your skin tone may be much lighter or darker than the celebrity you're trying to look like. If the designated colors in the makeup steps don't give you the desired effect, you will have to experiment a little to find the shade that works for you.

Note: Chances are you will perspire when performing. So for a stronger hold, substitute spirit gum for the glue stick. Be sure to matte down the desired portion of the eyebrow with powder and a puff to set in place.

PASTING DOWN THE EYEBROWS

1 Take a spray bottle of water and squirt the tip of a glue stick to soften the glue.

 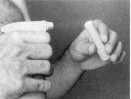

2 With a beveled cuticle stick, scoop out a little piece of glue.

3 Apply the glue directly on top of the eyebrow. Smear the glue across the eyebrow to flatten the hairs. (You may need to use two or three scoops of glue to keep all the hairs down for a matte surface.) Now, let the glue dry for four to five minutes.

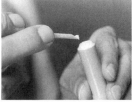 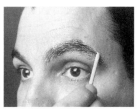

4 Once the glue dries, take a cuticle stick and a desired foundation color and cover all of the glue to conceal the brow.

5 Add foundation to entire face.

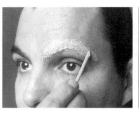 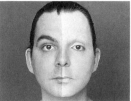

6 Finished look. Now you're ready to draw in any shape eyebrow. (When completely covering brows, it is easiest to use a liquid eyeliner or a Clinique brow shaper to draw in the brows.)

PARTIALLY PASTING DOWN THE EYEBROWS

1 Subject before.

 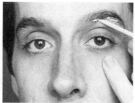

2 With a cuticle stick and glue, paste down only the portion of the brows that you wish to eliminate. Before creating desired shape, let dry for four to five minutes.

3 With another cuticle stick and a desired foundation color, conceal only the glue-covered portion of the brows.

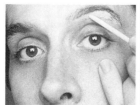 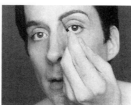

4 Create desired shape of the brows by using an eyebrow brush and a desired color. (Remember, you can use an eyebrow pencil or eyeliner pencil to fill in eyebrows if you don't have thick brows, or simply to darken them for dramatic effect.)

5 Subject after.

PLUCKING EYEBROWS

1 With a cuticle stick and desired foundation or white eyeliner pencil, apply to area of eyebrows you wish to eliminate and create desired shape without glue. (See step 3 photo in Partially Pasting Down the Eyebrows.)

2 Pluck area covered with foundation or pencil with tweezers.

3 Fill in eyebrows with brow brush and desired shadow or eyebrow pencil. (See step 4 photo in Partially Pasting Down the Eyebrows.)

CREATING DROOPY-SHAPED EYES

1 With a white eyeliner pencil, line the inner bottom lash line and then draw a line under the lash line as well. This second line should not follow the natural lash line. Make it as round and as big as you need to, to create the effect of droopy or rounded eyes.

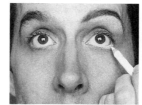 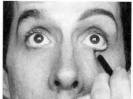

2 Now, with a black eyeliner pencil, outline the outside of the white line you just drew in step 1, but do not follow the path of your natural lash line.

3 With the same pencil draw a semicircular line along the top lash line. Start near the outer edge of the eye with a thin line, make it thicker as you curve to the middle of the eye, and then thin again as you near the nose.

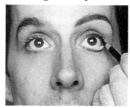

4 You now have a droopy–looking eye.

CREATING ALMOND-SHAPED EYES

1 With a black eyeliner pencil, extend the natural V of the inner eye down a little, as shown.

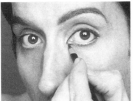

2 Now, swoop the line up to the middle of the eye and into the inner lash line from the center to the outer edge of the eye.

3 With the same pencil draw a thick line starting at the outer corner of the upper lash line. Concentrate on creating an almond shape by making the pencil line thinner as you move toward the nose.

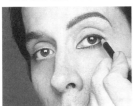

4 You now have an almond-shaped eye.

PREPARING AND APPLYING EYELASH TIPS

1 Cut a false eyelash in half.

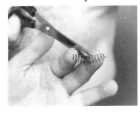

2 Keep the half that has the majority of shorter hairs.

3 Squeeze the tube of eyelash glue so that a ball of glue forms on the tip. Now, run the false lash band lightly across the ball of glue on the tube. (This allows for even distribution of the glue on the lash band and avoids an unwanted mess.)

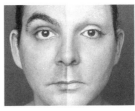

4 Allow the glue to dry for fifteen to twenty seconds, or until tacky. (This keeps the glue from running, which it will if you try to attach the lash tips too soon.)

5 Place the false eyelash tip on the outer edge of your natural lashes and mesh together. (See Meshing the Eyelashes on page 21.)

6 You're ready to go.

FULL FALSE EYELASHES

1 Follow eyelash tip steps but don't cut the eyelash in half. (You can use an even larger lash than appears here for greater effect.)

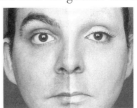

MESHING THE EYELASHES

1 Hold the end of an eye shadow brush in one hand and place the edge against the top bed of the lashes. With a mascara brush in the other hand apply mascara from under the lashes up and into the shadow brush edge. Press harder at the lash line and softer as you come up to avoid clumping. (Remember, after dipping the mascara brush into the mascara, be sure to wipe off excess mascara from the brush with a tissue. This further helps to avoid clumping.)

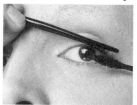

SEALING THE LASH LINE

1 Take liquid eyeliner and draw a thin line across the false eyelash line. (This gives a more realistic effect.)

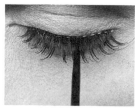

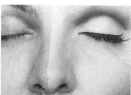

CONTOURING THE EYES

1 With a small eye shadow brush and a contour color—either a light, medium, or dark brown—follow the crease of the eye using a windshield wiper motion back and forth.

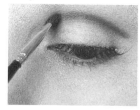
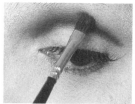

2 With a small eye shadow brush use a desired shadow or blush color that's lighter than the contour color you selected, and blend it into the contour color in the crease of the eye and above the crease. (Press harder in the crease and lighter up to the brow bone to create the natural-looking blend you want.)

CONTOURING THE CHEEKS

1 With a contour brush and a desired color—light, medium, or dark brown (deep black skin tones can use a black shadow)—draw a straight contour line from the middle of the ear to the mouth. (For a shorter contour stop the line in the middle of the cheek.)

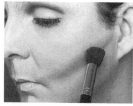
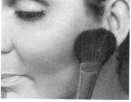

2 Now, with a blush brush and a desired color, blend into the contour line, pressing harder on the line and more lightly as you brush up the cheeks. (This creates a soft, natural blend and gives a higher cheekbone effect.)

CONTOURING THE JAWLINES

1 Use a contour brush and a light, medium, or dark shadow to draw a line directly under the jawbones and down, stopping at the neck.

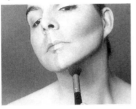 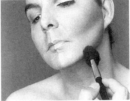

2 Then, with a blush brush and the desired blush color, follow the contour line and blend it as you go. (This creates strong but natural jawlines.)

CREATING A THIN NOSE

1 With a light beige to ivory foundation, draw a thin straight line down the center of the nose from the top to the nostril.

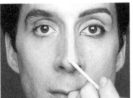 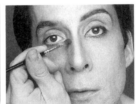

2 Then, with an eye shadow brush and suntan-colored shadow, outline both sides of the thin line you just made, blending as you go.

3 Shade underneath the nose with light brown shadow, using a beveled or regular eye shadow brush.

4 Now you have a finished thin-looking nose.

CREATING A MEDIUM-SIZE NOSE

1 With an eye shadow brush and a suntan-colored shadow, draw a line down both sides, just off center, of the nose. The line should start at the top of the nose and end at the nostrils.

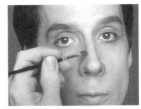

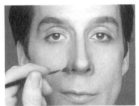

2 Using an eye shadow brush and light brown shadow, shade underneath the nose.

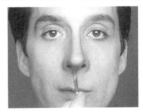

3 Now you have a completed medium-size-looking nose.

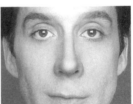

CREATING A LARGE NOSE

1 With an eye shadow brush and a suntan-colored shadow, draw a line starting from near the inner corner of the eyes down to the outer edge of the nostrils on both sides.

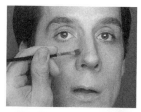

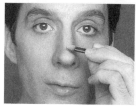

2 With a white shadow, lighten the area between the lines you've just drawn, using a sponge applicator. (Be sure to shade all the way from top to bottom.)

3 Dab just a touch of the same shadow on the outer edges of the nostrils.

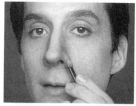

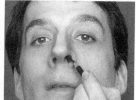

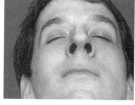

4 Take a black eyeliner pencil and outline the nostrils to make them look bigger.

5 Now you have a finished large-looking nose.

MAKING A FALSE NOSE

1 Place a lump of nose putty between fingers as shown to create a ball (one side of the ball should be flat).

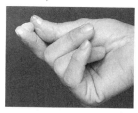

2 Apply spirit gum to the tip of nose.

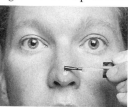

3 With foundation-covered fingers to prevent sticking, place flat side of putty to nose, and blend into skin.

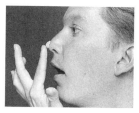

4 Apply foundation over entire face—this will camoflauge the putty.

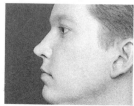

CREATING VARIOUS SIZES OF LIPS

You can make your lips larger or smaller to fit the character you're impersonating by following these easy steps.

1 If you have larger lips, use a skin-colored foundation to cover them.

2 Now, use a lip liner pencil and simply draw in smaller-shaped lips.

As I have smaller lips, I'll show you a natural look, and then methods to create medium- to larger-size lips.

CREATING SMALL LIPS

1 Use any desired lip liner pencil color and simply outline your own lips.

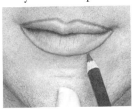

2 Fill in with the same or a lighter color lipstick, using a lip brush. Now you have a finished smaller lip. (A darker lip liner creates a stronger mouth, but be sure to blend to soften a harsh lipline.)

CREATING MEDIUM-SIZE LIPS

1 Using a lip liner pencil of any desired color, draw a line a little above the top lip and below the bottom lip.

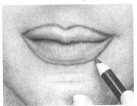

2 Fill in the lip outline with any desired lighter color, using a lip brush. Now you have finished medium-size lips.

CREATING LARGE LIPS

1 Use any lip liner pencil shade and greatly exaggerate the upper and lower lines of the lips.

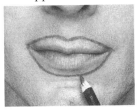

2 Fill the lines in with a desired color of lipstick, using a lip brush to apply it. Now you have finished large-looking lips.

When using these techniques, remember to always draw the shape of the character's lips—do not follow your own shape unless your lips closely resemble those of the celebrity you want to impersonate.

TUCKING

1 Choose underwear two waist sizes smaller than you normally wear. (The smaller underwear holds the tuck in place.)

2 Tuck genitalia between your legs and pull underwear between buttocks cheeks and up. (I have found this to be the most comfortable form of tucking without taping. If it doesn't feel secure, remember you will be wearing two to three sets of body stockings or panty hose to hide leg hair. This will also help keep the tuck in place. However, if the tuck still does not feel secure, take duct tape and attach it securely to the back of your underwear between the buttocks cheeks, pull up tightly, and tape to your back.)

PADDING

Certain characters may require padding to achieve shapely, natural-looking hips. Some body types require less padding, like the thin yet feminine figures of Cher, Diana Ross, and Grace Jones. Others, such as Marilyn Monroe, Liz Taylor, and Joan Collins, will require more padding. Use your own judgment according to your body type as to how much padding to use.

SMALL PADDING
DEVON CASS/CHER

If you don't need much padding, use two small shoulder pads, putting them together so they create a circle as shown. Make sure the ends of the pads are frayed so that once they are in place they don't bulge.

Here's the process:

1 Put on underwear. If you're a man, tuck and pull underwear up between buttocks cheeks so there are no panty lines in back.

2 A waist cincher is advisable. It gives a nice waist shape and helps hold the padding in place. This goes on next.

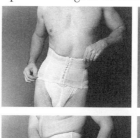
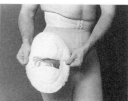

3 Now, place pads where you want them on your hips and pull on the first body stocking, or first pair of panty hose, to hold them in place. (You'll have to hold the padding in place as you're pulling the stocking or hose over the padding. Tuck top ends of pads under the waist cincher and smooth out as necessary.)

4 Now, once the padding for your hips is in place, it's time to put on your bra and any padding you need up there (try balloons, falsies, or crumpled-up tissue). Then put on the next bodysuit or pair of tights. These should go on easily. They are a must for keeping the padding in place, and for creating a smoother effect.

LARGE PADDING
SCOTT COOPER/ MARILYN MONROE

Larger pads are necessary when plenty of padding is required. Pads can be made by shaping foam rubber to fit your own hips. (Remember to bevel the edges so that they don't show.)

Now the steps are the same as for small padding:

1 Get into your underwear; adjust for comfort.

2 This is an example of a large foam rubber pad.

3 Place the padding where you want it and pull on that first body stocking or pair of panty hose.

4 Put on a second pair of panty hose to create a smoother look; then apply more pairs, depending on what you need.

5 Put on waist cincher.

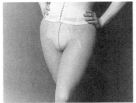

FAKE BUTT

1 Put on stockings.

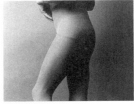

2 Then put on fake underwear butt (you can find this in costume stores).

WIGS

The right wig is the final touch that completes the illusion for any impersonation.

CREATING A NATURAL HAIRLINE

1 For a wavy Marilyn Monroe look, curl your own hair in the front and on the sides.

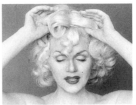

2 Position the wig behind the front curl.

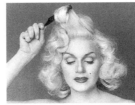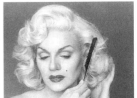

3 Next, take a comb and blend the curled bangs and sides of your hair into the wig, styling as you go.

(Always prepare the bangs and sides of your hair to match the texture and style of the wig you're using—straight, wavy, curly, or crimped. And always match the color as closely as possible for the most natural effect you can achieve.)

SOFTENING A WIG LINE

1 Put all natural hair up under a wig cap.

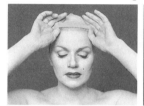

2 Rat the hair of the wig along the front and sides of the hairline, using a comb as shown. (This should create a short, disheveled line which, when the wig is properly placed, looks natural.)

3 Finished look.

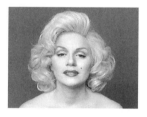

CARE AND STORAGE

- If you're a professional, have your wig styled as needed and place on a wig head in a wig box. (This keeps the style in place and allows quick access with minimal coiffing.)
- If you're not worried about keeping the style in place, turn the wig inside out and place in a hair net.
- When it comes time to wash a wig, sprinkle baking soda into lukewarm water and dip the wig into the solution, kneading for several minutes. Rinse under lukewarm tap water, shake, and place on a wig head to dry. (Baking soda eliminates hairspray residue better than soap and is gentle to the wig.) Or wash with Woolite.
- To create added luster that's usually lost after washing a wig, sparingly spray wood soap on the clean wig before it dries (but too much wood soap can wilt the wig).

WIG TIPS

- Use a steamer to straighten a curly wig. (This form of heat does not scorch synthetic wigs.)
- To curl synthetic hair, set with rollers, spraying each section of hair with sculpting spritz before rolling. (Never use a curling iron or hot blow dryer on synthetic hair. It will singe!) You can use hot rollers on synthetic hair, just be sure that the rollers have cooled off completely before removing. Velvet-covered rollers work best.
- Never use a brush to create a style on curly wigs. Always separate the hair with your fingers to create fullness, and style the wig with a pick. (A brush will cause a frizzy look.)
- For a fuller look, put two similar wigs together, one on top of the other. You can also place pieces of another wig into the wig you want to wear. (Always match texture and color for a natural effect.)

EARRINGS

To hold heavy clip-on earrings in place, put a little spirit gum, eyelash glue, or duct tape on the back of the earring and place it directly on the earlobe. Hold in place until secure.

IMPRESSIONS OF
DIANA GRAY
DIANA ROSS

I met Diana Gray while doing theatrical photo-
graphs for her. The minute I saw her it was an
undeniable truth that she would be my Diana
Ross. Those eyes! Since I had never done Diana Ross
makeup before, I had some reservations—maybe her
mouth is all wrong, and what about the nose? I was
pretty sure I could make the necessary shape changes
with makeup, but little did I know that once she was
made up, it was like having the real Ms. Ross right in
the room. Gray definitely has Diana Ross's eyes, but
everything else I created through makeup. Oh, she
also has the dazzling smile, and once she put the
wig on who else could it be but . . . Diana! The outfit
says Diana Ross during her heyday. She's done many,
many looks and gone through change after change,
but people will still see her with this dress and boa.
The wig, too, is so Diana.

OVAL TO SQUARE-SHAPED FACES
DO DIANA BEST!

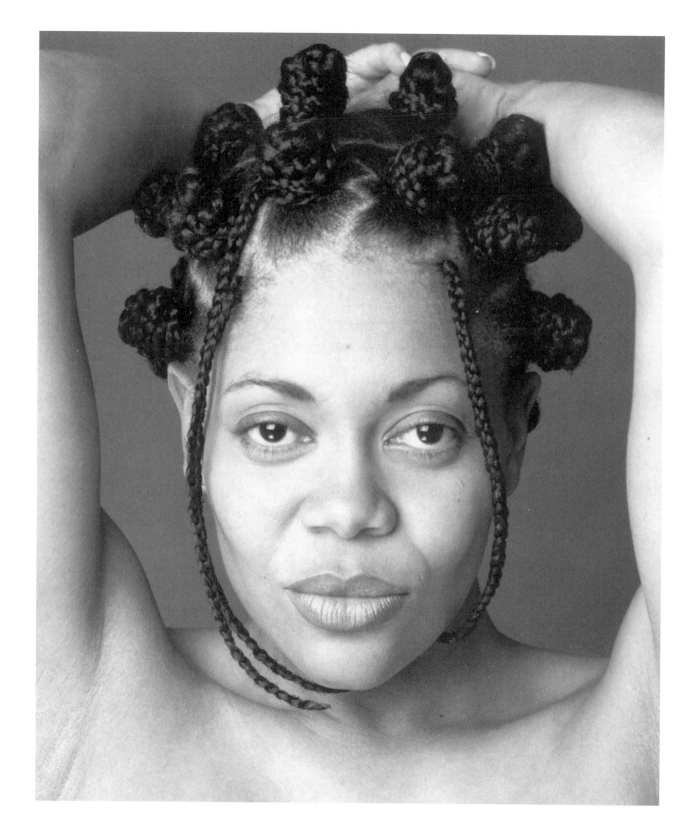

MANNEQUIN
DIANA ROSS

Diana Ross is undoubtedly one of the most glamorous women in the world. She's always been a trendsetter, a leader—not a follower. She's queen of the comeback and a definite survivor. Catch her spirit, add a pinch of elegance, and as much of her terrific sense of humor as you can muster to go along with these ideas.

CLOTHING

- Form-fitting long purple sequined gown with a plunging V neck, strap neckline, and train bottom.
- Two-toned purple ostrich-feather boa.
- Purple sequined pumps with spike heels.
- Simple clip rhinestone earrings.
- Chic but simple rhinestone bracelet.
- Fingernails (long, red drop-dead dragon-lady fingers).

EYELASHES

- Spiky black eyelashes.

WIG

Brush out a long, one-length, black curly wig. The hair should extend down beyond the shoulders and over the breasts as well as past the shoulder blades in back. (Big hair is better!)

OPTIONS

- Diana also wears red, silver, fuchsia, and white. (Not all at the same time of course!)
- She especially loves long sequined jumpsuits when she's not stepping out in a sophisticated gown.
- For a casual Diana, go with a short skirt suit, décolleté jacket, and glam blouse.
- And always—I repeat always—wear pumps.

- Torn jeans and white tank top give a dressed-down Diana. (Find appropriate matching shoes.)
- One makeup option would be to use a thick black eyeliner pencil to outline the eyes completely, extending the top and bottom eye lines to connect at the outer edge in a Cleopatra V shape. (With this step there's no need for false bottom lashes.)
- Some makeup colors Diana wears include burgundy and orange for blush.
- Eye shadow colors can also be burgundy, or charcoal with silver or gold highlights.
- For nails, think burgundy again, as well as dark brown and dark purple. (The same applies to the lips.)

FAMOUS QUOTES

"It's a new day."
"I love you. I love all of you!"
"If you need me, call me."

BEST SONGS TO PERFORM

"Reach Out and Touch"
"Theme from Mahogany (Do You Know Where Your Going To?)"
"Ain't No Mountain High Enough"

DIANA DUET!

Actress, model, wife, and mother—Diana (yes, it is her real name) Gray is a dynamic dramatist who's determined to have it all!

She's been grabbing attention since she left Jamaica when she was only eleven to live in New York City. Even when she was a young girl, people were comparing her to Diana Ross. Not only did she look like the Motown Maven, but she had the superstar's insurmountable spunk.

Like Detroit's favorite daughter, this Diana is also a woman who follows her own way. She's full of opinions that she's not afraid to express. She believes in telling it like it is, even if that ruffles a few feathers, but she also won't pull any punches when it comes to talking about herself. She says that today she's extremely comfortable in her own skin, but this wasn't always the case.

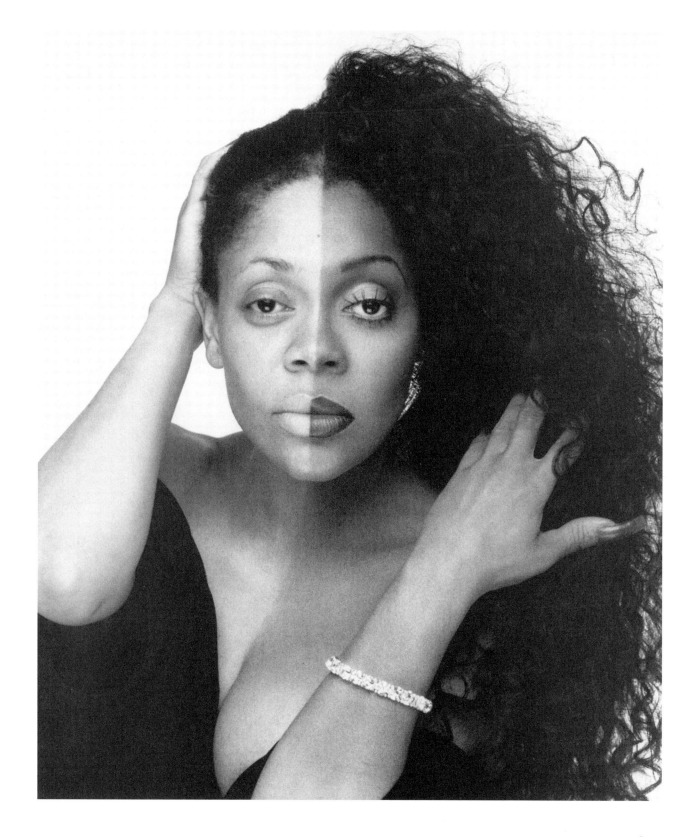

DG: Up until about a year or two ago I thought I was the ugliest thing because people always told me I was ugly. My eyes were too big, my lips were too big. People used to call me an ugly big-eyed b—. Now look, it's my eyes that are responsible for my being immortalized on the pages of this book, and all the women in Hollywood are paying top dollar to have lips that look like mine. Poetic justice, wouldn't you say?

JF: What is it that you like about being transformed into a physical reproduction of someone else?

DG: Well, I'm an actress so it goes beyond the physical makeover. That's important because after I'm dressed as Diana Ross I start to no longer see myself, and then I get into the character and it's an acting exercise. I'm an actor in a role. That's what I like. The first time I saw myself transformed it was the whole artistic point of view that fascinated me, but I also know I can wash her off.

JF: Have you performed as Diana Ross onstage?

DG: Not yet, but I want to. If somebody will pay me to do it and say that I look like her, I'll put her on more than I'll wash her off. Sometimes, I'll bet she wishes she could wash herself off.

JF: Have you ever met Diana Ross?

DG: No, but I'm sure I will. Do you know what trouble I've already gone through to try to meet this lady? I almost caught pneumonia in Central Park trying to meet her.

JF: What do you hope to accomplish from your work impersonating Diana Ross?

DG: I'm hoping it will open other doors for me as an actress. I was born to be an actor. If I can act so much like Diana Ross that I look like her and can fool you enough into thinking that I am her, well, then I'm a damn good actress.

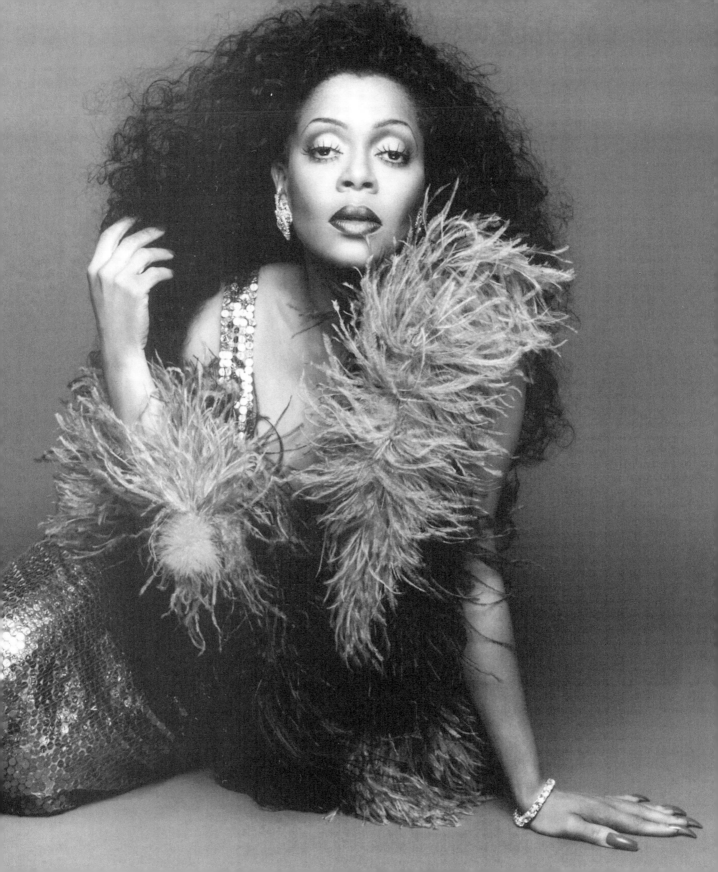

RICHARD MARCUS

BARBRA STREISAND

I first ran into Richard on the set of *To Wong Foo, Thanks for Everything, Julie Newmar*. He was impersonating Barbra, and I thought he resembled her a great deal. At the time, however, I wasn't in need of a Streisand look-alike, so I didn't think too much of it. Later, when I lost touch with the Barbra I wanted to use, I remembered the photo Richard had given me. I wasn't completely convinced that he was the Streisand I wanted, but I decided to test him. I did his makeup and the transformation was unbelievable.

The most similar features that Richard shares with Barbra are his nose and his blue eyes. The shape of his eyes aren't the same and have to be changed with makeup, but the color is exact. Richard's mouth is exactly the same shape as Barbra's but smaller, so I just completely follow his mouth with lip liner about a fourth of an inch wider, all the way around, and I've got it. I accent Richard's chin to give him a squarish one like Barbra's, and I contour the cheeks a little, but it's all pretty much there.

The reason I chose this outfit is because it's similar to what Barbra wore during her big return to the concert stage—it says Barbra the minute you see it. Richard bought it from a catalog for one hundred dollars—you don't have to spend a fortune to have fun!

SQUARE TO ROUND FULL FACES
DO BARBRA BEST!

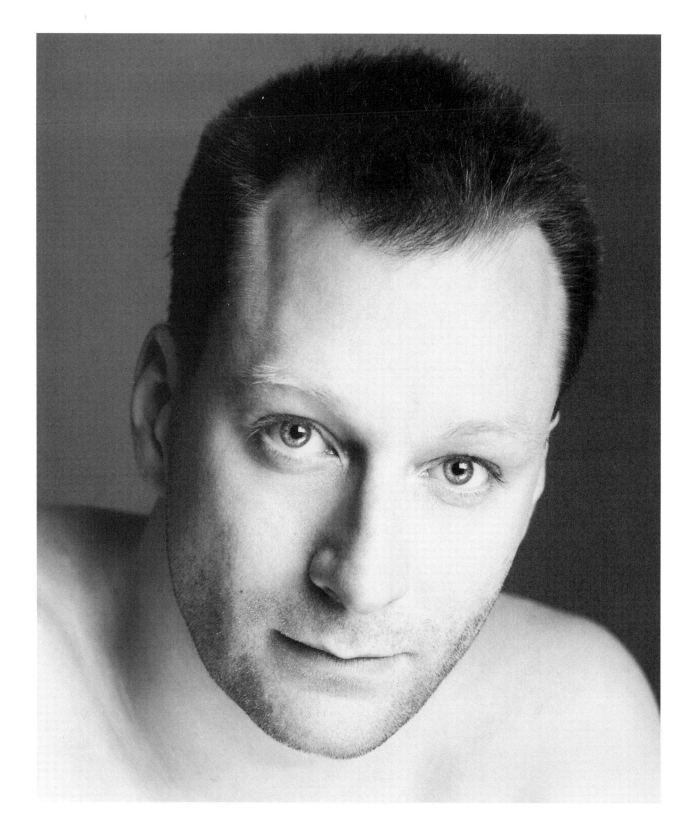

MANNEQUIN
BARBRA
STREISAND

Barbra's taste is simple yet refined, elegant but never gaudy. In addition to the clothes listed, you'll need a wacky sense of humor and a flirtatious manner. You should project a strong sense of self, but don't forget Barbra's vulnerable side too.

CLOTHING

- Slightly off-the-shoulder, deep décolleté V-neck black chiffon evening dress with lace sleeves.
- Black medium-high-heeled open sling-back shoes, with rhinestone jewel ornamentation on the instep.
- An ornate rhinestone ring in a gold setting.
- Matching tear-drop-studded rhinestone earrings.
- An ornate yet simple tiered rhinestone necklace that fits into the deep décolleté of the dress.
- Long, false fingernails with a French manicure.

EYELASHES

- Normal yet full black lashes.

WIG

A dirty-blond straight, longish pageboy that flips to the shoulders, with a part on the left side (Babs's most recognizable look).

OPTIONS

- For other recognizable Streisand looks try a sixties-style sailor dress with a large bow in front. (Any color will work.)

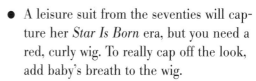

- A leisure suit from the seventies will capture her *Star Is Born* era, but you need a red, curly wig. To really cap off the look, add baby's breath to the wig.
- Another wig look you can use is the cropped boyish cut she wore in *Funny Girl*. It has volume on top and a whisk of hair that sweeps down to the chin.
- Be sure to find shoes to fit the outfit and the era.
- For more dramatic sixties makeup, follow the steps in Half-Face Makeup but make everything a little bit heavier.
- Any light, frosty shade of nail polish will work in place of a French manicure.
- Suggested colors for lipsticks are frosted orange, pink, or praline, and always with a metallic gloss.

FAMOUS QUOTES

"Hello gorgeous!"
"Just like buttah."
"Someday the whole world will look at me and be stunned." From *Funny Girl*
"When is it ever enough?" From *A Star Is Born*
 "I have opinions, but nobody has to listen." Streisand quote

BEST SONGS TO PERFORM

"Don't Rain on My Parade"
 "People"
 "Evergreen (Love Theme from *A Star Is Born*)"
 "On a Clear Day"
 "The Way We Were"
"Happy Days Are Here Again"

COLOR HIM BARBRA!

Richard Nardini, aka Richard Marcus, aka Babs, won't let anything rain on his parade. He's been impersonating Barbra Streisand for more than a decade and loving every minute of it.

Nardini, who was born in New Jersey, now makes his home in Rockland County in New York. He says he's addicted to the applause and all the attention his illusion brings him. But this thirty-something, hardworking performer also wants to attract some attention from the Lady herself. They've never met but Nardini is sure Ms. Streisand would be pleased with his portrayal.

RN: I think you really have to have the canvas to do Barbra. You have to have her face shape, and it helps to have the nose. She's a perfectionist and I want to be perfect, so I draw on that. I also believe we draw from the same spirit. I've been told by two psychics that if I hadn't been born me, I'd have been born her. That might be a little deep, but it's what I believe. I've always said if I'm going to do this, I'm going to do it right because I don't want to mock the image.

JF: Which looks of Barbra's have you impersonated?

RN: I do all her looks from the sixties on up: the sailor-suit look with the pageboy haircut, the Dolly thing with the big hat and the hoopskirt and all, *A Star Is Born* Barbra, up to today's sophisticated look. I start off as me, sit down in front of the mirror, take a deep breath, say a prayer, and think of what I'm going to do.

JF: Do you share any other similarities other than physical or spiritual?

RN: She's always believed she was a misfit, the ugly duckling, the outcast, and in school I was like that. I was a nonconformist leader. I did a lot of rebelling. So I guess the attitude's the same—the drive to succeed. Tell some people they can't do something, and if they have any fortitude or sense of self-worth, they'll go ahead and try anyway.

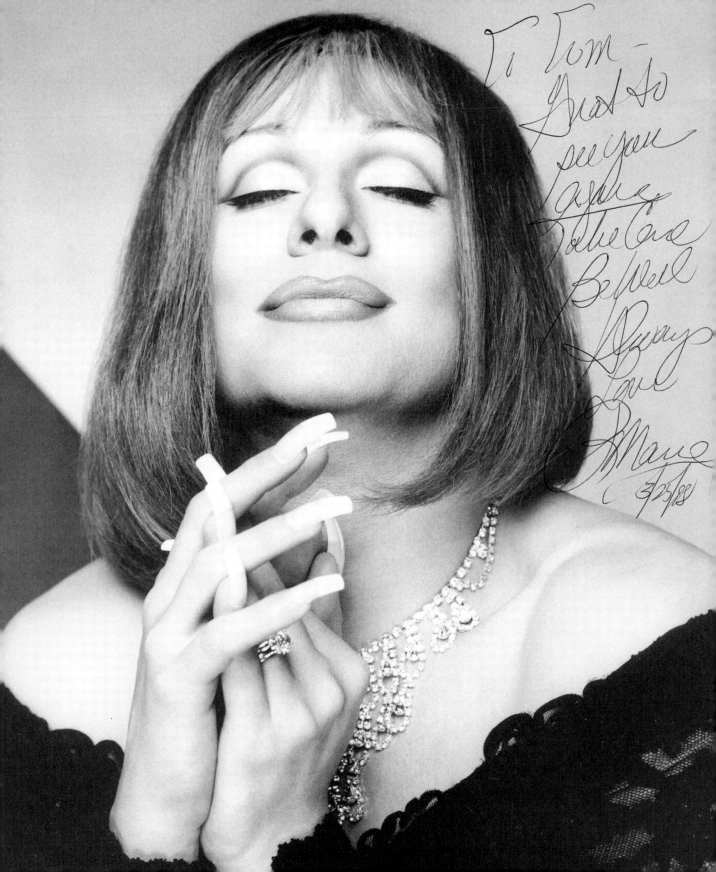

IMPRESSIONS OF
STEVE GLASSMAN
HOWARD STERN

Elaine Chez, the "look-alike agent," sent me a package of composite photos and Steve's was one of them. Howard Stern is a very recognizable character whom you either love or hate. If you're tall, as Steve is, Howard is rather easy to do. You just need the wig and glasses and basic Howard Stern garb. It helps to have the big nose, but it's not really necessary.

Oddly enough, Steve doesn't look like Howard without the glasses and wig, though you can see a little of Howard in the shape of his long face, nose, and mouth—but it doesn't jump out at you until he puts on the wig and glasses. He has the voice too, so that helps when he talks.

The white pirate shirt with the vest is typical Howard. I put lots of jewelry on Steve because Howard wears jewelry. Makeup isn't an essential for creating the illusion. It's about glasses, hair, and having fun.

LONG FACES
DO HOWARD BEST!

MANNEQUIN

HOWARD STERN

Dressed-down formality or a modern-day hippie look are just two ways one might describe Howard Stern's fashion style.

Once you have the wardrobe down, practice being sarcastic, insulting, and out-and-out loud and obnoxious to get the impression on track.

CLOTHING

- Baggy black jeans.
- White pirate shirt with black laces.
- Multicolored funky vest.
- Black leather construction boots.
- Silver spear drop earring on a small hoop, worn in left ear.
- Two small hoop earrings worn in right ear.
- Round silver-rimmed glasses with blue-black tint.
- Four silver and black multistyled rings.

- Black/silver ball-and-chain bracelet.
- Black digital wristwatch.

WIG

A long, black, slightly wavy, layered look.

OPTIONS

- T-shirt and jeans.
- T-shirt under an open button-down shirt.
- Suit jacket with casual shirt.
- Vest worn with high-collar shirt.
- Distasteful drag.
- Choker necklace.

FAMOUS QUOTES

"Hey Dick, do you have any daughters I can bang?"
"F—!"
Loud growl or roar.
Any other rude or disgusting comment you can get away with.

TH STERN LOOK

Howard Stern is definitely an individual. From the way he looks to the way he acts, he has no equal—except when someone is impersonating him.

Makeup isn't the key ingredient for transforming yourself into Howard. It's all in the wig and glasses, as you can see in these before-and-after photos.

STERN JEWELRY DEMO

To imitate Howard's take on jewelry, just wrap a long, black/silver ball chain several times around your wrist, attaching it with a clasp. Wear a variety of silver and black pieces. You can team chains with beads and leather laces together with a wristwatch for a funkier effect.

STERN WARNING TO HOWARD: HERE COMES STEVE GLASSMAN!

To say that Long Island, New York–born Steve Glassman has the Howard Stern schtick down is an understatement. Glassman, who now calls Manhattan home, has even doubled for the cantankerous, wisecracking, yet charismatic radio personality.

At six foot six, Steve can look Stern right in the eyes. They have similar noses, bone structure, dimples, and even the same jutting Adam's apple. It doesn't hurt that they also sound alike. Although Stern has long hair and Steve doesn't, just add a wig and dark glasses and voilà! They could have been separated at birth.

Steve has also been mistaken for Ric Ocasek of The Cars, and has the physical attributes to impersonate the Kramer character from *Seinfeld*. But for now, Steve is content to stay with Stern.

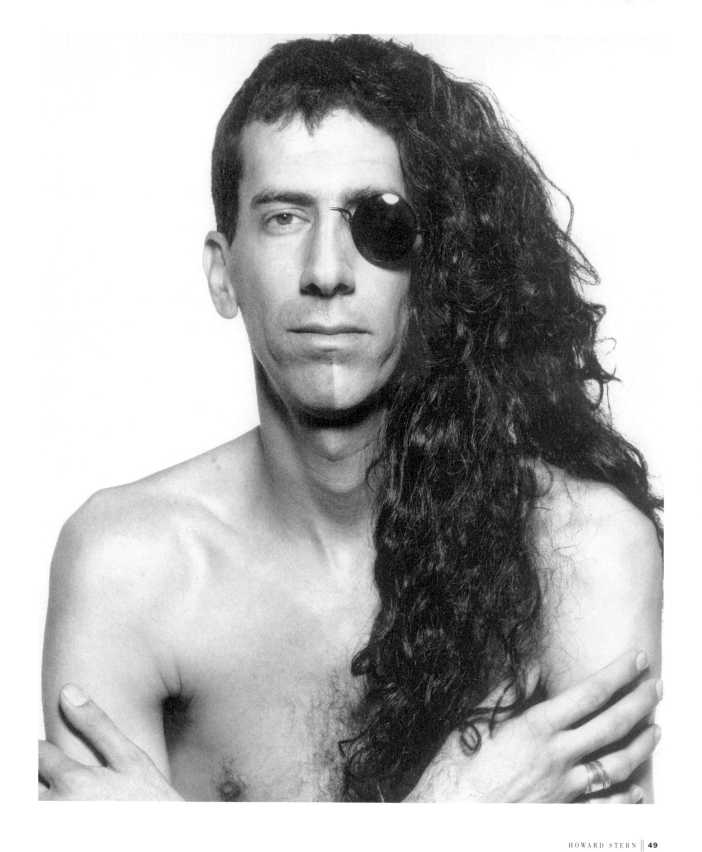

SG: I just wish I'd come along before he did. He's got me beat by about ten years, so from an age point of view he had a head start—otherwise, hell, I could see myself doing what he does for a living. I mean there's a lot of similarities in our personalities, but obviously I'm not exactly Howard Stern. But I always turn on Stern when I put the wig on. That seems to be the point of no return for me. Then it's all about attitude.

JF: You say you have similar personalities. Does that come from similar backgrounds as well?

SG: We're both pissed-off Jewish kids from Long Island, and we both have parents who've stayed married. But he's married and has three kids, and I'm single. He takes a limo to work every morning; I take public transportation. He lives in a mansion; I live in a studio apartment. We both like hot women, though. We like to be seen with babes on our arms.

JF: Do you have any advice for people who might want to try their own impersonation of Howard?

SG: Don't do it! Stay out of the business. I don't need any more competition. You'll suck anyway. I'm the only good Howard.

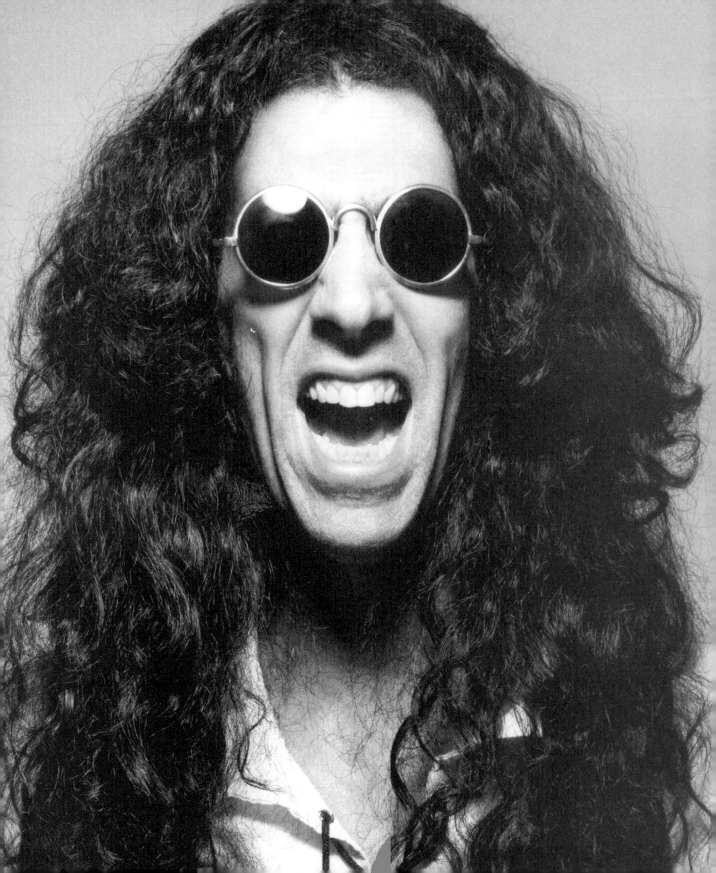

LINDA MORAND

JACQUELINE KENNEDY ONASSIS

I met Linda on *The Joan Rivers Show* around 1993. I immediately saw her resemblance to Jackie O. When you look at Linda's face, you right away notice the wide-eyed, square-jawed features. Jackie had the same strong yet graceful structure. Linda has a similar nose to Jackie O.'s, but it is fairly easy to create a Jackie O. nose with makeup on most people.

When I started working with Linda, I also realized she could impersonate Loni Anderson, but the Jackie O. character is the one I really wanted to bring out. So, I drooped Linda's eyes down a little bit, contoured the nose to make it just slightly wider looking, rounded off the mouth, thickened her eyebrows, found the right wig, and it's Jackie!

SQUARE FACES WITH DRAMATIC JAWLINES DO JACKIE KENNEDY ONASSIS BEST!

MANNEQUIN

JACQUELINE
KENNEDY
ONASSIS

Jackie O. loved high-class luxury displayed in a refined yet simple way. It's a big challenge to try to impersonate American royalty. If you think you're up to it, speak softly and present a dignified demeanor in outfits like these.

CLOTHING

- Black knee-length shift dress.
- Matching black jacket with a bertha collar and three-quarter-length sleeves.
- White triple-strand faux pearl choker.
- Black medium-high-heeled pumps.
- White faux pearl clip earrings.
- White wrist-length gloves.
- Mod black sunglasses.

WIG

An ash brown, one length to the shoulder, flipped pageboy worn with a baby pink pillbox hat.

OPTIONS

- Horseback-riding attire. (Jackie was an accomplished rider.)
- Long column evening dress.
- Any color short shift dress.
- Slim cut, flat front khakis.
- Crisply starched white men's oxford shirt.
- Lipstick colors include frosted pinks, peach, and rose.

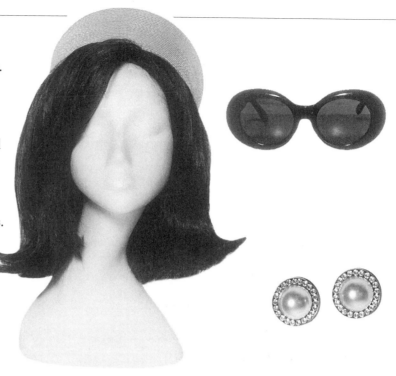

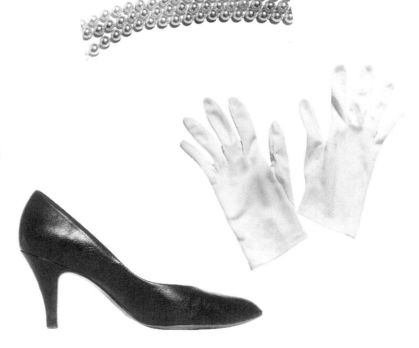

HALF-FACE MAKEUP

LINDA MORAND
JACQUELINE KENNEDY ONASSIS

Jacqueline Kennedy Onassis was the embodiment of style and grace. She left a profound mark on fashion, and as First Lady she brought an almost fairy-tale-like royalty to the White House. Here's how you can be part of the fantasy:

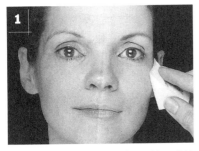

With a sponge, cover your face with a light beige to beige-colored panstick foundation. Use a translucent powder applied with a powder puff to set it in place.

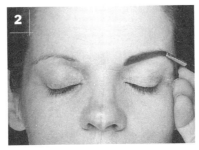

Starting with the eyebrows, use a brow brush and black eye shadow to create a graphic sixties-looking arched brow.

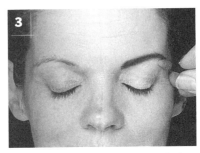

With a frosty cream-colored eye shadow, using a sponge applicator fill in the eyelid up to and on the brow bone without covering the brow.

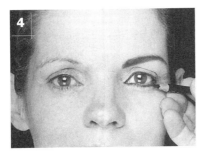

With a black eyeliner pencil, lightly outline the entire eye to emphasize the shape.

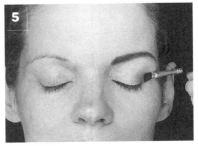

With a medium-size eye shadow brush and a medium brown eye shadow, highlight outer corner of the eye.

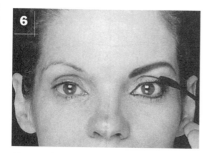

Next put black mascara on both the top and bottom lashes.

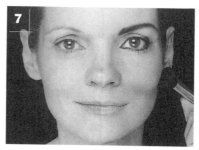

To contour the face that graced thousands of newspapers and magazines, use a medium brown contour shadow, and with a contour brush draw a light, crescent-shaped line from the ear, under the cheekbone, and over to the nose. Smile or smirk slightly to make it easier to see where the line should be drawn. Contour jaw if necessary.

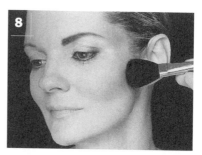

A coppertone-colored blush applied with a blush brush will blend the brown contour line into the softly shaded effect you want (see Devon's Recommendations, page 21).

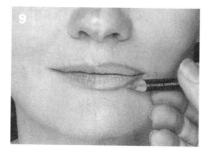

With a light brown lip pencil, draw in Jackie's thin, elongated lips (see Devon's Recommendations, page 24).

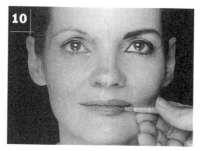

Fill in the lips using any of the many colors Jackie wore, but be sure to put the lipstick on using a creamy stick and apply it with a lip brush.

OH JACKIE!

Impersonating America's answer to royalty and the woman who was the epitome of elegance, style, and grace is no easy task. Linda Morand meets the challenge and then some. This model who travels the world makes her home on New York's Long Island. That means she's just a stone's throw away from Jackie O.'s stomping grounds—Manhattan! In fact, it was in Manhattan where real life imitated art and the Jackie look-alike met the real Ms. Kennedy Onassis. Morand says it was her resemblance to Jackie that changed her life at an early age, and their meeting was just icing on the cake of a career that's been very good to her.

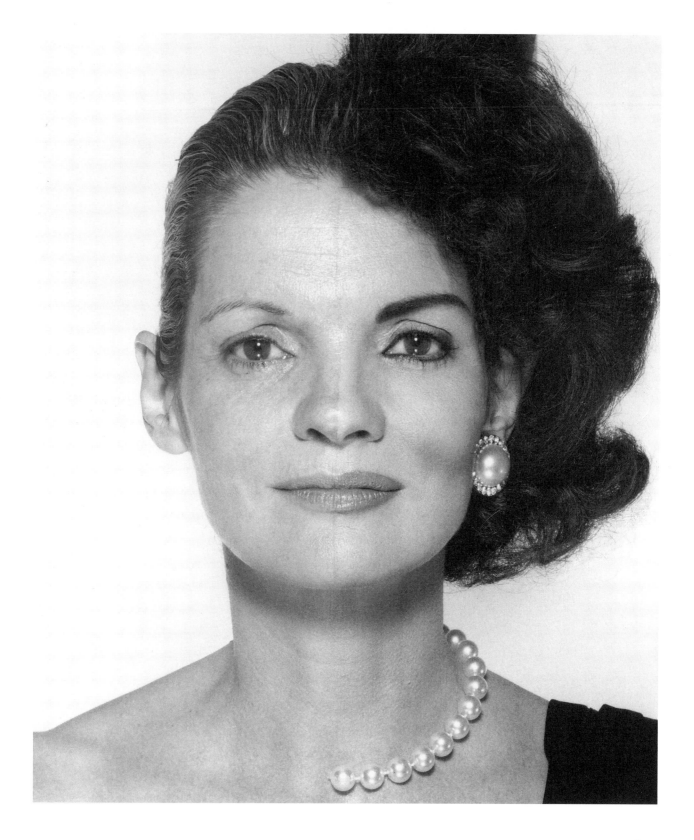

LM: I was in junior high when people first began saying I resembled Jackie Kennedy. It was fabulous and came at just the right time in my life. I was transformed from an ugly duckling into Cinderella and I reveled in it. The positive reaction gave me the confidence and courage I needed to become a model.

JF: You met Jackie at P.J. Clarke's in Manhattan?

LM: Yes, at the time I was one of the hottest cover girls in New York, and Jackie must have known about me because she so graciously said in that wispy voice of hers, "Oh, you must be the model who everyone is saying I look like!" I was completely captivated.

JF: In the early days, did you ever actually model as Jackie?

LM: No. After a successful couple of years as a cover girl in New York, I moved to Paris and married a French viscount, but I missed modeling and wanted to try again, but nobody seemed interested until one day I met Helmut Newton. He saw through my blondness and asked if I'd do a shoot as Jackie with him. I said I never deliberately imitated Jackie before and it would depend on the photographer and the magazine. He said how about him shooting a ten-page spread for *Vogue*. I said yes, and a new phase in my career was launched.

JF: What tips do you have for others who want to try an impersonation of Jackie?

LM: For Jackie, get a pillbox hat at any millinery supply store or thrift shop. Find a revival sixties look. A classic loose-fitting sheath is best in black or a pastel. The wig is important as are the gloves, pearls, and those big black sunglasses. All of these are easy to find because of the recent return to retro. Just remember, everything that Jackie wore was simple and elegant, and you can't go wrong if you choose black.

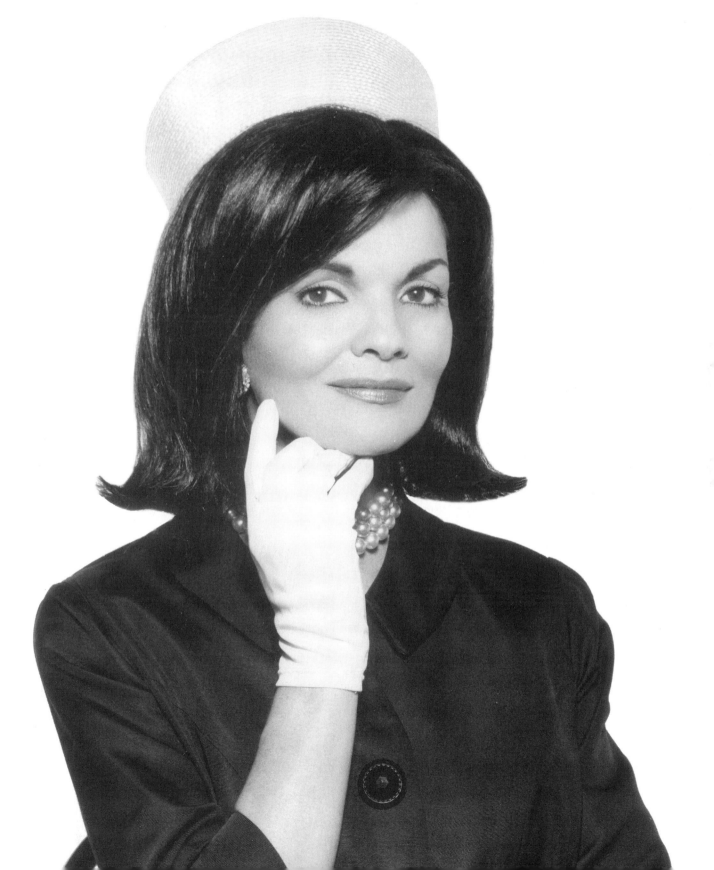

IMPRESSIONS OF
NATALIE BLALOCK
MADONNA

My best friend, Mavis Jennings, the rock-and-roll singer, introduced me to Natalie. He told me he'd met this woman who was trying out to be a back-up singer for his band, and she looked just like Madonna. I was skeptical, but when I saw Natalie for the first time I was floored. She was taller than Madonna and had different hair, but the bone structure was definitely Madonna.

Natalie's eyes are a little smaller than Madonna's, but I change them with makeup to get the same shape and size. Her nose is also a little thinner than Madonna's, so I widen it with makeup.

Natalie's mouth is a little smaller as well, but actually Madonna probably draws over her own mouth too, so I make the mouth bigger. Their profiles are almost exactly the same.

I chose this particular suit for Natalie to wear because Madonna is someone many people like to impersonate, so I needed something that almost everyone could find and look good in. Different body types can wear it. It's from a popular video so people recognize it. The monocle and chain help define the character, as do the shoes, which are comfortable men's wing tips.

HEART-SHAPED TO SQUARE FACES
DO MADONNA BEST!

MANNEQUIN
MADONNA

She's a rebellious, thought-provoking entertainer who has set nearly as many fashion fads as she's sung songs. Her aggressive allure is always accompanied by a nonjudgmental attitude.

To do Madonna you need to be strong, focused, and have lots of fun in outfits like these.

CLOTHING

- Navy blue, double-breasted men's suit.
- Black lace bra (showing, of course).
- Men's black, wing-tip oxford shoes.
- Clear monocle on a silver chain.

EYELASHES

- Short, spiky black lashes.

WIG

A short, layered, pin-curl blond wig, parted on the left side.

OPTIONS

- Tight sixties polka-dot bell-bottom pants (black-and-white or blue-and-white).
- Black or blue sixties-looking bell-sleeved blouse that ties under the bust. (The sleeves should be polka-dotted to match the pants.)
- High platform shoes.
- Gaultier-like spaghetti-strap top with big bra cones and short, short hot pants (worn with fish-net stockings).
- Sixties-style black go-go boots.
- Blond wig with hair slicked back and pulled up into a high pony-tail (use a braid wrapped around the start of the ponytail to keep it high).

- Blond curly wig worn with a beret.
- For a more dramatic Madonna look, à la *Erotica*, put black eyeliner all around the eye.

BEST SONGS TO PERFORM

"Vogue"
"Erotica"
"Justify My Love"
"Express Yourself"
"Secret"
"Holiday"
"Like a Virgin"

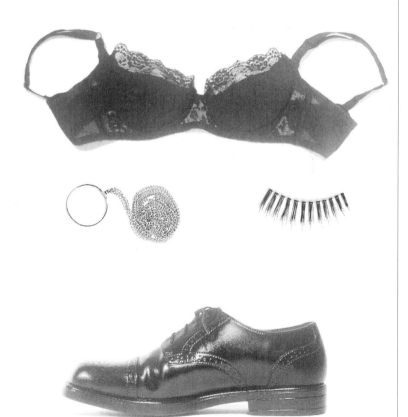

INEVITABLE ALLIANCE!

From her high school days portraying characters such as Pluto at Walt Disney World, Florida's Natalie Blalock has been linked to impersonation.

Blalock's been told she looks like Madonna (though she says she and her mother don't see it) since her Disney days, and ever since she's had a love/hate relationship with the "Material Girl." While she admires much of what Madonna has accomplished, Blalock has always wanted to be recognized in her own right for the accomplished actress that she is.

Today she's more comfortable creating the Madonna illusion because she now realizes that it doesn't have to hinder her career the way she thought it might. In other words, if you can't beat 'em, join 'em! In fact, the similarities in their looks, even without makeup, may prove to be a career booster for Blalock.

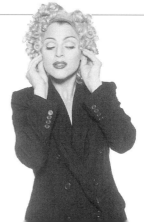

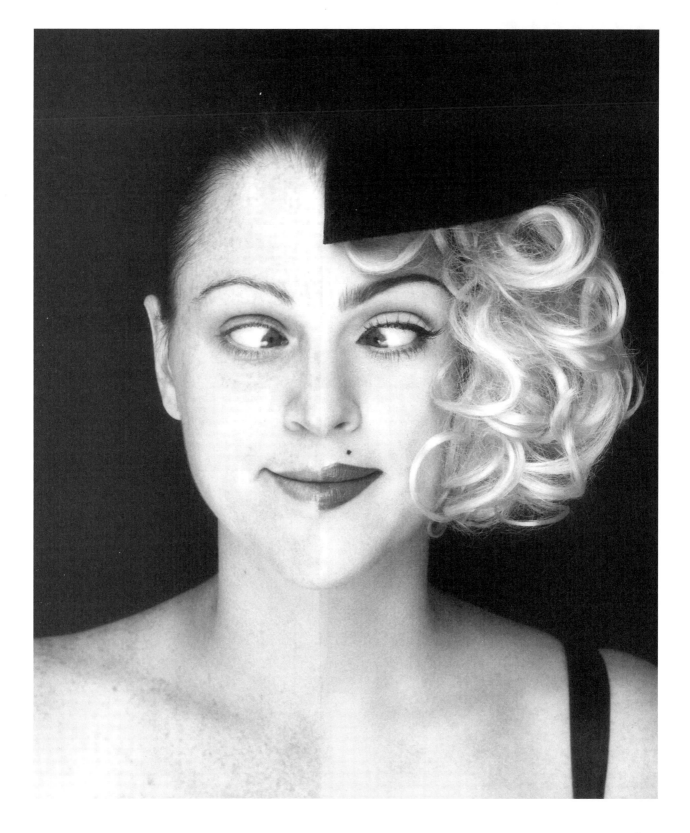

NB: Oddly enough, looking like Madonna may have helped me get this particular job that I'm doing right now. I'm a musical-theater actress and I'm working in a project, *Paper Moon*, at the Goodspeed Playhouse in Connecticut. The director was looking for character types, and of course he made a comment at my first audition, "Anybody ever tell you, you look like Madonna?" "Yeah, yeah, yeah." He liked my acting ability, but being able to do characters helped.

JF: What is it that you like about the transformation to Madonna?

NB: It's just fun. I've done it a couple of times for money, which is always a bonus. I worked on the Conan O'Brien show ten or so times. That was pretty interesting. I also like the fact that because of the shape of my face and my features I can pull off the illusion without a great deal of fuss. When I got the call for Conan O'Brien they asked me if I could be there in thirty minutes. I was cleaning my house, and I literally just rinsed myself off. My hair was a mess, but I went over because I knew I would be wearing a wig. I just threw on some foundation, mascara, a little bit of shadow, some lipstick, and a mole. Of course the more time I take, the better the illusion. But it's easy to bring her out with minimal effort on my part.

JF: Most people see the obvious physical similarities, but are there any coincidences in your backgrounds?

NB: She's Italian. I'm Irish, Scottish, and English. We were both brought up by single parents, but I wasn't raised religiously. From what I can tell she wanted to be a performer all her life, and so have I. We're both Leos, but she's nine or ten years older than I am. We both live in New York. As for other similarities, I can be obnoxious or hard—all of those things. My truck-driver mouth tends to make people think Madonna too.

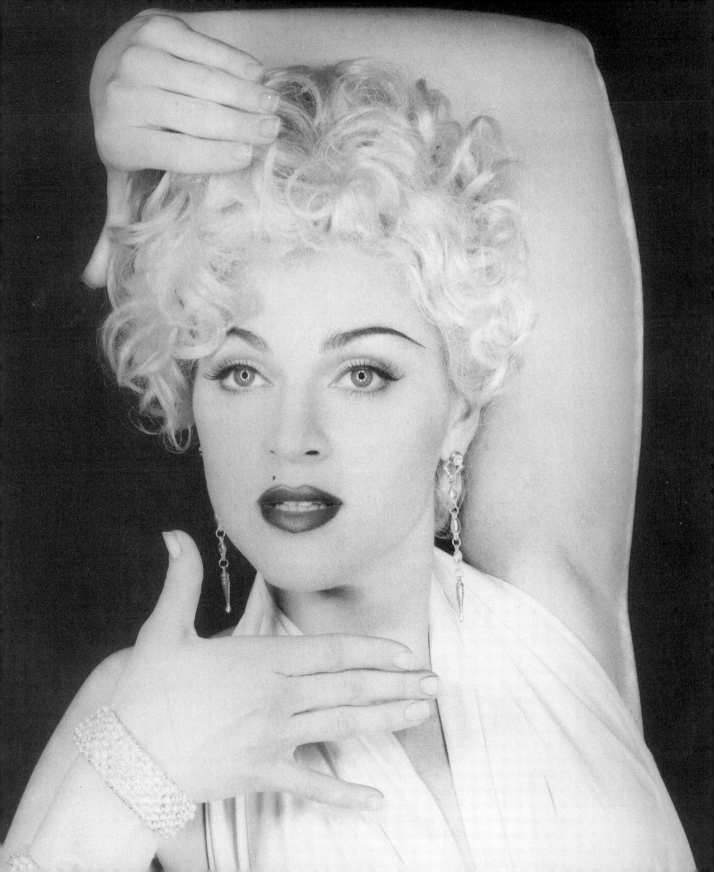

IMPRESSIONS OF
BETTINA J. WILLIAMS
WHOOPI GOLDBERG

I first met Bettina when she came to New York to talk to me about doing Whoopi. I picked her up in a limo—very glamorous!—and as we drove around I was stunned by how her essence is really that of Whoopi. I really felt like I was in the car with a celebrity!

Bettina just naturally resembles Whoopi, but with the right makeup, costume, and wig it's really phenomenal. Bettina was thrilled to see how fantastic the Whoopi braids look when they're put up. These braids are instrumental in creating Whoopi.

The Oscars tuxedo is a very identifiable outfit for Whoopi, and of course the round sunglasses are now somewhat of a trademark with her. For a lot of people, the costume, glasses, and hair convey the idea immediately, so even if people who want to impersonate Whoopi don't look that much like her, they can still do it with these accessories.

Whoopi has a cocky, yet endearing, attitude and a fabulous sense of humor, which Bettina captures perfectly. She's outgoing and has that smile. Shaking the braids around and acting a little crazy and carefree help too.

ROUND TO OVAL-SHAPED FACES
DO WHOOPI BEST!

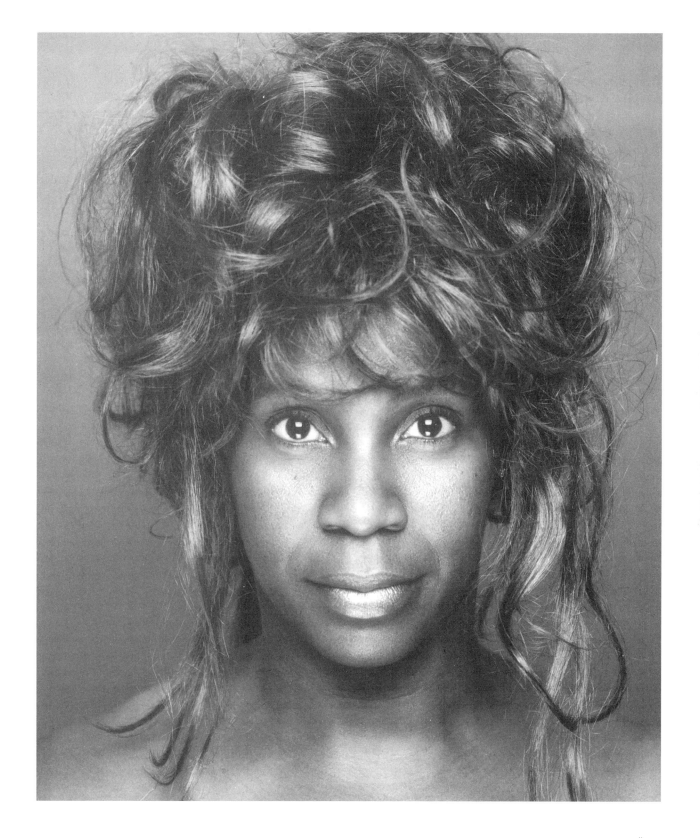

MANNEQUIN
WHOOPI GOLDBERG

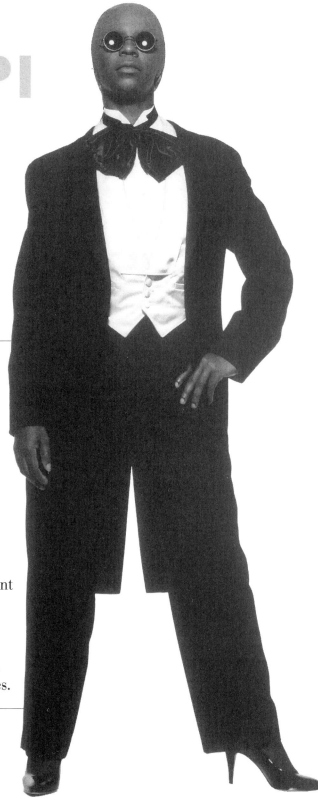

Whether it's a baggy tuxedo look or a glamorous Oscars night evening gown, Whoopi Goldberg gives everything she wears a dignified sense of style, along with a hint of humor.

She's never afraid to be herself, so if you want to wear Whoopi for a while, you need her sense of humor and strong self-image when you put on these clothes.

CLOTHING

- Men's black tuxedo with tails.
- White tuxedo shirt.
- White vest.
- Large, exaggerated black satin bow tie.
- Black high-heeled pumps.
- Round, black sunglasses (if desired).

WIG

Multibraided black wig. (Braids should be shoulder-length. You can buy a short black wig and separate braided extensions, which you sew in one by one and style accordingly.)

OPTIONS

- Sporty pantsuit with simple white T-shirt. (Purchase a Comic Relief T-shirt or simply draw on Comic Relief if desired.)
- Black-and-white nun's habit, à la *Sister Act*.
- Red pumps. (They go with the nun's habit and tuxedo looks.)

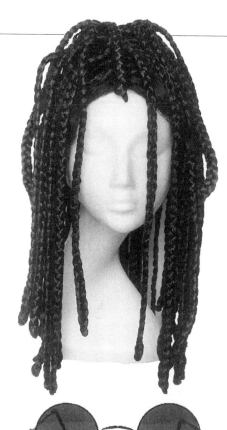

FAMOUS QUOTE

"Mufasa, ooooohhh, say it again!" From *The Lion King*

BEST SONGS TO PERFORM

Any song from *Sister Act*

EXPRESSIONS

Big, wide toothy grin. Whimsical squint accompanied by a wide, closed-mouth smirk. Shocked and surprised look.

HALF-FACE MAKEUP

BETTINA J. WILLIAMS

WHOOPI GOLDBERG

She's a comedienne in a class by herself. Whoopi "Karen Johnson" Goldberg is as fine an actress as she is a humanitarian—a woman who works not only to make the world laugh, but also to make the world a better place to live. With a little work you can laugh and play looking like Whoopi. It's as easy as this:

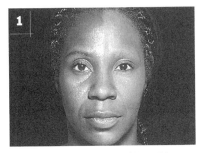

1 Paste down entire eyebrow (Whoopi has no eyebrows), and cover the face with a dark brown foundation using a sponge (see Devon's Recommendations, page 18).

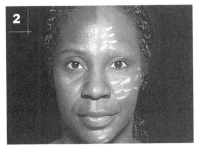

2 Now, dotting lightly with a medium beige foundation, highlight the cheek, forehead, and chin.

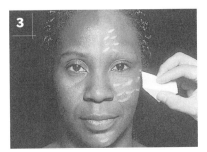

3 Blend the lighter foundation into the darker one with a sponge.

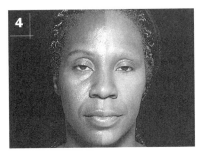

4 Use a matching dark powder to set the darker foundation in place, and a matching lighter powder for the highlighted areas. Apply the powders with separate powder puffs.

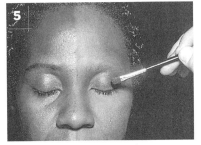

5 Next, with a medium-size eye shadow brush, use a dark brown eye shadow and cover the entire eyelid.

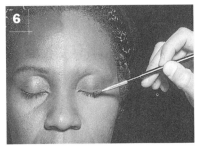

6 Using a smaller eye shadow brush and a charcoal shadow, draw a line along the upper lash line, blending it into the brown shadow on the lid.

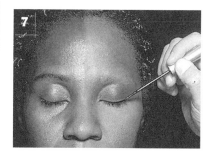

With black liquid eyeliner draw a thin line all the way across the upper lash line.

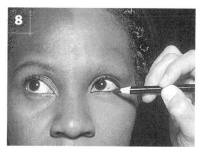

Now, use a black eyeliner pencil to fill in the bottom, inner lash line.

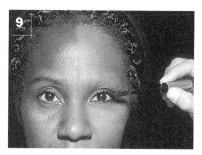

Take mascara and apply to both the top and bottom eyelashes (not too heavy, not too light).

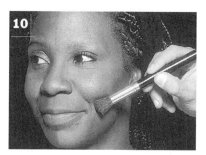

Use a contour brush and a dark brown contour shadow to draw a line under the apple of the cheek, starting from the upper edge of the ear all the way around to the nose.

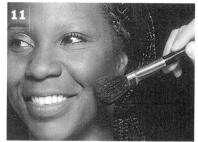

Next, take a burgundy blush and, using a blush brush, follow directly on top of the contour line you just created. (Be sure to blend the blush evenly into the dark brown contour shadow to make a more natural blend.) (See Devon's Recommendations, page 21.)

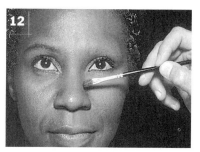

Getting Whoopi's nose right is as easy as applying a medium brown shadow with an eye shadow brush and drawing a line from the top of the nose, just to the side of the nose bone, all the way down to the nostril (this creates shading). (See Devon's Recommendations, page 23.)

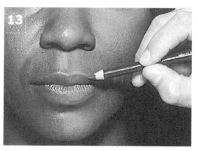

Use a dark burgundy lip liner pencil to draw on Whoopi's lips (see Devon's Recommendations, page 24).

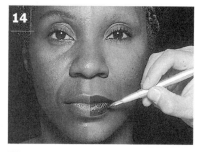

Fill in the lips with a dark purple lipstick, using a lip brush.

WILLIAMS IS MAKIN' "WHOOPI"!

When you can't walk down the street without a police escort, even in a tiny foreign country such as Belize, either you're very famous or you look like someone very famous. Either way you're causing a commotion.

For Bettina J. Williams, who causes a commotion everywhere she goes, it's a little of both. That's because looking like Whoopi Goldberg is making her as famous as her celebrity counterpart. Williams says she knew she resembled the actress and comedienne the minute she saw Goldberg in her first HBO special. Friends also saw the similarities, but it took Williams twelve more years to begin impersonating Whoopi.

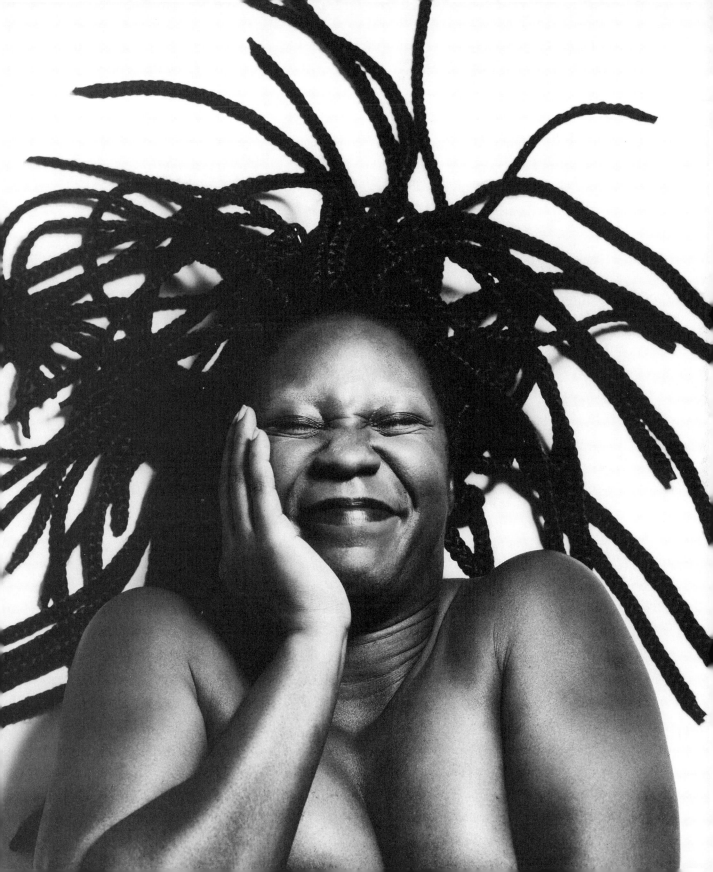

Having Goldberg's onscreen personality all the time is helping Williams launch a career that includes performing as her idol, as well as doing stand-up comedy as herself. That means this Seattle-born court reporter may soon be leaving her San Antonio, Texas, home for the bright lights and big city life she believes she was always meant to live.

When she does, she knows she'll be just fine because Williams also believes her connection to Whoopi Goldberg is more than just skin-deep.

BJW: I think we share the same spirit. It's very strange. We're the same age, almost exactly. I was born November 10, 1956, and she was born on the sixteenth, and of course we're both African American women—but I think our connection is a more cosmic kind of bond. She also had it a lot tougher coming up than I did— she struggled a lot more. I had to deal with prejudice when I left Seattle, but that was the toughest thing I had to face. Whoopi was on welfare and drugs. She went through some changes to get where she is, while I took paths, and, thank God, they happened to be right.

JF: What's the funniest thing that's happened to you as Whoopi?

BJW: I was eating, as always, and someone ran up to me and shouted "Mufasa" right in my face. Now I saw *The Lion King*, but at the time it didn't hit me that the reaction this guy was looking for was for me to say, "Ooooh, say it again." I just looked at him and said, "Ookaay!"

[*Laughs.*] I thought he was crazy, and later I realized he wanted me to do the line from the movie, but it was very weird to have someone come right up in your face and go "Mufasa."

JF: Has there ever been an embarrassing moment?

BJW: Believe it or not, it can be embarrassing when people cry, and they do cry. That kind of embarrasses me because it's such a personal and emotional experience. People just come up and start crying because they love Whoopi so much and they think I'm her, and I don't know what to do. I don't have the heart to tell them I'm not her because they're just so into it. You have to maintain a kindness all of the time because people want to believe it's her. So I can't be rude since that would reflect negatively and those people will believe that Whoopi's a rude person, which she is not.

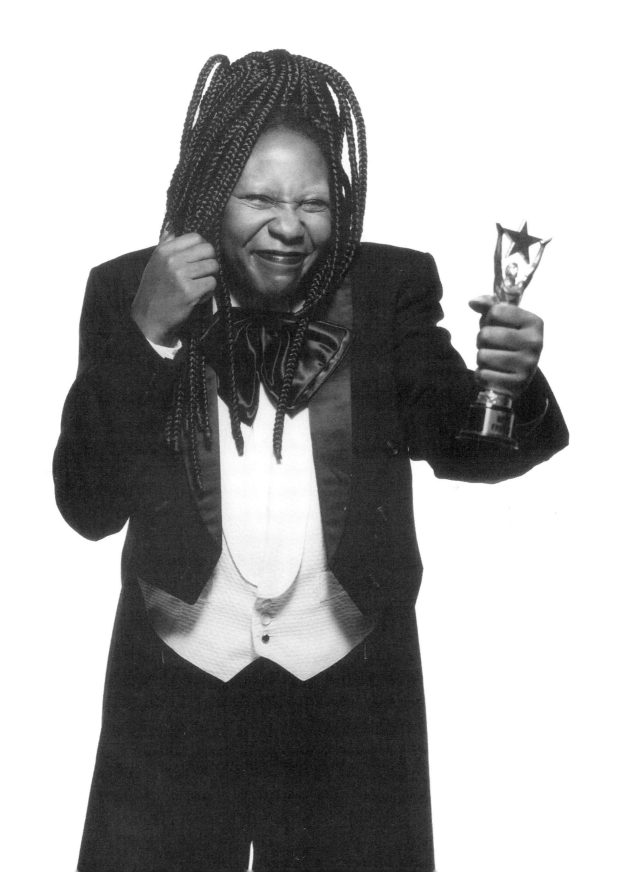

I first worked with Joe Manuella on *The Montel Williams Show*. When I saw him I didn't really see Robert De Niro, amazingly enough! He wasn't doing the gestures, the squinting, the act. In fact, throughout the whole taping of the show I kept thinking, "I don't see it." Then when I saw the show air, it hit me.

Joe's nose, mouth, teeth, even his face shape, are really similar to De Niro's, and when he squints his eyes get as intense as De Niro's do. He doesn't have De Niro's mole, though, but that's easy to apply with makeup. He also has a cleft in his chin that De Niro doesn't have. You can lose the cleft in photos with lighting and a touch-up, and in person makeup covers it a bit, but you can't really get rid of something like a cleft chin.

Joe also has the accent, but more than anything it's the facial gestures and the *Cape Fear* outfit I chose that really help the look, which includes a hat and longer hair. If you don't have the hair you can get a wig for the character. It's easy to get a Hawaiian shirt, or something that has that vibe. The white pants and white shoes help complete this look, but the most fun I had with the De Niro character was doing the tattoos— I really enjoyed drawing them on. The cigar says De Niro too!

SQUARE FACES
DO ROBERT DE NIRO BEST!

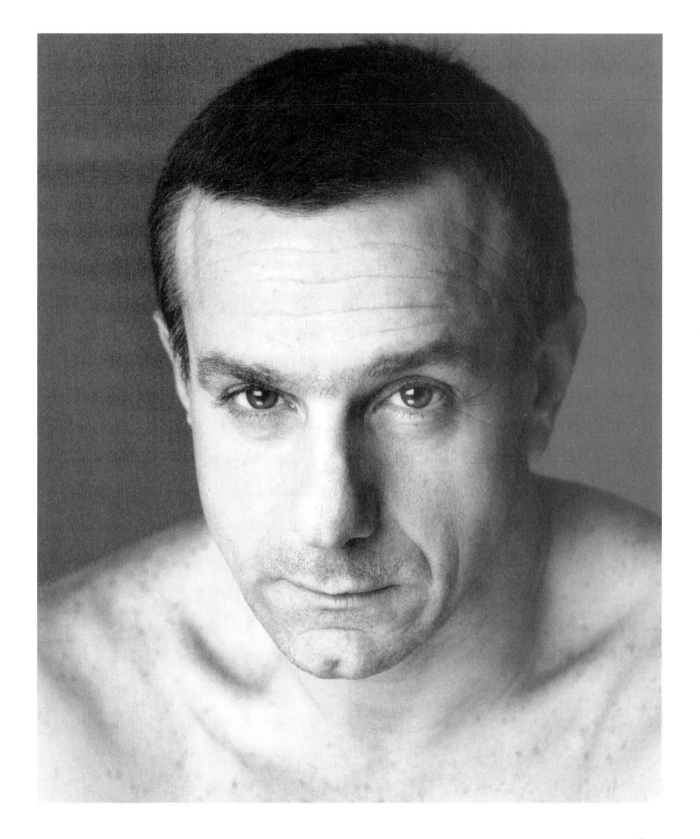

MANNEQUIN

ROBERT DE NIRO

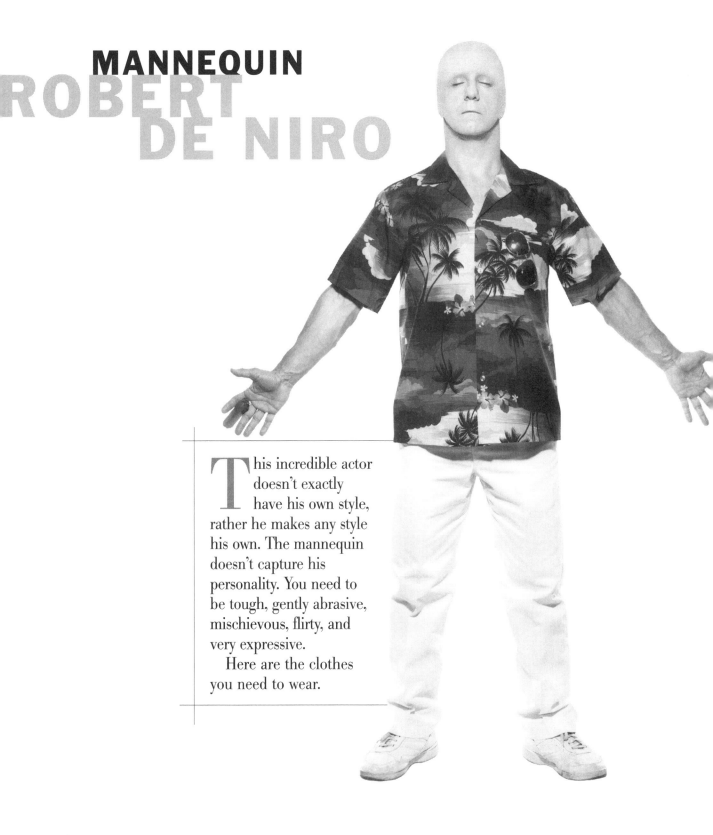

This incredible actor doesn't exactly have his own style, rather he makes any style his own. The mannequin doesn't capture his personality. You need to be tough, gently abrasive, mischievous, flirty, and very expressive.

Here are the clothes you need to wear.

CLOTHING

- A brightly colored short-sleeve Hawaiian shirt.
- White slacks.
- Slightly used white sneakers.
- Mirrored motorcycle sunglasses.
- A fat cigar.
- Greek sea captain's white hat.

WIG

A shoulder-length black wavy wig worn pushed back behind the ears.

OPTIONS

- For De Niro's *Taxi Driver* look, a green army jacket with a patch on the left arm and a little pirate's ring over the right chest works with loose-fitting jeans and cowboy boots. Gray sunglasses and a baseball cap or a Mohawk top off the look.
- *The Fan* requires a San Francisco Giants baseball cap, a brown suit, and a pink shirt.
- Going in Bob's *Casino* attire is like being pretty in pink. You need a pink shirt, pink satin tie, shiny pink jacket and pants, worn with white socks, and slick short black hair combed straight back.

- De Niro also does a salt-and-pepper hair look. For this style, like he wore in *Sleepers*, make the temples slightly gray with white clown makeup. Apply it to the fingers, then lightly touch it on the hair at the temples, distributing it evenly as shown in the photo on page 85.
- Since expressions can make or break a Robert De Niro look, practice those pictured on pages 88 and 89. They fit with some of De Niro's most famous film lines—or things he should have said.

FAMOUS QUOTES

"Whoa! Stand back, not too close."
"Phisssh, what ya talkin' about?"
"You're talkin' to me? You're talkin' to me? You're talkin' to me?" From *Taxi Driver*

HALF-FACE MAKEUP

JOE MANUELLA
ROBERT DE NIRO

Robert De Niro has one of those faces that makes him a natural character actor. It's handsome, a little gritty, and very malleable. You supply the movement, here's the makeup:

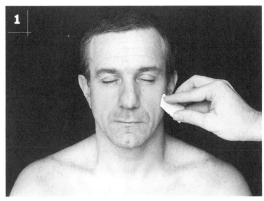

Use a water-based, very matte warm-beige foundation and sponge. If desired, lightly powder in place with a translucent or matching powder using a powder puff.

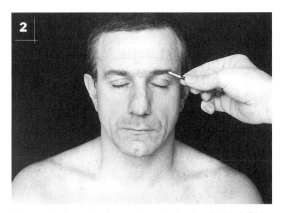

Now, with a brown shadow and eye shadow brush, lightly fill in and slightly darken your own eyebrows.

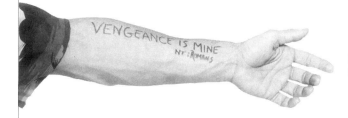

For the forearm tattoos, just write the sayings with midnight-blue eyeliner pencil.

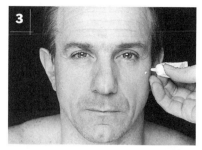

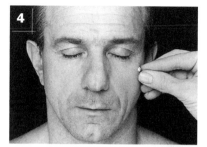

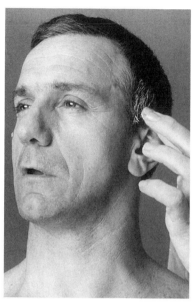

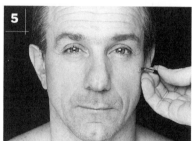

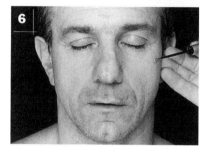

To create Bob's three-dimensional mole, take a small glob of glue stick and roll it between your forefinger and thumb. Once it's a nice little tight ball, squish one side flat, leaving a tiny mound on the other. (3) Next, take a dab of eyelash glue and apply it directly to the skin. Place it on the right cheek about half an inch under the eye and slightly over toward the ear, as shown. (The left cheek is shown here because of the half-face format.) Allow the glue to dry for fifteen to twenty seconds and (4) place the flat side of the ball on the glue and let dry for a minute or two. Now, cover the ball lightly with warm-beige foundation using the tip of a sponge. (5) With an eyebrow brush and medium brown shadow, dab the mole to give it color. (6) Then with the point of a black liquid eyeliner, make two or three fine dots on the mole. (If you're in a hurry, you can create a one-dimensional mole by drawing it on with a brown eyeliner pencil.)

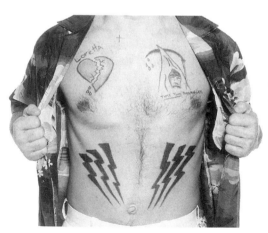

Now, using a midnight-blue eyeliner pencil, draw on the body tattoos, as shown. These are replicas of the actual tattoos used on De Niro's character in *Cape Fear*. Once the shapes are drawn, lightly fill in the heart tattoo with red blush, using an eye shadow brush to keep it light. It also allows you to stay within the lines. For the lightning bolts, strategically place a series of dots. Connect the dots to create the first, inner line of the bolt. Next, follow that line up on the outside, connecting those dots. Then fill in with some eyeliner pencil.

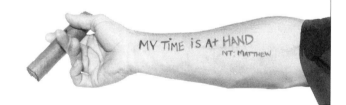

UN
TOUCH
ABLE!

Untouchable is the title of a biography of Robert De Niro, a takeoff on one of his hit movies, and it also describes his acting ability, but it also can be applied to Joe Manuella. He's a De Niro look-alike who grew up just three miles from De Niro in Brooklyn, New York. They share the same mannerisms, the same accent, even the same voice, and many of the same childhood experiences.

Manuella says he'd been told for years that he looked like De Niro, but he didn't see it until the late eighties, after *Midnight Run* was released. After that, he started doing TV talk shows and entering look-alike contests. From there it was on to Hollywood to actually work with Robert De Niro as his double in films.

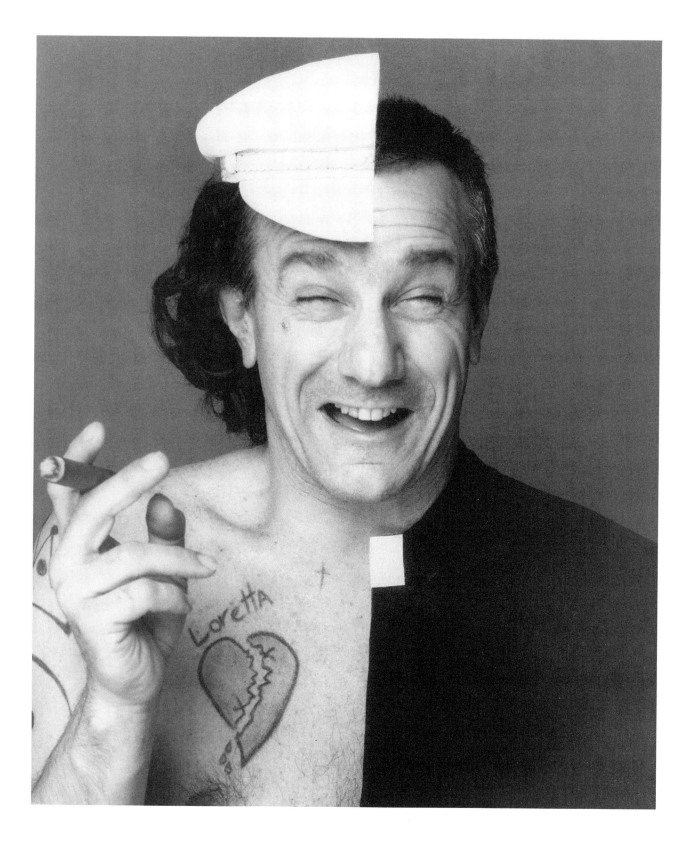

JM: There's a definite transformation going on when I impersonate De Niro, but instead of having a whole bunch of makeup like Cher or Marilyn or Madonna, all my makeup consists of is a mole. A little touch of brown on the eyebrows and maybe a little bit on the cleft and that's it, I'm ready to go.

JF: So pretty much what you see is what you get?

JM: Yeah, it's only about thirty percent acting. Genetically, it's so close it's scary. I even have certain veins in my arms that he's got. Even my chest is about the same when I take my shirt off. But when I have to become him, I point my toes in a little bit, cup my hands, tilt my head over just a little bit, and I talk too much.

JF: Are you obsessed with De Niro at all?

JM: No, but I am a fan. I collect his photos and his films on video, and I have an actual cigar he smoked, but I'm not obsessed or looking to have plastic surgery to improve the look or anything like that.

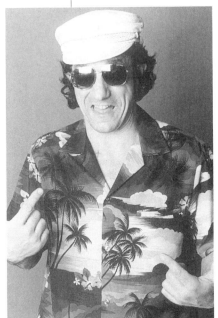

JF: What's one of your favorite lines from a De Niro movie, something you say that people get immediately?

JM: That's easy, it's from *Taxi Driver*: "You're talkin' to me? You're talkin' to me?" It's probably the most quoted line since "Frankly, my dear, I don't give a damn."

JF: Do you have an advantage doing De Niro?

JM: I have an advantage genetically, but you can do it through makeup and clothing and come pretty close. As long as you have the trademarks: the mole, the hair, and for *Cape Fear* the cigar—the biggest, fattest cigar you can get.

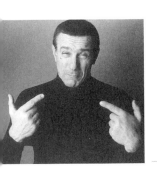

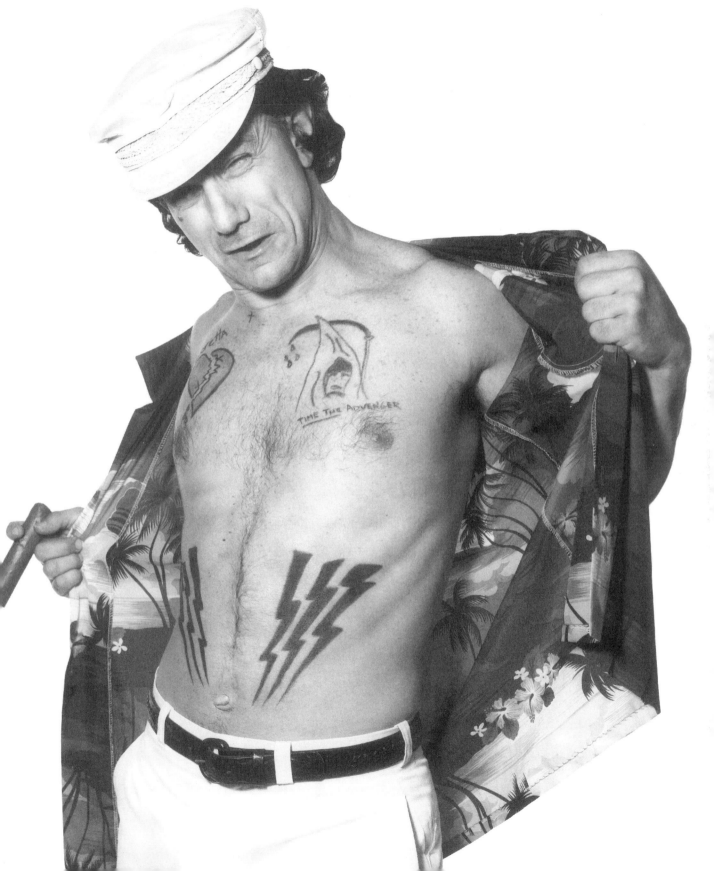

IMPRESSIONS OF
PAT COLLINS
GRACE JONES

When I was fifteen years old and living in Houston, I went through a filing cabinet in the boutique owned by my aunt, the designer Suzy Creamcheese. Under M for models I saw a picture of a tall, lanky woman who looked just like Grace Jones. Years later, after I set up shop in New York, a tall, lanky woman walked into my photography studio, and I immediately recognized her as that Grace from my aunt's boutique. It really was her, and when it came time to do this book, who else could I go to but Pat Collins for my Grace Jones?

Pat has Grace's high cheekbones, but it's possible to get great cheekbones with makeup. The key to accomplishing the look is that whether you wear a hat or a wig, it has to be square—and that's what I did with Pat. Pat is very thin, with a thin face and hollow cheeks under those high bones and square jaw. She has a muscular body type and is statuesque like Grace so she can wear the clingy clothes Grace likes to wear. Pat is actually a little softer-looking than Grace, until she does the expressions—the snarl and the hiss. I use makeup to give that softness a harder edge too.

The black patent-leather cat suit is so Grace, as are the gloves, which are really easy to make—just glue on large fake black fingernails to the glove fingertips. It's very dramatic.

SQUARE, LONGER FACES DO GRACE BEST!

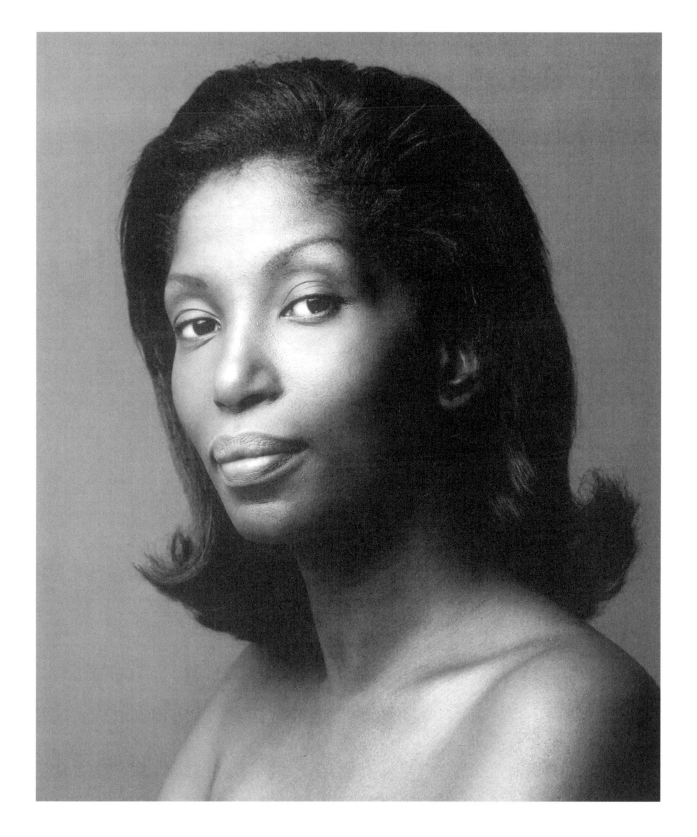

MANNEQUIN
GRACE JONES

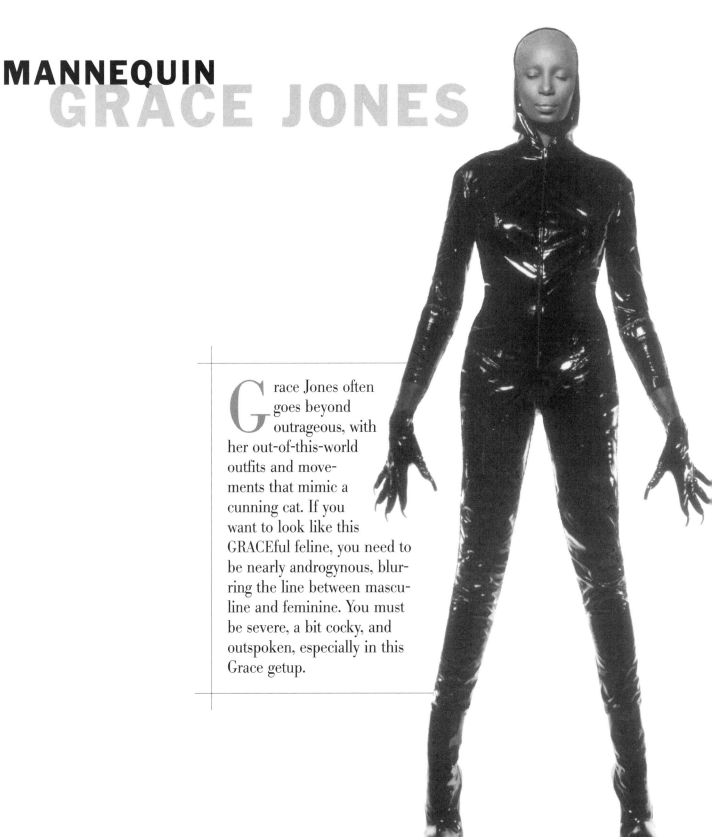

Grace Jones often goes beyond outrageous, with her out-of-this-world outfits and movements that mimic a cunning cat. If you want to look like this GRACEful feline, you need to be nearly androgynous, blurring the line between masculine and feminine. You must be severe, a bit cocky, and outspoken, especially in this Grace getup.

CLOTHING

- Black patent-leather cat suit with hood.
- Black patent-leather box hat, with patent-leather draping.
- Black patent-leather gloves with long, fake black fingernails.
- Black space-age, claw-edge sunglasses.
- Black patent-leather ankle-high, lace-up boots with five-inch heels.

EYELASHES

- Normal yet full black lashes.

WIG

If you're not wearing the box hat and hood, a high flattop men's haircut will work. (Or go bald and put on a pair of dark sunglasses.)

OPTIONS

- Spandex bodysuit in any color.
- Spandex animal-print bodysuit.
- Large, square-shouldered men's tailored suit jacket (worn with tights and thigh-high boots).
- Color options for makeup. include dark burgundy or purple blush and lipstick.

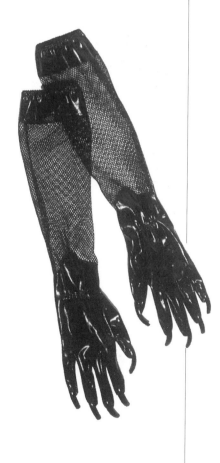

BEST SONGS TO PERFORM

"Pull Up to the Bumper, Baby"
"Slave to the Rhythm"
"La Vie en Rose"

EXPRESSIONS

Growling.
Snarling.
Sneering.
Hissing.

HALF-FACE MAKEUP

PAT COLLINS

GRACE JONES

Grace Jones has modeled, acted, sung, and sneered her way into our hearts. She's tough, but she can also be tender. Either way, she always makes a strong fashion statement. Her makeup is no exception. It's high-tech, but easy to accomplish:

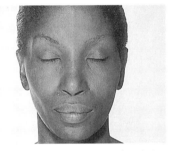

Cover the face with a dark ebony foundation with sponge.

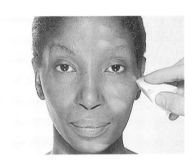

Take a medium beige foundation and highlight the cheek, forehead, and chin, dotting each area lightly and blending it into the ebony foundation with a sponge.

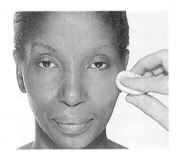

Now, apply dark powder to darker areas and a light powder to highlighted areas with separate powder puffs. (This sets the foundation in place.)

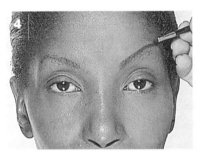

Now it's time to create Grace's highly arched eyebrow. Draw in an exaggerated arch-shape brow using black eye shadow and an eyebrow brush. (To eliminate excess bushy brows, see Devon's Recommendations, page 18.)

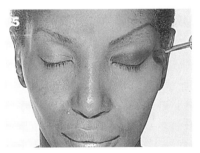

With a small eyebrow brush and black shadow, draw a thick line across the entire eyelid near the lash line, starting from the inner edge of the eye all the way over to the outer edge, ending in a point at the outside of the eye.

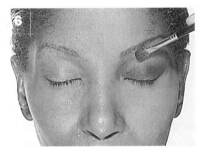

Next, with a small eyeshadow brush and charcoal shadow, draw a thick line from the inner bridge of the nose up to the brow and across the entire eyelid.

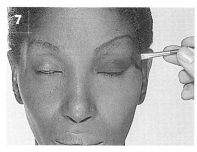

Making sure to extend this charcoal line out and up toward the temple. (The charcoal shadow should touch and blend into the black shadow line that you drew in step 5.)

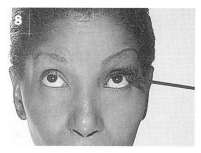

After gluing a full, medium-size black false eyelash onto your natural eyelashes, apply black mascara to mesh the top false and natural lashes together (see Devon's Recommendations, page 21). Also, lightly put mascara on the bottom natural lashes.

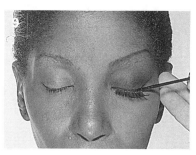

With a black liquid eyeliner, draw a medium-thick line across the entire upper eyelash line, ending at the outer edge of the eye in a point.

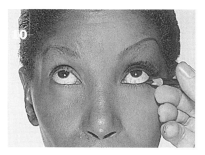

Next, use a black eyeliner pencil to line the inner bottom lash line.

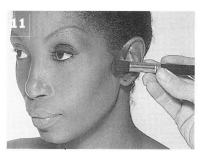

Take a contour brush and a dark brown contour shadow and contour the cheek starting from the upper edge of the ear straight down to the edge of the mouth. Contour the jawline too. If you don't already have high cheekbones, contour the temples too. This adds to the illusion. (See Devon's Recommendations, page 21.)

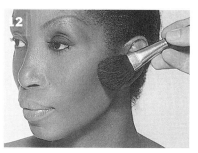

Now, using a blush brush, blend in all of the brown contour lines with a red blush.

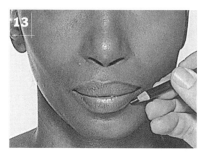

With a black eyeliner pencil (not lip liner pencil), outline voluptuous lips. (See Devon's Recommendations, page 24.)

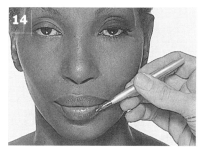

Fill in the corner of the mouth with a cherry-red lipstick using a lip brush. This should be a line on the upper and lower lip just inside the black outline. Be sure to leave the center of the lips and mouth natural.

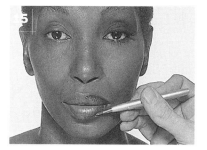

With dark burgundy lipstick, make yet another line in the corner of the mouth, inside the cherry-red lipstick line, and then blend the dark burgundy and cherry colors together. Keep the corners of the mouth darker and lighten toward the center. (You can leave the center of the mouth natural or add a silver, shimmering eye shadow to cover the middle of the mouth.)

AMAZING GRACE
PERFORMED BY
PAT COLLINS!

She's a devout Christian who sees no conflict, contrast, or contradiction impersonating the club scene's infamous bad girl, Grace Jones.

That's because Pat Collins is one secure woman who knows it's all in fun. In fact, it's the perfectly innocent way of being just a little naughty, without ever ceasing to be nice.

Though she comes from Miami, this mother-to-be lives in Brooklyn with her husband and cat, and shares a Caribbean upbringing with Amazing Grace. Collins's parents are from the Bahamas, and Jones is Jamaican.

Collins is also taller than Jones. She stands over six feet and has thirty-seven-and-a-half-inch legs. Her deep, raspy voice makes it almost impossible for people not to make the obvious comparison.

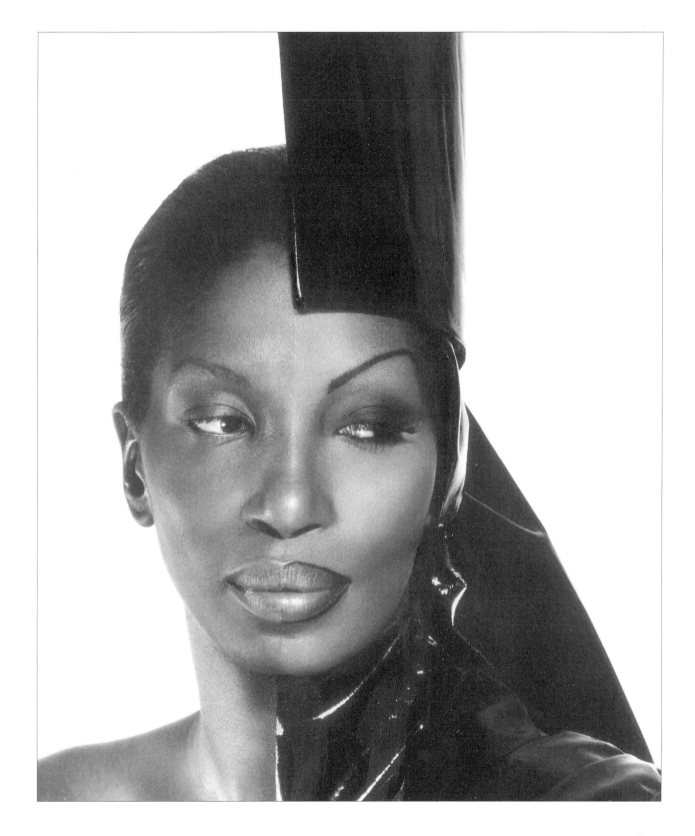

PC: I get it riding the subways, walking down the street, everywhere. When I had short hair, people would always ask me whether I was a man or a woman, and then if I was Grace Jones.

JF: What's been the most unusual incident when someone thought they were seeing Grace Jones in person?

PC: I was walking down Seventh Avenue in New York and a European couple in a car literally pulled up on the sidewalk. I didn't understand what they were yelling at me, but I did catch "Grace" a couple of times, so I signed her autograph for them.

JF: So is it all the attention you get that makes you especially like transforming into Grace Jones?

PC: I think it's the fantasy of being someone else. I think everyone has a little curiosity about what that's like, and why not? It's fun and exciting. I can be a Grace Jones look-alike and still be Pat Collins. I'm not going to take away Grace's soul or identity, nor am I going to loose mine.

JF: Is there one question you've been waiting to ask Grace if you meet her?

PC: Yes. How does she handle the reputation she has as this meat-eating, animal-like, even offensive, diva? How does she stay sane and keep a sound mind? She's a performer and it's gotten her to where she is today, but, come on, people, let's not get carried away! She's unique and different with all the costumes and motorcycles and such, but I don't know how she maintains balance without just coming out and saying, Look I am who I am — I'm not a man, I'm a woman. I enjoy what I'm doing so some of you need to just let it be.

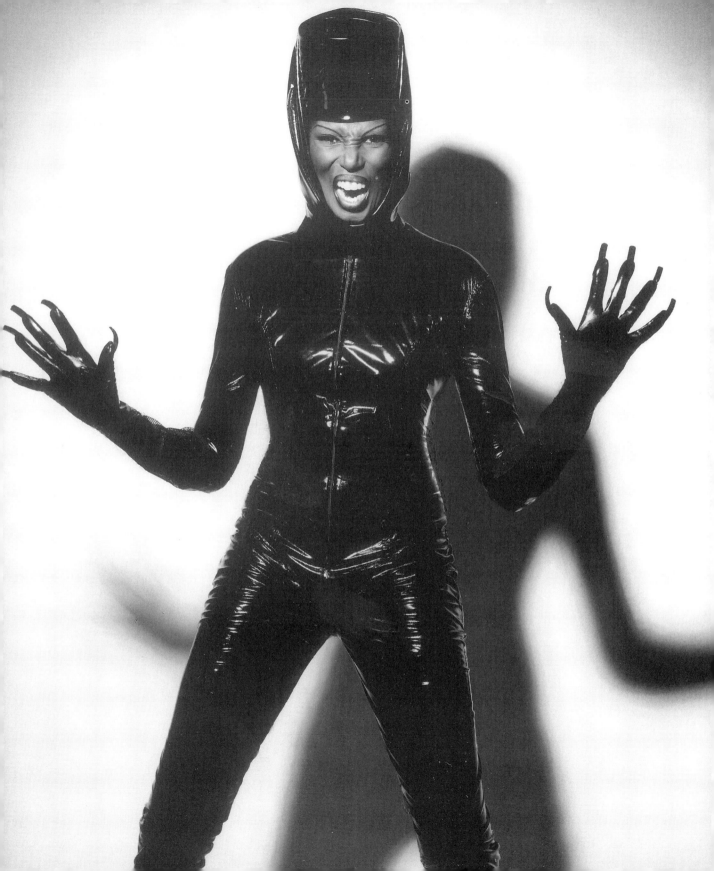

IMPRESSIONS OF
PAT BURNS
JOAN COLLINS

I've known Pat for about eight years. She called me to do Joan Collins shots back when *Dynasty* was really hot. I was working with another Joan Collins look-alike, but when I started putting the makeup on Pat I was blown away. I just couldn't believe it, and then when we put the hair up, she really became Joan Collins. She looks more like Joan with her hair up than down, and that's something I still haven't figured out.

Pat has Joan's mouth, eyes, and basic bone structure, though her face is a little more square than Joan's. Joan's face has more of a heart-shaped quality, but Pat has that slanty Collins smile.

The basic beaded slip dress is something that's easy to find and fairly inexpensive. You don't need a Bob Mackie beaded gown to pull this off. You just need to find something that looks expensive and meets the high taste that's associated with Joan Collins, and especially her Alexis Carrington character. I wanted her to look the way everyone remembers Joan, with the jewelry and, of course, the bitchy attitude.

HEART-SHAPED TO SQUARE FACES
DO JOAN BEST!

MANNEQUIN
JOAN COLLINS

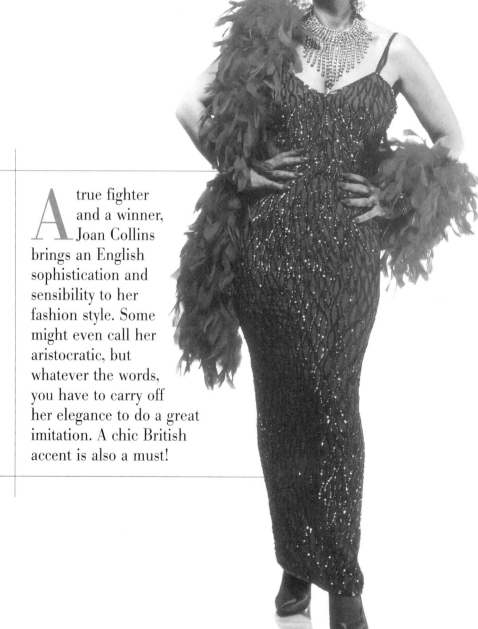

A true fighter and a winner, Joan Collins brings an English sophistication and sensibility to her fashion style. Some might even call her aristocratic, but whatever the words, you have to carry off her elegance to do a great imitation. A chic British accent is also a must!

CLOTHING

- Red-sequined, spaghetti-strap evening gown.
- Red feather boa.
- Large, ornate rhinestone necklace.
- Red satin, high-heeled pumps.
- Medium-length, oval-tipped red false fingernails.
- Large, rhinestone chandelier earrings.
- Chic rhinestone bracelet and ring.

EYELASHES

- Short, spiky black lashes.

WIG

A dark brown, crown-cupped hairpiece with medium-size curls.

OPTIONS

- Short, black, layered wig with spiky bangs.
- Knee-length tailored business skirt suit (for the eighties *Dynasty* look).
- Big-brimmed hat with netting in front.
- Medium-high-heeled pumps (any color to match outfit).
- Best Joan Collins colors include red, royal blue, gray, kelly green, white, and black.
- Lip colors include frosted pink and frosty shades of orange.

EXPRESSION

Flirty (with bedroom eyes and a twitch of the mouth that expands into a sexy smile).

FAMOUS QUOTES

"Blake Darling!"
"Fallon Darling!"
"Krystle, you bitch!"
"If I can't have you, nobody will!"
"If I can't have him, nobody will!"

HALF-FACE MAKEUP
PAT BURNS
JOAN COLLINS

J oan Collins has a powerful statuesque presence with a charm school aura that captivates everyone with whom she comes in contact. Take this lesson to learn how to do her makeup and be the charmer that she is:

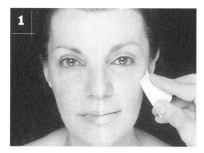

Using a sponge, start with an ivory foundation that you keep in place with translucent powder applied with a powder puff.

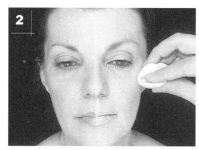

Now, apply white eye shadow to highlight the cheek, forehead, and chin using a powder puff.

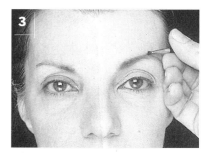

With black shadow and an eye shadow brush, draw in Joan's medium-arched brow.

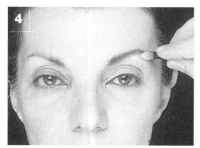

With white shadow, cover the brow bone just underneath the arch of the brow using a sponge applicator.

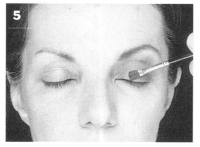

Now, take an eye shadow brush and use midnight-blue shadow to cover the eyelid, blending the blue slightly above the crease of the eye and up past the outer corner of the eye toward the temple.

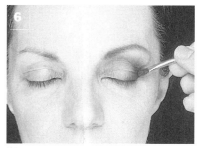

With an eye shadow brush and black shadow, blend the black into the midnight blue in the outer corner of the eye. Extend the black out and up toward the temple too.

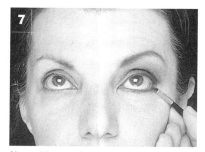

Now, with an eyebrow brush and black shadow, draw a thin line under the bottom lash line, extending it slightly out past the eye into a point.

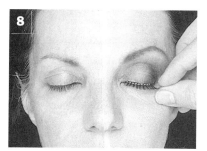

Next, glue on a black full false eyelash to your top natural eyelashes.

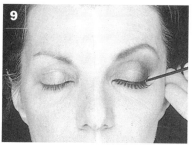

Use black liquid eyeliner to draw a thin line across the upper lash line and extend it out past the outer edge of the eye, ending in a point.

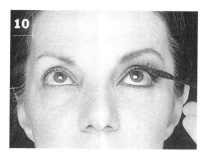

Apply black mascara to mesh the false top and natural lashes together (see Devon's Recommendations, page 21). Lightly put mascara on the bottom lashes.

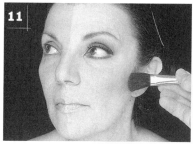

With a blush brush and red blush, lightly highlight the apple of the cheek and the temple. Contour the nose and jawline if necessary (see Devon's Recommendations, page 21).

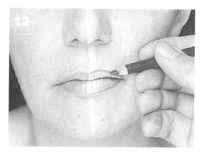

Take a burgundy lip liner pencil and draw in Joan's medium-size, semi-arched lips (see Devon's Recommendations, page 24).

Next, add lip gloss for shine.

Finally, pull your hair back tightly and pin it in place. Now, set a high hairpiece on the crown of the head and pin in place, as on page 107. Style accordingly. (Remember, Joan always wore messy bangs to create her eighties *Dynasty* look.)

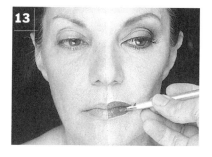

Using a lip brush and deep-red lipstick, fill in the lips.

IT'S BURNS'S TURN!

When she's not all dolled up as the diva of *Dynasty*, native New Yorker Pat Burns is busy helping to keep the Brooklyn Supreme Court on an even keel.

While she's proud of her accomplishments as a secretary for one of the court's judges, her real success story centers around her two daughters and, believe it or not, her granddaughter. That's right, Pat Burns is a grandmother who doesn't look the part unless she's playing Alexis. That's another success story Burns likes to boast about.

JF: When was the first time you were recognized as a celebrity?

PB: It was right after the outset of the TV series *Dynasty*, when Joan Collins first appeared on the show.

JF: What happened?

PB: Many years before *Dynasty*, Joan Collins was appearing in what I would call B-grade films. I remember I used to take my daughter to school and there was a patrol car in the area. The policeman would stop me and say, "You know you look like Joan Collins?" I would say, "Joan Collins, who?" Then nothing really happened until *Dynasty*, and then it happened quite often. I got stopped frequently. I had always known her as an actress, but I had never looked at myself as resembling her. When I was in high school people used to say I looked just like Natalie Wood. If I cut my hair a certain way it's Liza Minnelli, or Tyne Daly, so I sort of wonder. It's a good thing I know who I am, or I might get caught up in the illusion.

JF: What was the oddest thing that ever happened to you as Joan Collins?

PB: I was doing a talk show to model *Dynasty* fashions. The guests scheduled on the show were in the VIP room when a woman came up to me and said, "Oh my God, I can't believe it, Joan Collins!" I told her I was a look-alike, but she wouldn't believe me. Finally she said, "What the hell, I want your autograph anyway." The thing that's almost schizophrenic about look-alike work is remembering who you are as opposed to whom you appear to be. Our lives don't parallel in any way. I'm a Brooklyn girl, and she's from England. Her whole life has been totally different from mine—except for all the men.

JF: Has there ever been a moment when you wished that you were Joan Collins?

PB: No. That comes under the heading of "The grass is always greener." You look at

someone else and everything appears to be perfect. But she really had some tough breaks. She had marriages that didn't turn out well. She had hardships. I don't think I'd ever want to change my life for hers. Everyone knows what the positive effects of fame are—wealth and such—but I think a negative side of fame is that people maintain an illusion about you. You're never really allowed to be yourself. I don't think I'd want to be a part of that.

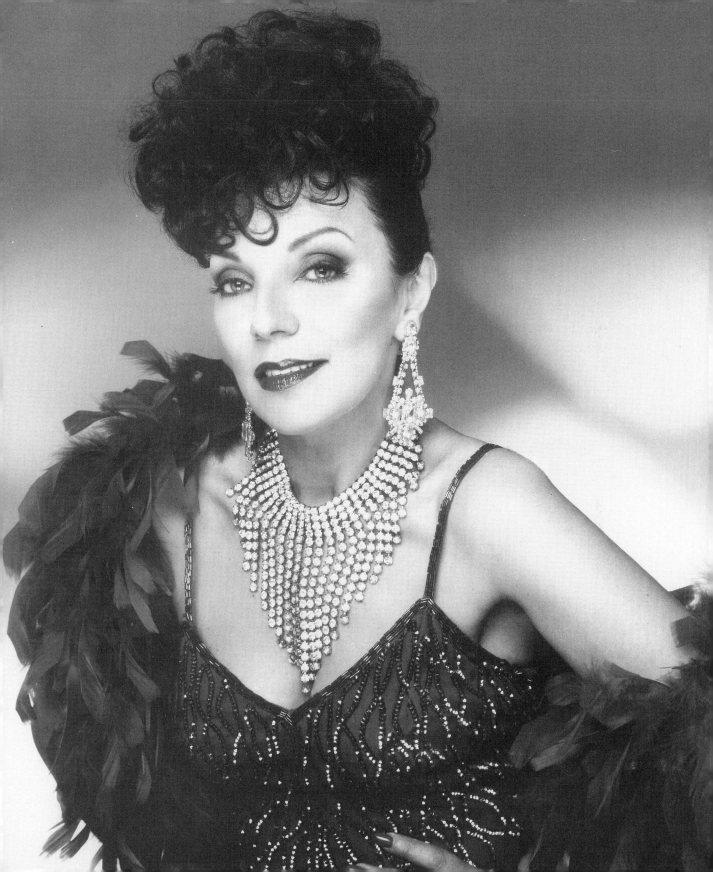

IMPRESSIONS OF
JO ANNE MEEKS
ELAINE CHEZ
SCOTT COOPER
MARILYN MONROE

I have three Marilyn Monroes now. I started out with two, both women and both great in their own right, and then I met Scott Cooper. I wanted to show not only that a man can do Marilyn, but that he can also do all of Marilyn's different looks, whereas I chose the women because each specializes in a particular Marilyn look.

Let me start with Jo. Jo has dark hair with a touch of red in it and resembles the Marilyn of the Norma Jean Baker years. She has a very innocent yet sexy quality. The one thing she has that the other Marilyn look-alikes don't have is the blue eyes. The others all use contact lenses. Often they don't even use contacts because when they're doing Marilyn, much of the time their eyes are slanted while smiling and saying "AAAhhhhhh." Her nose is very similar to Marilyn's, so very little contouring has to be done. I think Jo's biggest difference, as far as features go, is the mouth. It's the least like Marilyn's but it can be corrected with lipstick. Besides, having all the other features just allows the lips to kind of blend in.

Elaine Chez has more of Marilyn's look when she was in *Gentlemen Prefer Blondes*. She looks best with that makeup, hair, and costume. She can also pull off the "Happy Birthday" look. Elaine has Marilyn's bone structure and the same shaped eyes, although hers are brown. The nose is a little more bulbed, but that can be altered with contouring. She has more of what Marilyn's natural nose looked like before it was altered. And Elaine's face is a little more heart-shaped compared to Marilyn's oval face.

And then there's Scott.

Scott also has that innocent Marilyn quality. Of all the look-alikes, Scott can do all of Marilyn's expressions and even with his brown eyes, he's right on. If he had blue eyes he'd be perfect. He has the same nose and needs just a little contouring to create more of a bulb at the tip. His lips are a little different but easily fixed with lipstick. He has the same shaped eyes, and the lines of his face are perfect to do Marilyn. He has the smile. He makes a very impressive Marilyn.

OVAL, ROUND, SQUARE, AND HEART-SHAPED FACES CAN ALL DO MARILYN!

MANNEQUIN
MARILYN MONROE

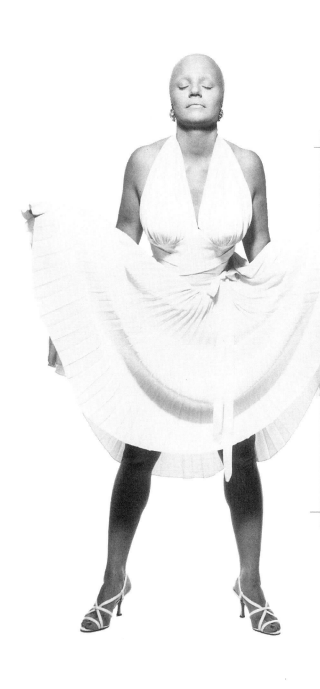

The sex kitten of the century, Marilyn Monroe believed in clothes that showed lots of skin. She wore body-conscious outfits that were low-cut more often than not. To bring Marilyn back you'll have to whisper in her flirtatious tones. You'll also have to imitate her style. Here are three major looks.

GENTLEMEN PREFER BLONDES LOOK

CLOTHING

- A strapless, belted fuchsia evening gown with a bow in back.
- Ornate rhinestone necklace.
- Dangly rhinestone earrings.
- A cluster of rhinestone bracelets on each wrist.
- Satin elbow-length fuchsia opera gloves.
- Black patent-leather strappy high-heeled sandals.

EYELASHES

- Short, spiky black lashes.

WIG

A shoulder-length platinum-blond look, with the part on the left side.

THE SEVEN YEAR ITCH LOOK

CLOTHING

- Short, pleated white halter-top circle-skirt dress, with crisscross ribbon belt.
- Strappy white sandals with medium-high heels.
- Medium-size white faux pearl earrings encircled with rhinestones.

WIG

A short, full platinum-blond wig, with the part on the left side.

IMPROVISED MARILYN MONROE LOOK

CLOTHING

- Short black Egyptian sunburst halter dress with broomstick pleating and gold Lurex threads throughout.
- Narrow black high-heeled pumps.
- Gold-sequined, double-ball dangling earrings.

WIG

Medium-length, platinum-blond curly wig parted on the left side.

OPTIONS

- Blue jeans worn with gingham, western-style, snap-front shirt.
- "Happy Birthday" look—deep plunging décolleté V-neckline illusion-fit dress with bottom flare, worn with Austrian crystals.

EXPRESSIONS

Open-mouth sigh.
Wide-mouth toothy smile.
Innocent, surprised look.

FAMOUS QUOTES

"I just love finding new places to put diamonds!"
"Thank you ever so!"
"How do you get it around your neck?" —Marilyn talking about a tiara she thinks is a necklace in *Gentlemen Prefer Blondes*.

BEST SONGS TO PERFORM

"I Wanna Be Loved by You"
"Happy Birthday to You"
"Diamonds Are a Girl's Best Friend"
"After You Get What You Want You Don't Want It"

"Heatwave"
"Some Like It Hot"

MEEKS SHALL INHERIT
THE LEGACY!

Quiet, unassuming, and somewhat shy! This small-town girl from the farm and rodeo community of Pendleton, Oregon, might be considered an unlikely candidate to play America's sexiest, most glamorous blond bombshell, but put that thought completely out of your mind.

Jo Anne Meeks, who uses the stage name Jo Anne Rice, can sauce it up with the best of them. She always wanted to be an actress, and says being transformed into Marilyn Monroe is as exciting as any theatrical role she could ever do. It's also a nice departure from her work in public relations and marketing.

Now a bona-fide New Yorker, Jo, as she likes to be called, is well on her way to perfecting the illusion. Appropriately enough for a New Yorker, Jo got her start impersonating the original "Material Girl" one Halloween.

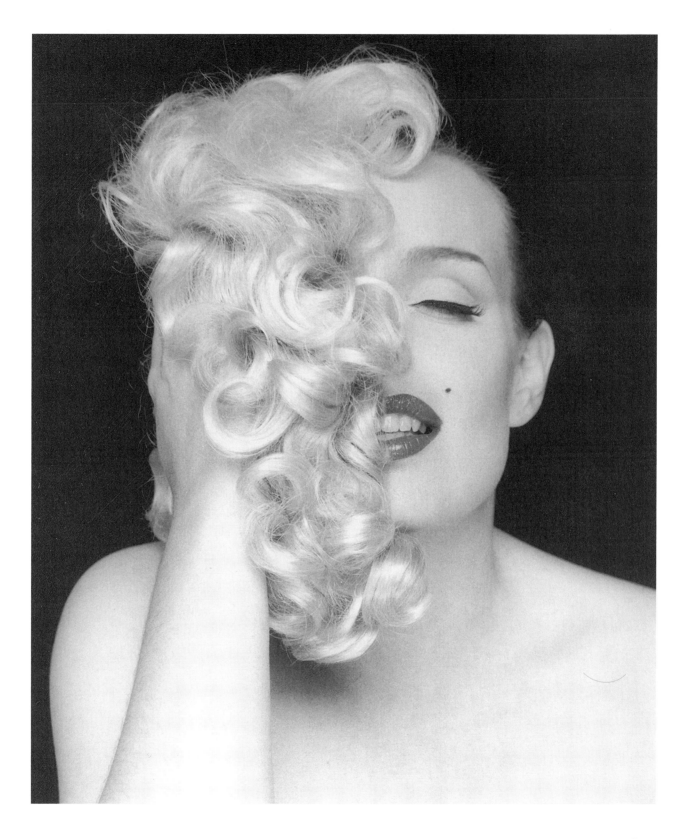

JM: I moved to New York in 1988, and after about a year of auditions and disappointments with acting, I decided that living hand-to-mouth was not the way I wanted to live. Giving up acting, however, always bothered me a little bit, because even though I've also always wanted to be a successful businesswoman, I felt I was giving up a lot of my creativity. Then, I guess it was in 1994, I was supposed to go to a Halloween party and I didn't know what to go as, and someone suggested Marilyn Monroe. Well, I did it, everyone loved it, and then I got the idea to try to be a Marilyn Monroe look-alike.

JF: Did you think you resembled Marilyn in any way, and that's why you could pull off the masquerade?

JM: Not really, because it's hard to tell. I think that Marilyn Monroe without makeup looked a lot different than the way we remember her or think she looked. So for her, or me, or anyone who impersonates her, I think it involves a good couple hours of work.

JF: Obviously you can't meet Marilyn in this life, but if you could, is there anything you would want to say to her?

JM: I think I would just listen, because I've always gotten the feeling that maybe a lot of people never really listened to her. I think that not many people understood her, and that she had all kinds of people telling her what to do and what not to do. Did anyone ever just listen to what she had to say?

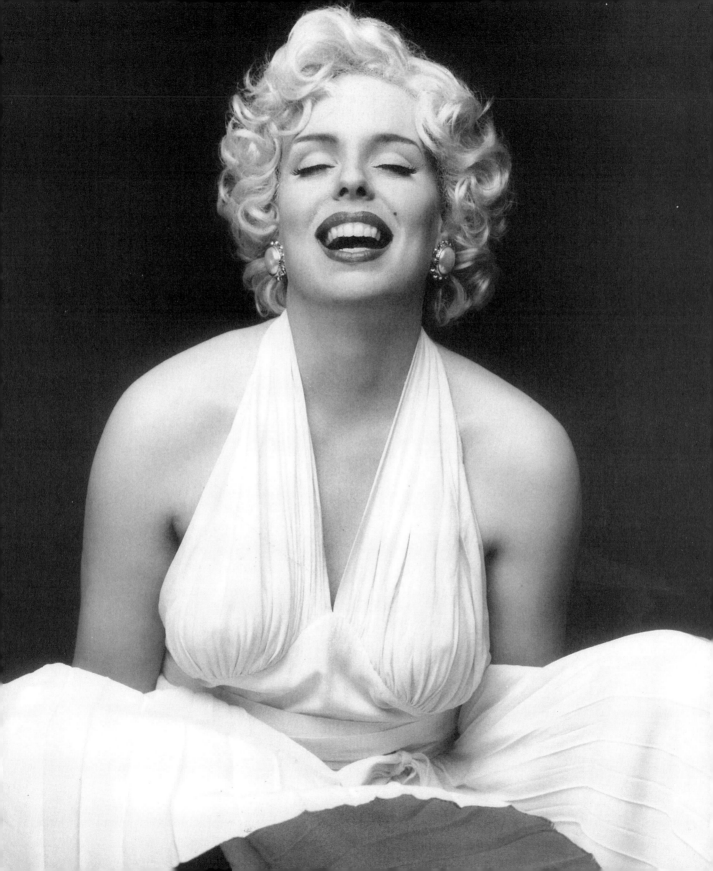

CHEZ
MARILYN!

She's been conjuring up the "Glamorous One's" glory days from the fifties and early sixties since 1977. Little did Elaine Chez know then that impersonating Marilyn Monroe would lead to her own business as a talent agent who specializes in look-alikes. Chez Company is located in Astoria, Queens, where Chez has lived since moving from her childhood home in Derby, Connecticut.

Chez still creates the platinum-blond sex goddess illusion, but says, ironically enough, it was her resemblance to Norma Jean Baker that first got her noticed.

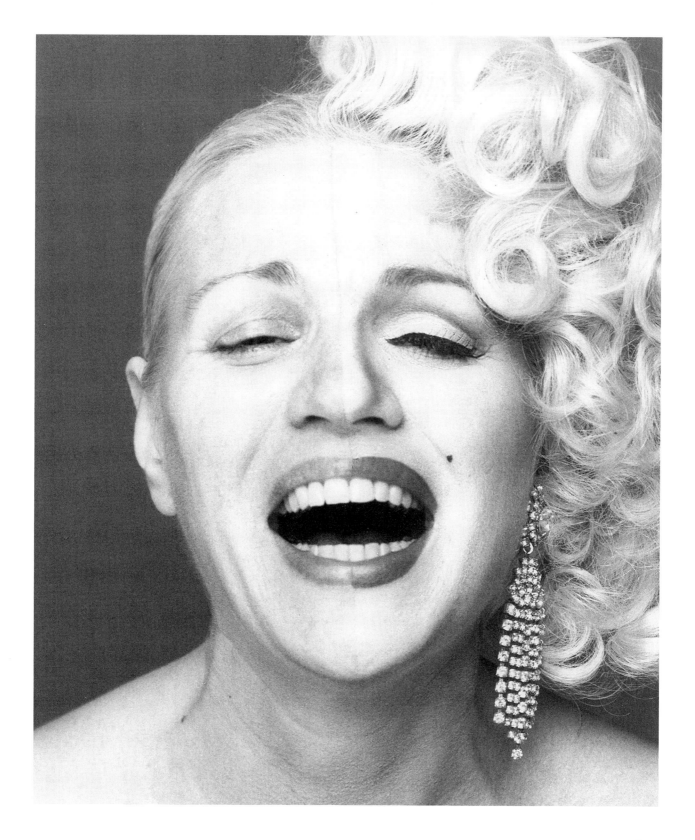

EC: I was at a party in Connecticut and met a photographer from *Time* magazine who thought I looked liked Norma Jean Baker, and I was like, "Norma who?" And then he said, "You know, Marilyn Monroe." Norma Jean Baker is of course her real name, but this was all new to me back then. I had my natural hair color then, which is dark blond, and I have the old Marilyn nose, the ski slope nose, but all this got my curiosity going. He said I should do some test shots and dye my hair blond, and eventually I did.

JF: What were some of the jobs you've gotten as Marilyn?

EC: My very first break was in New York for Studio 54—the famous disco—and then a gig for Twentieth Century-Fox, so I was a spoiled brat look-alike. No hundred-dollar birthday grams for this girl.

JF: Do you do Marilyn's voice?

EC [*Imitating Marilyn perfectly*]: In my pictures all I wanted was money and diamonds, but now for the first time, all I ever really want is to do this interview, with you.

JF: Are you in any way obsessed with Marilyn?

EC: I think in the beginning. I think all of us who do this are a little bit obsessed. I took to answering the phone using her voice and people who knew me would call me Marilyn, and I'd respond as she might have. But I decided that wasn't healthy. Then, I also collected everything that had anything to do with her. I've been lucky enough to have worn two of her original dresses, and I own a key chain that she had on the Fox lot when she was there.

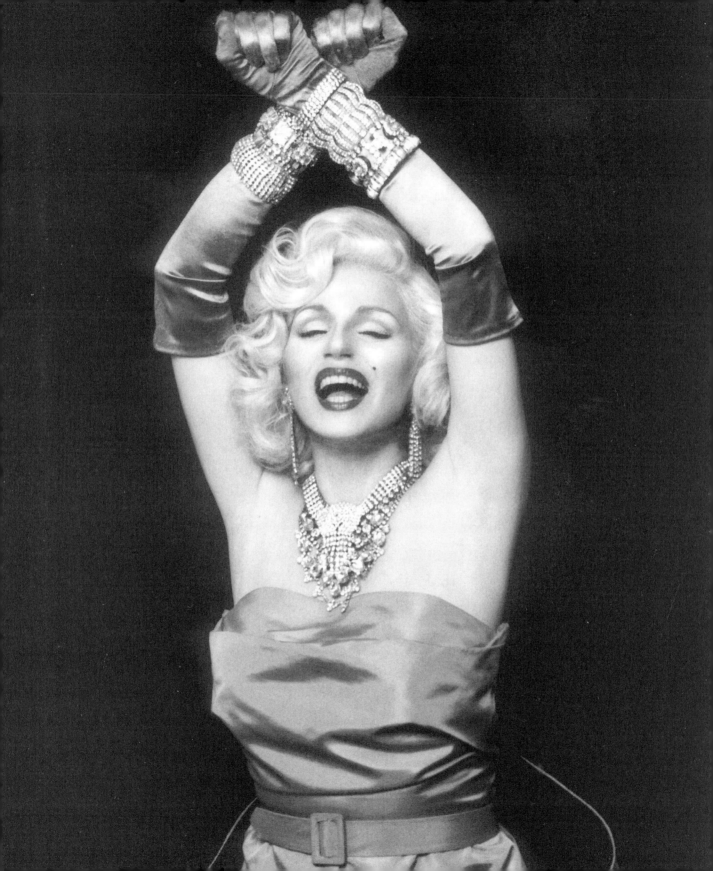

COOPER'S SUPER
AND MARILYN
IS A MAN!

Even without makeup you can see Marilyn Monroe in Scott Cooper's face. It's subtle, but it's there, and like Marilyn there's a quality about Cooper that is captivating. They have blond hair in common, but Cooper doesn't have to play dumb to get where he wants to go. He just has to play Marilyn, or Judy, or become his alter ego, Michele Dupree, and be fabulous in beauty pageants.

For Cooper, who's also a registered nurse and cancer specialist, entertaining is his passion. He says the stage is the place he most wants to be. When he's not onstage, he's at home in Begona, New Jersey, where he was born and raised. Cooper says he was thrown into the world of female impersonation quickly. Just three weeks after winning a Marilyn Monroe look-alike contest in 1993, he found himself cast in a *La Cage* show. The contest was the first time he'd ever done drag. He says back then he was passable, but the look was wrong at times. Today that's all changed, and when Cooper becomes Monroe it's not only magical, it's eerie.

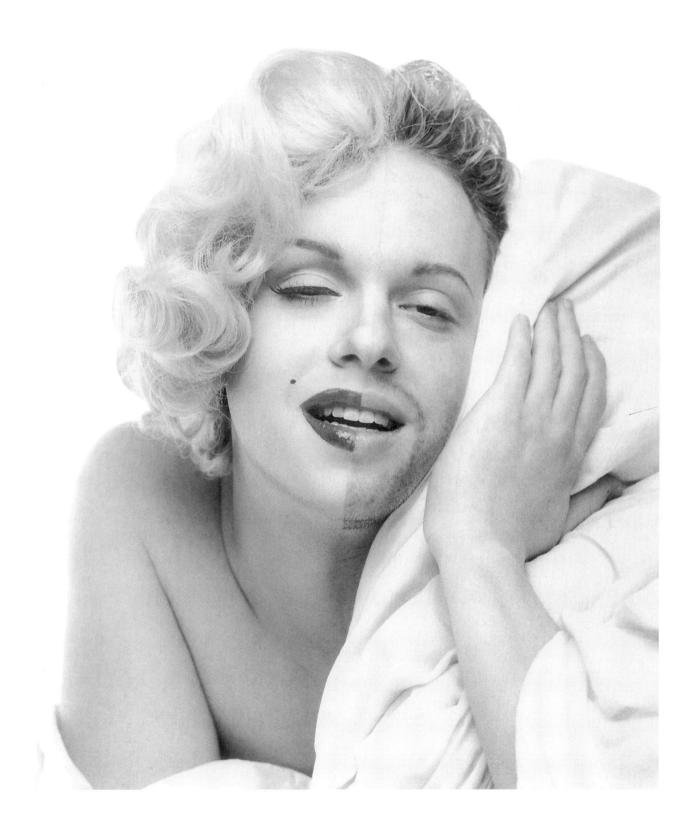

SC: That's what I like the most about doing her—the whole "gasp" shock value of it all. I'll never forget the first "identity applause" I got, or when I could hear people saying, "Oh, my God! Oh, my God! That's a guy!" That's the thrill for me.

JF: What's amazing to me is that most Marilyn Monroe impersonators can do a look or capture a certain period in Marilyn's life, but you can do it all. How many facial expressions do you have in your repertoire?

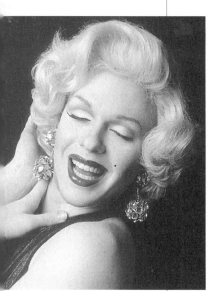

SC: Marilyn really only has three. She has what I call the "bedroom eyes," then she has the big fifties smile, and then the happy sex kitten look. When you impersonate someone you have to play up the stereotype.

JF: Do you have any outfits that are exact duplications of the ones she wore?

SC: Yes, I have the white halter dress. I had a duplicate made of the *Gentlemen Prefer Blondes* fuchsia dress, and I have one similar to the gold lamé that she wore. I tend to do Marilyn in very simple, fifties halters. Marilyn and I are also similar in that respect, in that we both like everything to be about the face. She rarely wore bracelets in her personal life because she always wanted it to be about her face. And if you look at most of her dresses, they were halters or cut straight across the chest so the focus would always be above the dress line.

JF: Do you love what you do?

SC: I genuinely love it. And I respect the people I impersonate. I think that whether you do this for fun or money you have to have respect for the character. That's why I never spoof or joke about Marilyn Monroe or Judy Garland. I know impersonators who play up the whole addicted, drunk, crazy Judy, but I don't think there's anything funny about someone else's misfortune. The same with Marilyn. If you don't have the respect, then it's not worth doing.

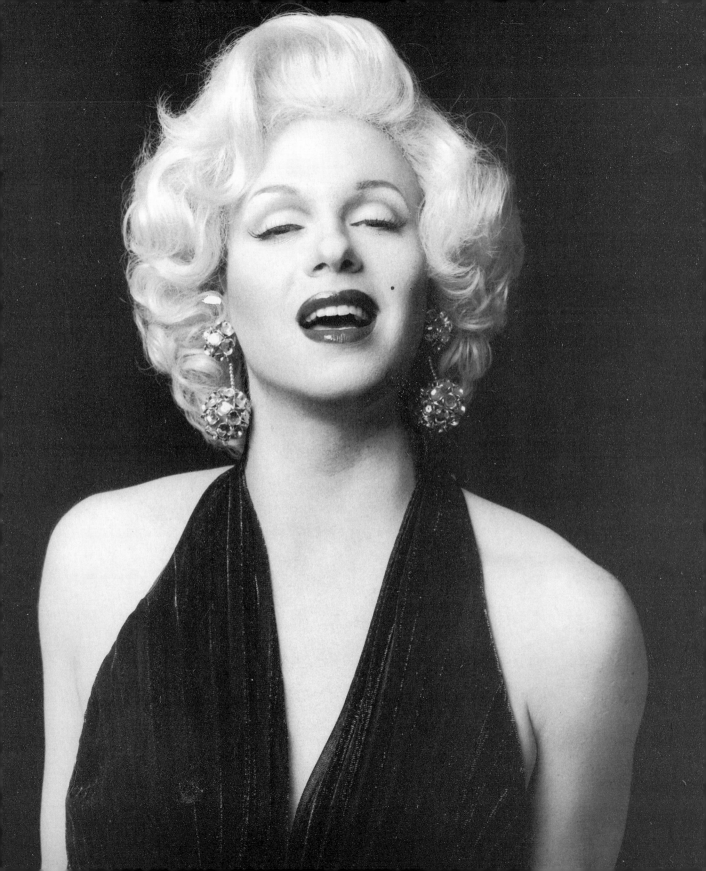

IMPRESSIONS OF
LORRAINE FILLMANN
BETTE MIDLER

I first came across Lorraine at a party at the Plaza Hotel in New York, and she was pretty much a dead ringer for Bette Midler. She was dressed as Bette, but she didn't have on a lot of makeup, and she had never really seen herself transformed into a realistic likeness of Bette until I got a hold of her. She says she was pretty amazed during our photo shoot. The smile is undeniably Bette, especially when seen straight on. I'd say Lorraine has a more sculpted face than Bette.

Lorraine has the elongated face, the thin nose, the slit eyes—all the things that make it easier for someone to do Bette, but you can create these things with makeup.

Lorraine definitely has the spirit to do this kind of work, and she has the personality to do Bette. The costuming also helps, which is why I picked the costume from *For the Boys*. It's something that you don't have to be overly body-conscious in: it's fun, it's easy, it's memorable, and it's very inexpensive as well as sexy. I think anybody who puts this outfit on, with a blond wig, will automatically scream Bette Midler. Having the face is icing on the cake.

ELONGATED FACES
DO BETTE BEST!

MANNEQUIN
BETTE MIDLER

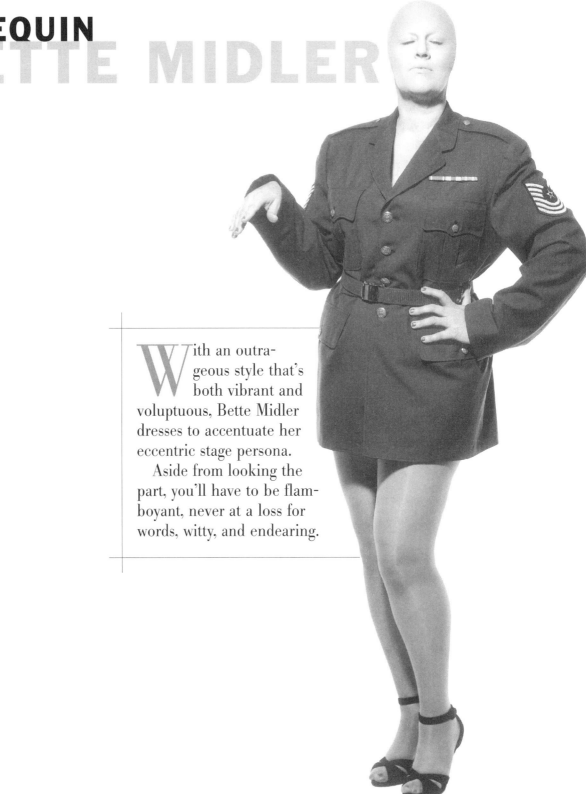

With an outrageous style that's both vibrant and voluptuous, Bette Midler dresses to accentuate her eccentric stage persona.

Aside from looking the part, you'll have to be flamboyant, never at a loss for words, witty, and endearing.

CLOTHING

- Blue U.S. Air Force jacket with matching belt.
- Woman's blue Air Force cap.
- Shimmery, suntan-colored control-top panty hose with sheer toes.
- High-heeled ankle-strap black sandals with platform.

EYELASHES

- Normal yet full black lashes.

WIG

- Short, curly strawberry-blond hair.

OPTIONS

- A short, platinum-blond wig will work with the *For the Boys* look.
- A medium-length, tightly curled red wig for *The Rose* look.
- A long, spiral-curled strawberry-blond wig for a *Beaches* look.
- The mermaid outfit from Bette's concert tours. (You'll need a wheelchair to get around.)
- Frilly hat à la "The Divine Ms. M."
- Fun, funky, outrageous cleavage-exposing top with tight pants.
- Tailored suit with wide-brim hat for *Big Business* Bette.
- Bette Midler colors cover a natural range of browns, reds, and pinks.
- Short, red fingernails.

EXPRESSIONS AND GESTURES

Squinty-eyed smile.
Smile with eyes rolled to the left and looking up.
Hands outstretched and shaking.
Startled.
Wrists limp while pacing quickly back and forth across the stage.

BEST SONGS TO PERFORM

"Stuff Like That"
"Boogie Woogie Bugle Boy"
"The Rose"
"From a Distance"
"Wind Beneath My Wings"
Lip-synch to Sophie Tucker and stand-up routine jokes.

HALF-FACE MAKEUP

LORRAINE FILLMANN
BETTE MIDLER

T he Divine Miss M. has been wowing audiences for three decades. Her looks have changed over the years, from frizzy-hair baudy to body-conscious to elegant at over fifty. Whatever look you decide to do, be sure to do it with the same panache and pizzazz that Bette has.

With a sponge apply an ivory foundation over the entire face, which gives you that Bette glow, and apply translucent powder with a powder puff to hold it all in place.

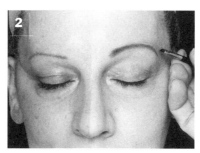

To create Bette's circular brow, use a dark brown eye shadow and a brow brush and draw a downward-reaching half moon.

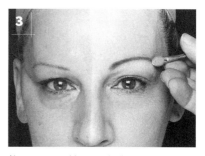

Next, put on white eye shadow with a sponge applicator to cover the entire brow bone under the brow.

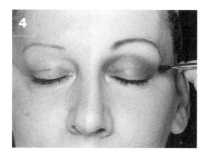

Go back to the dark brown shadow, and with a medium-size eye shadow brush, apply the shadow to the entire eyelid. Press harder near the lash line and lighter as you get into the crease of the eye, near the brow bone. Be sure to extend the shadow softly out toward the temple.

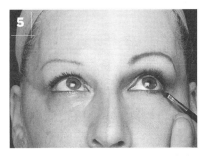

With a thin beveled eyebrow brush and the same dark brown eye shadow, draw a line under the eye following the shape of the eye, but don't make this line thick. For a more dramatic eye, you may also use a charcoal eye shadow.

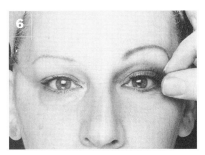

Now, glue on a medium-size black false eyelash (see Devon's Recommendations, page 20).

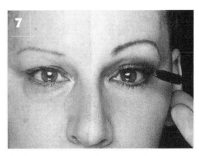

Apply black mascara to top and bottom eyelashes (see Devon's Recommendations, page 21).

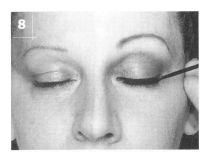

Now it's time to use black eyeliner to draw a line completely across the lid along the lash line and up toward the temple. Again, charcoal eyeshadow will make the look more dramatic, especially if you make the line thicker.

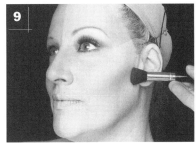

Take a contour brush and medium brown or dark brown shadow and contour under the cheekbone, along the jawline, and on the temple.

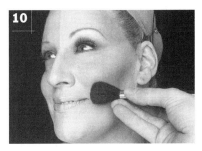

Now, with a medium blush brush and either a red or an orange blush, blend the contour lines so they're not too harsh. Extend the blush lightly to the nose while smirking or smiling. This allows you to better follow the line. The result? Bette's apple cheeks.

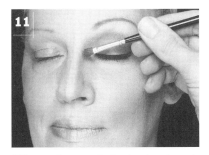

With a medium eye shadow brush and a natural-tan eye shadow, draw a line down the nose bone, just slightly off the center. This is done to create a thinner-looking nose (see Devon's Recommendations, page 22).

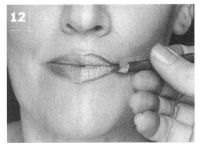

With a burgundy lip liner pencil, draw in thin, heart-shaped lips.

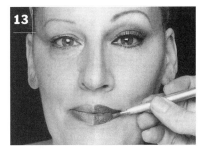

To create a *For the Boys* look, always use a cherry-red lipstick. Be sure to fill in the lips using a creamy lipstick applied with a lip brush.

LAUGHTER IS THE "BETTE" MEDICINE!

Ask Lorraine Fillmann what she has in common with Bette Midler, aside from the obvious, and she'll tell you a sense of humor—she practically laughed her way through the entire interview.

She also has Bette's determination to give her all in everything she does. So it's no surprise that Lorraine can be transformed into the picture-perfect image of "The Divine Miss M." Like she says, with a little makeup and a little nerve, you can do whatever you want to.

She started perfecting her impersonation back in 1989, at home with her husband and three children on New York's Long Island, where she was born. This grandmother, who works in nursing, can't wait until her grandson gets a little older so he can see what Grandma does on stage. You see, for this entertainer, the reaction is what it's all about.

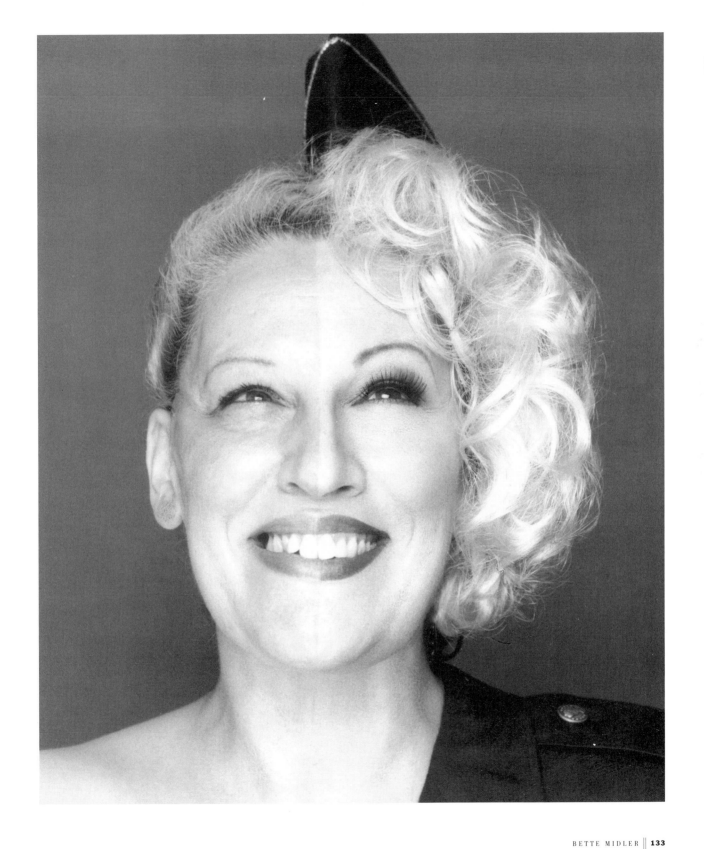

LF: Seeing how people feel about Bette—thinking it's her and seeing the joy it brings—that makes me happy, to think that I've contributed a little something nice to people. I always tell people what a great lady I think Bette Midler is.

JF: What's your favroite song to perform?

LF: "Wind Beneath My Wings": it's so emotional, I love that!

JF: How do you put your outfits together?

LF: Well, it depends on the number. If you want to do something from *For the Boys* you wear what I'm wearing now, the blue Air Force jacket and cap. Just go to your neighborhood vintage military or army/navy store.

JF: What's your favorite Bette Midler look to do?

LF: The classy look. I like to wear those gowns, but actually I like her mermaid look. [*Laughs.*] Just once I want to be a mermaid. [*Laughs.*]

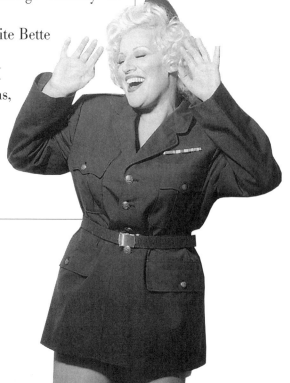

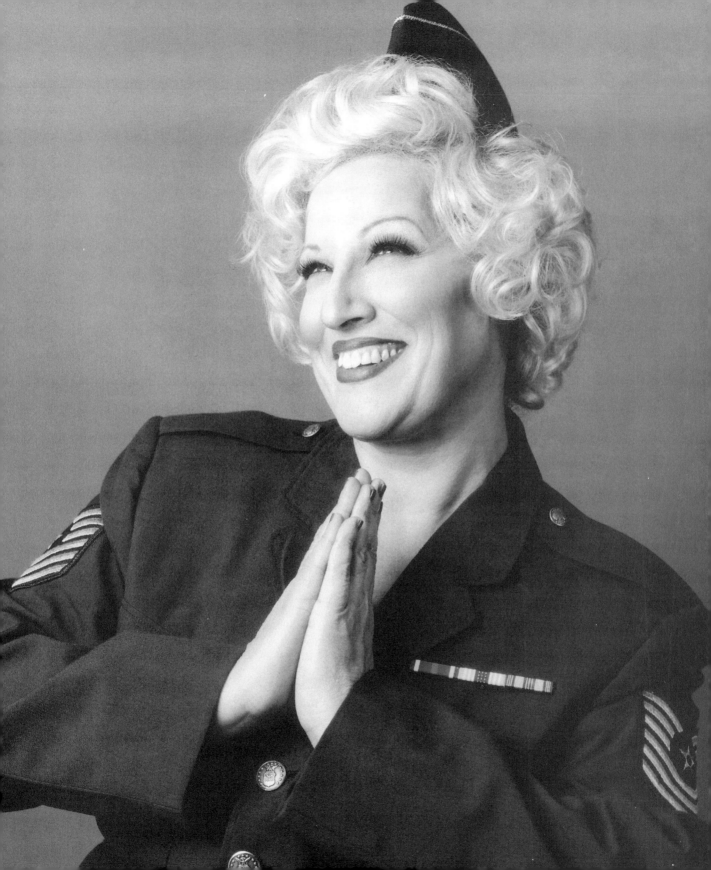

IMPRESSIONS OF
SCOTT ENGLISH
ROD STEWART

I was really impressed by the photo that Scott sent me of his impersonation of Rod Stewart. I wanted him for the book immediately, but he's a perfectionist and wanted to be sure I was too. He came and saw my work, liked it, and decided to come onboard.

To do Rod, basically you need the props, the hair, and the glasses, but Scott has the facial structure and the nose, which really cement the impression. The loud clothing also helps the look. I picked this yellow jacket, which in a black-and-white photo comes out looking very light, but it's really a bright yellow. It's very Rod Stewart when worn with a polka-dot shirt and black leather pants. Rod is laid-back offstage, so impersonating him is pretty much a performance gig. I mean sometimes it's enough just to look like him and get a reaction, but if you lip-synch to his songs, like Scott does, and get the onstage persona down like Scott has, then it's an exciting experience to watch.

LONG, OVAL TO SQUARE FACES
DO ROD BEST!

MANNEQUIN

ROD STEWART

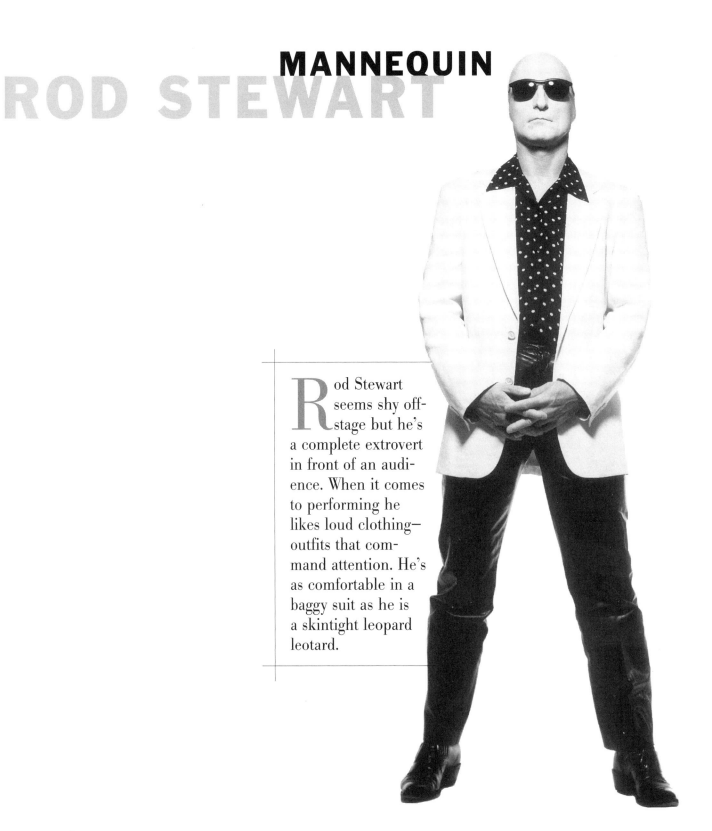

Rod Stewart seems shy offstage but he's a complete extrovert in front of an audience. When it comes to performing he likes loud clothing—outfits that command attention. He's as comfortable in a baggy suit as he is a skintight leopard leotard.

CLOTHING

- Black leather pants.
- Black shirt with small, yellow polka dots.
- Yellow sport jacket.
- Black leather, ankle-high shoe boots.
- Hip black sunglasses.

WIG

Spiky punklike blond wig that's short on top but down to the neck in the back.

BEST SONGS TO PERFORM

"Do You Think I'm Sexy?"
"Tonight's the Night"

EXPRESSIONS

Be able to pucker your lips!

OPTIONS

- Leopard shirt with black jacket (or the other way around).
- Leopard spandex pants (or spandex of any color).
- Tight stretch jeans and sneakers.
- Pirate shirt.
- Striped or polka-dot bow tie or thin neck tie. (Remember, animal prints are always a great option.)
- Funky round sunglasses, mirrored or black.

RE-CREATING ROD!

Rod Stewart lets his expressive face speak for itself. It's not about makeup as much as the bone structure, nose, hair, and glasses. Oh, and the mole, you have to have the mole! Here's how to get it:

Take a glob of glue stick and roll it between your forefinger and thumb. Flatten one side, leaving the other side rounded.

Place a dab of eyelash glue where the mole is to be applied. (The left side of the face is correct.) Now, place the mole on the glue, flat-side down, and cover with a beige foundation.

Darken mole with a dark brown eyeliner pencil, or use a dark brown eye shadow and apply it with an eye shadow brush. (You can use a black liquid eyeliner to dab on tiny black spots for a more realistic look.)

Finished look.

New York City–born and bred Scott English is a married, forty-something baby boomer with a teenage daughter, and he can belt out a tune with the best of them.

He's a musician on a mission to bring fun and excitement to fans everywhere. That's why it's not so unusual that he has been performing as Rod Stewart nearly as long as he's been playing music of his own.

English has been mistaken for the rock superstar more times than he can count, a comparison he's come to cherish.

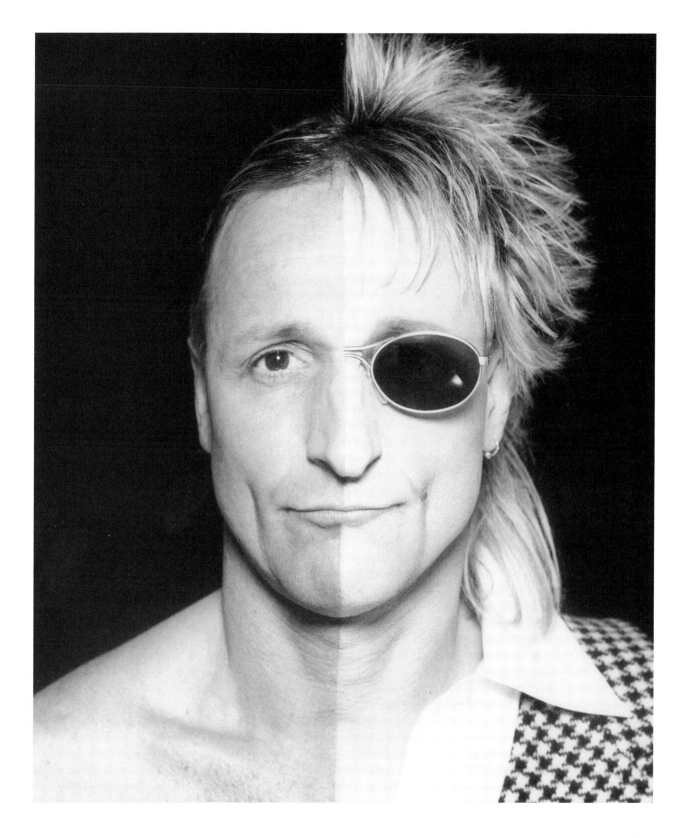

SE: I was a teenager, just seventeen years old, when I realized I looked like Rod Stewart. I was looking through some rock magazines and I saw the resemblance in a couple different pictures right away. It was actually a tremendous resemblance, especially the nose and the hairstyle, because I've always worn a long, chopped shag.

JF: Do you get stopped a lot on the street?

SE: Plenty of times, but the one time I'll never forget was once when I was walking on Madison Avenue. This person came over to me who I recognized immediately as the comedian David Brenner. He said he actually chased me for three blocks, running the whole way, and then he invited me to lunch. I told him, "Listen, you've got the wrong guy, I'm not Rod." He said, "Come on, I just had lunch with you in California a few weeks ago. Stop pulling my leg." I said, "No I'm really not him." He just wouldn't believe me, until finally I had to show him my driver's license. Well, he walked away a little embarrassed and maybe even a little upset, but he did laugh about it.

JF: Have you met Rod Stewart?

SE: I've met him a couple of times. We just had casual conversations. He asked me where I was born and raised. Then he said he thought that maybe he had a lost twin brother he never knew about. He was pretty amazed by the resemblance.

JF: What is it that you especially enjoy about looking like Rod Stewart?

SE: I like the personal star treatment. I never have to wait in long lines, and I get great tables at restaurants.

JF: I know there's one place that really rolled out the red carpet for you.

SE: It was at Planet Hollywood here in New York. I just walked in with another friend and they gave us the complete star treatment. They closed off the restaurant, didn't let anyone in, and the line was wrapped around the corner.

JF: Did they ever find out you weren't really Rod?

SE: They caught on eventually, but they thought it was a great thing for the restaurant. It makes for good publicity.

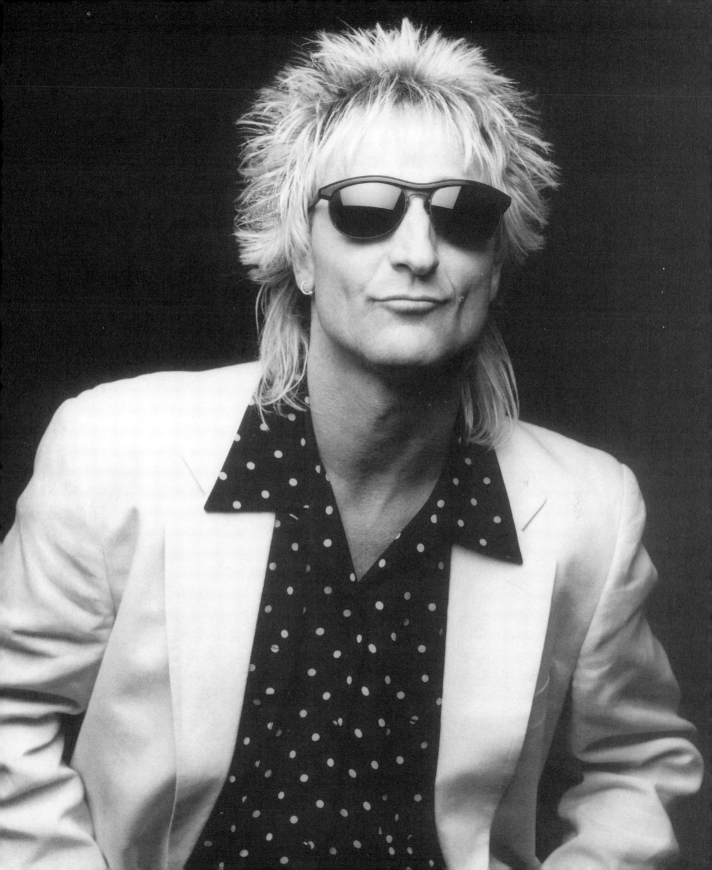

IMPRESSIONS OF
NATALIE DUPONT
TINA TURNER

Natalie was a client of mine who came for theatrical photographs. I actually did two sessions with Natalie, because as you'll see the first are pictures where she just posed, while the second incorporated movement, like dancing. The movement shows the liveliness of Tina, while the posed ones have the beauty. I wanted to capture both and have that "Private Dancer" vibe.

Natalie has Tina's cheeks, chin, mouth, nose, eyes, and the eye color. It's remarkable. When I'm in the room with her I sometimes feel as if I'm with Tina.

I went with the silver dress because Tina usually goes more with a metallic mesh look but that's very hard to find—and expensive. The silver dress can be done with simple sequins. It's really the cut and length of the dress that count with Tina. It's got to be sexy and show off the legs. Legs are very important for doing Tina. I chose her wonderful spiky hair look because it's the Tina everyone recognizes, and creates the illusion regardless of face shape. The shorter hair look requires more accurate bone structure.

ROUND TO WIDE, SQUARE
FACES DO TINA BEST!

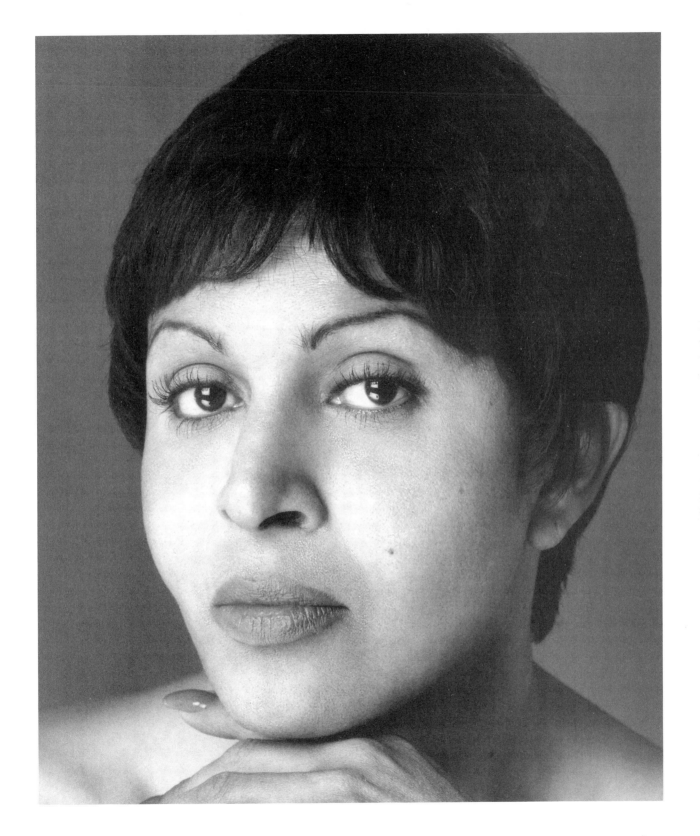

MANNEQUIN

TINA TURNER

With an aggressively sexy style when it comes to clothes, Tina Turner has shed her victim status and can no longer be called shy. A dancer from way back, she makes sure audiences get a full dose of those fabulous legs. You can imitate Tina by acting independent and strong-willed. Have a great sense of humor and a marvelous, deep throaty laugh. Oh, and be sure to wear outfits like this.

CLOTHING

- Silver mesh, spaghetti-strap minidress.
- Rhinestone stud earrings.
- Medium-heeled silver pumps.
- Medium-length, natural-colored false fingernails.

EYELASHES

- Normal yet full black lashes.

WIG

A long, layered, spikey light brown look with blond highlights.

EXPRESSIONS

Pouty-lipped sneer.
Wide-mouth toothy smile.

BEST SONGS TO PERFORM

"What's Love Got to Do with It?"
"Proud Mary" (For a better effect, have two females backup singers.)
"Golden Eye"
"Simply the Best"
"Private Dancer"

- Shorter, crimped wig that's cropped to the neck in back, in the same light brown with blond highlights.
- Short, layered wig that's full in front, cropped to the neck in back, and the same color as the other two.
- Short chain-metal mesh dress in a metallic shade.
- Black halter minidress.
- Minidress with long, medium, or short fringed hemline.
- Baggy denim jeans.
- White tank T-shirt, worn with a men's button-down over it and the shirttails tied up in front.
- High-heeled black pumps (a Tina Turner favorite).
- Black cowboy boots.
- Silver high heels, with ankle straps and open toes.
- Any simple rhinestone jewelry.
- Tina's best colors: white, silver, gold, and black.
- Other makeup colors that work are peach, red, and fucshia.

HALF-FACE MAKEUP

NATALIE DUPONT
TINA TURNER

To call Tina Turner a survivor is truly an understatement. She has a rags-to-riches story that's laden with physical and emotional abuse, but ends in triumph. Turner is a powerful example of how someone can overcome any obstacle to become what he or she look-alike, wants to be. If you want to be a Tina Turner look-alike, here's how:

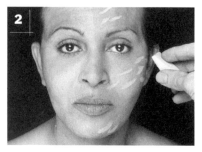

Start by applying a cafe' latte' foundation to your face using a sponge.

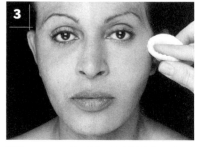

Highlight the cheek, forehead, and temple with a light beige foundation using a sponge.

With a sponge blend the highlights in and set the entire base with a translucent powder using a powder puff.

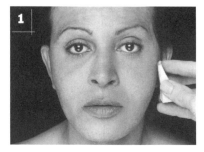

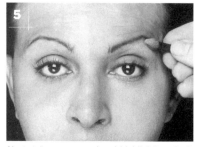

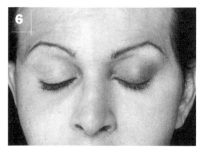

Use a small eyebrow brush and a dark brown shadow and draw in Tina's thin, arched eyebrow. (If you need to paste down part of your eyebrow, see Devon's Recommendations, page 19.)

Next, take a cream-colored highlighting shadow and, using a sponge applicator, apply the shadow to your brow bone.

With a small eyebrow brush and brown shadow, cover the entire lid. Start near the nose and work out, pressing harder as you move toward the outer end of the eye. Be sure to blend the brown shadow into the cream-colored highlighting on the brow bone.

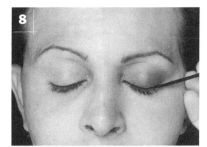

7 Take a beveled eyebrow brush and dark brown shadow and draw a thin line under the bottom lash line.

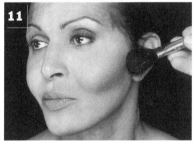

8 With black liquid eyeliner, draw a thin line across upper lash line.

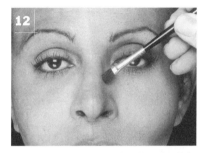

9 Apply black mascara to top and bottom lashes. You may also apply a normal false eyelash (see Devon's Recommendations, page 20).

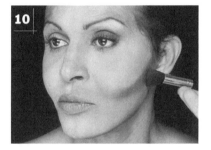

10 Now, with a contour brush and medium brown shadow, draw a line from the upper edge of the ear down and under the apple of the cheek. Press more lightly as you move toward the nose. Be sure to contour the chin and temple as well.

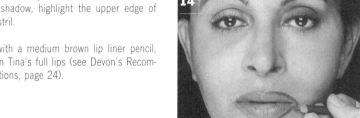

11 Next, use a blush brush and coppertone-colored blush to blend in all the contour lines (see Devon's Recommendations, page 21).

12 With a small eye shadow brush and a light brown shadow, draw a line down the side of the nose starting near the inner eye going all the way to the nostril.

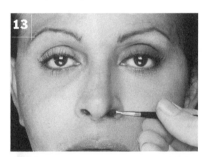

13 Now with an eye shadow brush and dark brown shadow, highlight the upper edge of the nostril.

Next, with a medium brown lip liner pencil, draw on Tina's full lips (see Devon's Recommendations, page 24).

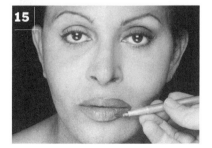

14

15 Using a lip brush, fill in the lips with one of Tina's favorite colors. (see Options, page 147).

Highlight the top and bottom of the middle of the lips with sponge applicator with gold shadow for a poutier effect.

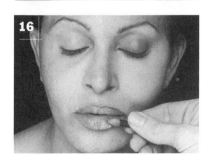

16

DUPONT PAINTS THE TOWN AS TINA—TURNER, THAT IS!

A little glitter and a lot of guts go a long way, but for Natalie Dupont it took nearly twenty years and thousands of miles to reach the top of the impersonation profession. Her long journey began in Cuba, where she was born and raised but discouraged from pursuing the profession she wanted. So during the 1980 Mariel boat exodus, Dupont made a daring escape. The ninety miles of treacherous ocean from Cuba to Key West was only the start, but once she stepped on free soil, there was no keeping Dupont down. Especially once she realized she could look like one of her favorite recording stars.

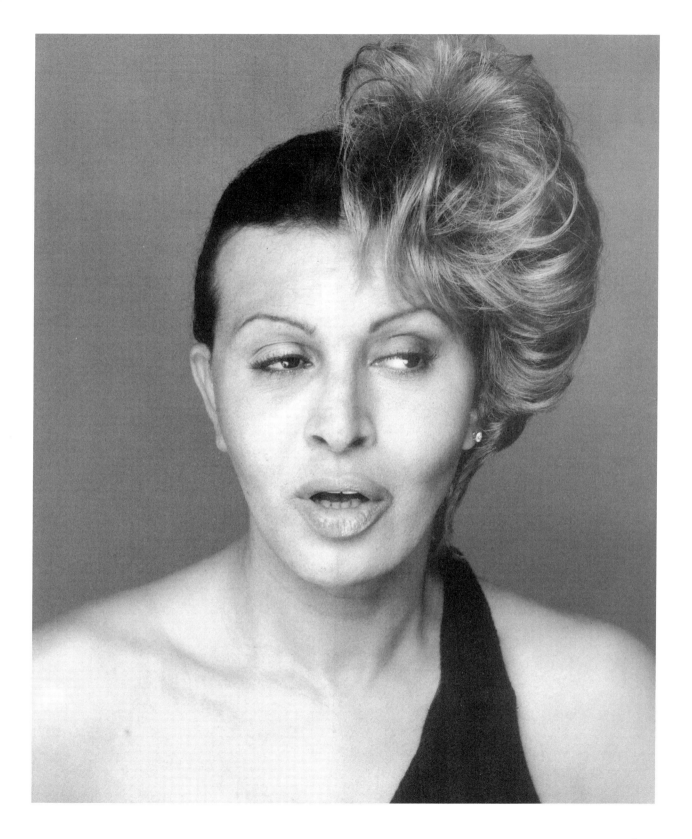

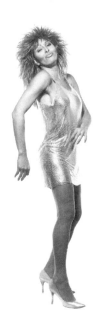

ND: It was 1984. I was living in Dallas, Texas, at the time and my friends started telling me I looked like Tina Turner. Her "What's Love Got to Do with It?" video was out and she was getting a lot of airplay. The more they saw her the more they said I reminded them of her.

JF: Did you see similarities before that?

ND: Yes, I always thought my cheekbones were like hers, and I noticed she moves her mouth the same way I do. The funny thing is, even when I'm not made up to look like her I sometimes get stopped on the street. I remember once, right after I moved to New York, this guy asked my boyfriend if I was Tina. That was nice.

JF: If you ever met Tina, what one question would you like to ask her?

ND: I want the real truth about how she got away from Ike. I'm not convinced the way her life was portrayed in the movie was the way it really happened. I'd like to know what made her stay in that situation for as long as she did, especially when she was carrying him the whole time.

JF: Have you suffered any similar hardships in your personal life?

ND: I've never been beat up or anything like that, but I have been persecuted. In Cuba I would never be allowed to do what I'm doing here. But still, sometimes I get a negative reaction from other performers if I'm impersonating a Caucasian singer. Some people can't get past my Hispanic heritage and would still just like me to impersonate Hispanic singers like Gloria Estefan. Of course, when I do Tina I change a lot of minds, because they can't deny that I've got her down.

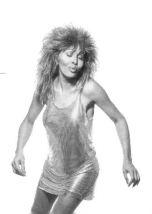

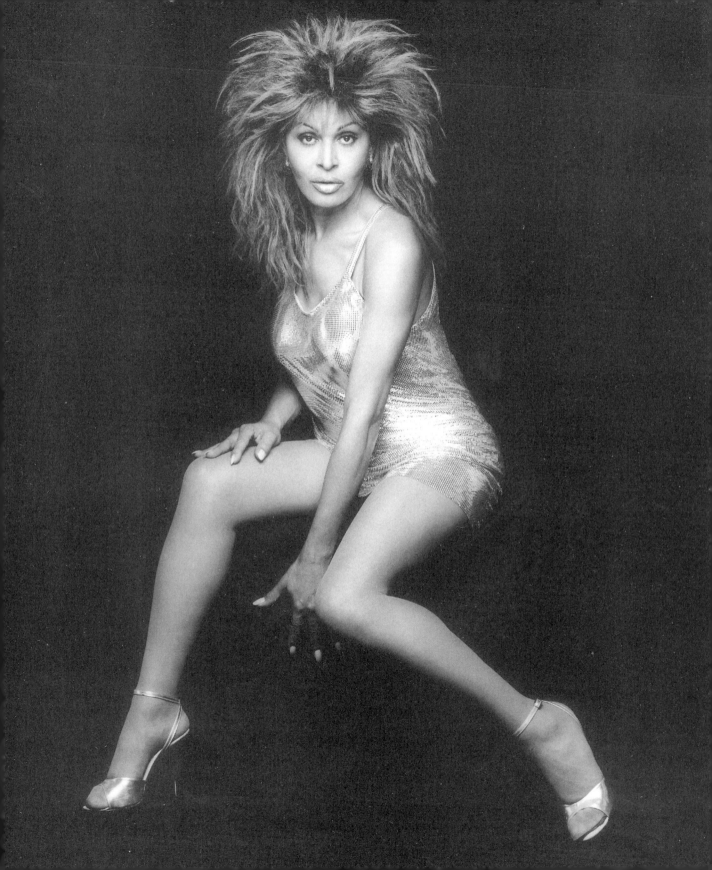

IMPRESSIONS OF
MARILYN ROSE
ELIZABETH TAYLOR

Marilyn Rose took me to dinner once to talk about photos because she'd just started doing her impersonation work. This was about 1994. I knew then that I wanted to work with her, and we've had a great working relationship ever since.

Marilyn has the face shape and most of the same features as Liz, but it's the costuming and the wig that really bring Liz to life. Because Liz's style is so recognizable many people can do her. Marilyn did need the violet contact lenses.

Not too many people have Liz's eye color. And don't forget the beauty mark. I had a hard time finding just the right kind of high-profile fabulous evening gown for my Liz, though a friend of mine finally came through with a great dress. If you have trouble with this look I've given you other options for creating your own Liz look.

HEART-SHAPED
TO ROUND FACES
DO LIZ BEST!

MANNEQUIN
LIZ TAYLOR

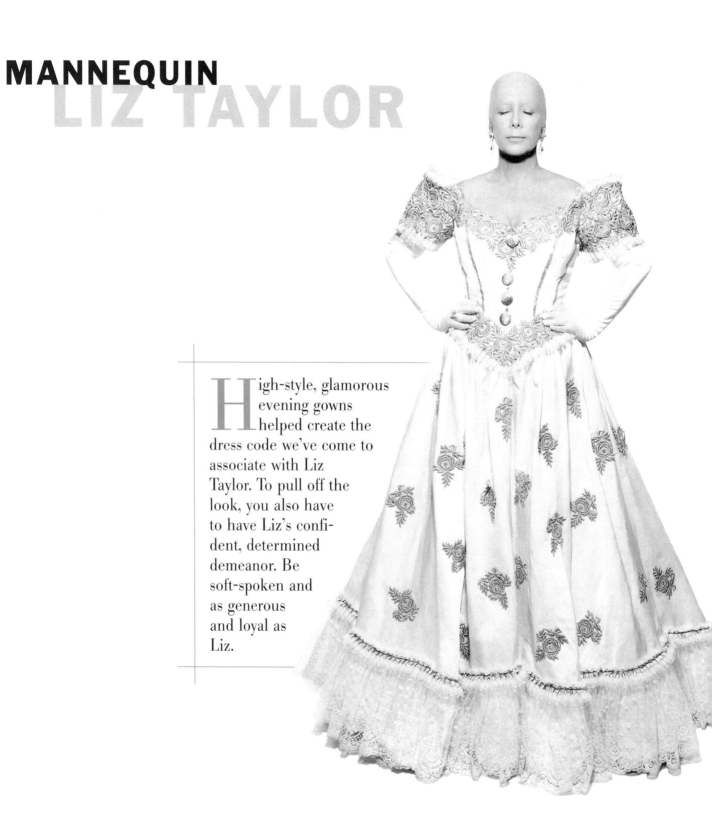

High-style, glamorous evening gowns helped create the dress code we've come to associate with Liz Taylor. To pull off the look, you also have to have Liz's confident, determined demeanor. Be soft-spoken and as generous and loyal as Liz.

CLOTHING

- Long, frilly white ball gown with sweetheart neckline and gold trim. (The sweetheart neckline showing cleavage always works for Liz.)
- Gold pumps with medium heel for tall women! If you're shorter, wear a higher heel.
- Long, white satin opera gloves.
- Large diamond ring (worn outside the glove of course).
- Large, diamond teardrop earrings.
- Violet contact lenses.

EYELASHES

- Short, spiky black lashes.

WIG

Round, shoulder-length, spiky, and layered black hair.

OPTIONS

- The same wig with gray highlights and the hair combed straight down the back of the neck.
- Beaded cocktail suit with matching shoes.
- Knee-length cocktail dress with sweetheart neckline.
- Round or oval diamonds or pearls work well.
- Elizabeth Taylor colors include yellow, peach, red, gold, and purple.

HALF-FACE MAKEUP

MARILYN ROSE
LIZ TAYLOR

Glamorous, enchanting, even mysterious, but always alluring and sexy. Elizabeth Taylor has been an icon to moviegoers around the world for decades. Celebrating the legend that is Liz is simple:

Using a sponge, apply a light beige foundation to the face and set with translucent powder using a powder puff.

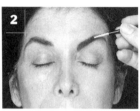

The eyebrow comes next. Using a brow brush and black shadow, create a very high V-shaped arch. The brow is thicker near the nose, medium-size at the arch, and thinner as you move away from the arch. (If you need to partially paste down your brows, see Devon's Recommendations, page 19.)

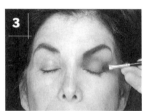

Now, using a charcoal eye shadow and a small shadow brush, cover the brow bone under the brow and all of the eyelid. Make the lid slightly darker than the brow bone.

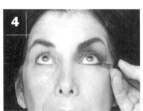

Using black eye shadow and a thin, beveled eyebrow brush, draw a thin line under the eye and above the upper eyelash line, starting in the center of the eye. Start by making the line thin but draw it thicker as you move out to the edge of the eye, ending in a point.

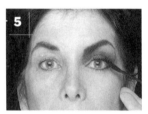

Glue on a black, short, and spiky false eyelash. Mesh the false lashes with your natural ones using black mascara (see Devon's Recommendations, page 21). Lightly brush mascara on the bottom natural lashes.

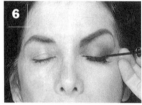

Use black liquid eyeliner to draw a line across the entire upper eyelash line. (To create a more almond-shaped eye, see Devon's Recommendations, page 20.)

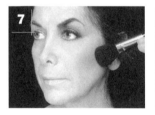

Next, take a blush brush and red blush to draw in a wide, lightly blended line from the upper edge of the ear to the middle of the cheek. Contour the jawline and temple if necessary (see Devon's Recommendations, page 21).

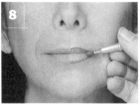

With a red lip liner pencil, outline medium-size lips (see Devon's Recommendations, page 24.)

To enhance cleavage, take an eye shadow brush and medium brown shadow and draw cleavage. Blend shadow with a coppertone-colored blush for a more natural effect.

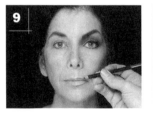

Fill the lips in with a pink frost lipstick using a lip brush, and blend the lipstick into the red lip liner.

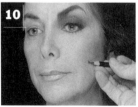

Now, with a black eyeliner pencil, draw in Liz's beauty mark on the right cheek an inch and a half away from the corner of the mouth. (It's shown on the left side of the face here to fit the half-face format.)

"TAYLOR" MADE ROLE FOR ROSE

Marilyn Rose is a Long Island, New York, interior designer with designs on adventure. In addition to running the very successful Marilyn H. Rose Interiors company, Marilyn is a licensed pilot who also loves to fly hot-air balloons. She's a gifted artist with a flare for painting, and a bona-fide Egyptologist! So looking like one of the silver screen's bigger-than-life legends only adds to the excitement.

Marilyn is divorced with two children, and lives with what she calls her "fuzzy daughter." That would be the one and only Priscilla Victoria Veronica Marie Delores Ann, a Yorkshire terrier that Marilyn says is special because she doesn't talk back. Miss Priscilla thinks she's really Liz Taylor's dog, though, and that means living a celebrity's life. Marilyn concedes the dog is the only celebrity in her family, but Marilyn's learning just what it means, even if only in a small way, to be a living icon.

MR: I travel to Egypt a lot and about three and a half, maybe four years ago something happened that made me decide I should be paid for looking like Liz. I was surrounded by police at the airport—I guess they thought I needed an escort for my own protection, because so many people believed I was Liz Taylor. Then at the hotel where I was staying I had my very first fan letter delivered to my room. People refuse to believe I'm not her, assuming that Liz travels under an assumed name.

JF: Have you had any embarrassing moments being mistaken for Elizabeth Taylor?

MR: Not embarrassing, but I do recall one particularly annoying incident when this woman kept pestering me. I was at a nightspot in New York and she followed me around the entire evening. I think she wanted desperately to work for Elizabeth Taylor, so she wouldn't leave me alone. That gave me another little glimpse into what it must be like to be such a big star.

JF: Do you have any fears that this could become an obsession with you?

MR: None at all. I have a very strong identity and sense of myself. I do this for fun and it gives me a chance to meet lots of different people and make friends whom I wouldn't normally have a chance to meet. I love doing things that I haven't done before, and this is one of them.

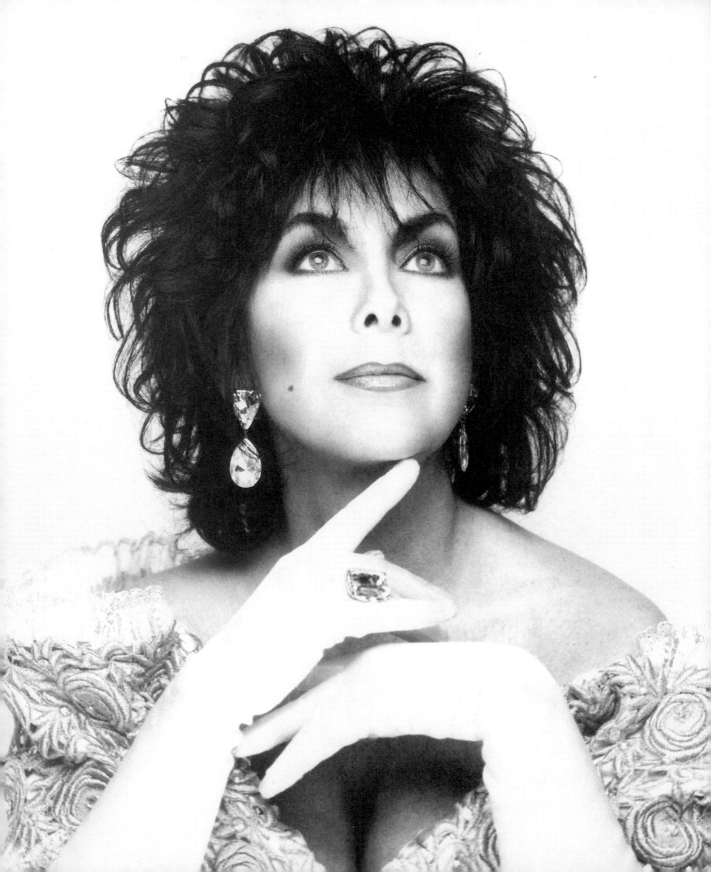

HALF-FACE MAKEUP

HALF-FACE MAKEUP
DIANA GRAY
DIANA ROSS

T he Motor City's most famous recording artist has a medium brown complexion. So to come up with a really close Diana Ross illusion, a café au lait foundation will usually lighten darker skin or darken pale tones.

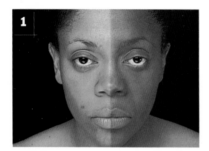

With a sponge use a café au lait foundation over the entire face. It's always important that you set the foundation with translucent powder. (Using a powder puff eliminates any dusty, loose powder from flaking and caking on fresh mascara and on your face.)

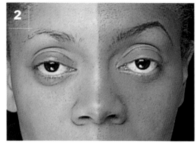

Once the foundation is generously applied over the entire face and sealed in place, move directly to the eyebrow. Take a brow brush and black eye shadow, or a black eyeliner pencil, and create a pointed arch right over your own brow in the middle of the brow bone.

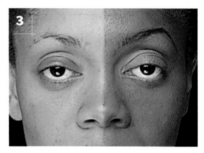

Highlight the eyelid and the area directly under the brow with a cream-colored eye shadow, using a sponge applicator. Now, apply a medium brown eye shadow in the crease between the lid and brow with a small eyeshadow brush, starting from the outer part of the eyelid and working in to the nose.

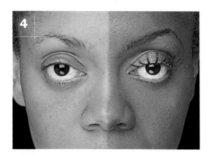

Next, put on a spiky false upper eyelash and mascara. (See Devon's Recommendations, page 24.)

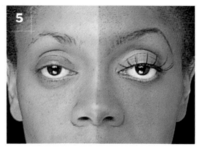

With a black liquid eyeliner, draw a thin line across your lash line.

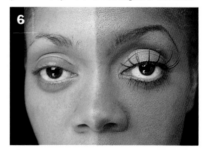

Before attaching the bottom eyelashes, put a subtle line of medium brown eye shadow with a small shadow brush under the eye for definition. Now, take six individual fake lashes and space them equally across your real bottom eyelashes. Using the point of a black liquid eyeliner, lightly dot all the way across the bottom lash line.

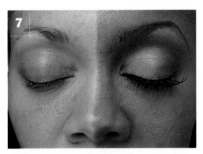

It's the right mix of natural and vibrant colors that helps capture the big bedroom eyes that are synonymous with Diana Ross. With a small eyeshadow brush blend a bright red eye shadow sparingly into the brown shadow you've already applied to the crease of the eye, while mixing some red into the cream shadow under the brow. (For the best result, press harder when applying the red eye shadow to the crease of the eye, and lighter as you blend up onto the brow bone.)

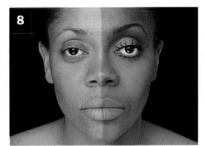

Defining the shape of the face is essential for the right Diana Ross look. Use a medium brown blush, and with a contour brush draw a semi-thick line from near the top of the ear down and over the cheekbone toward the middle of the face. With a small eyeshadow brush and the same color, contour the nose starting at the top near the eyes and coming straight down to the nostrils. Remember to brush blush on the temples, too.

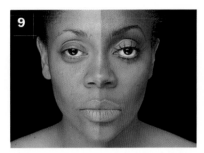

Next, take a red blush with a blush brush and blend it into the medium brown contour lines you've just created on the cheeks. Be sure to extend the red blush line past the brown, all the way to the apple of the cheek. Use the red contour blend on the temples as well, extending the red past the brown toward the middle of the forehead. (When blending contour lines, always press harder covering the original color, and lighter as you move out and away from the mix.) Depending on the shape of your face, contour the jawline to echo Diana Ross's, using the same blending methods you did for the cheeks and temples. (See Devon's Recommendations, page 22.)

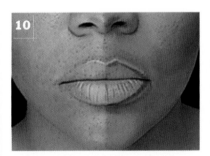

To do justice to the mouth that made Motown famous, take a burgandy lip pencil and draw in a full lip line. (See Devon's Recommendations, page 24.)

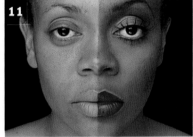

Fill in the lips with a rich, cherry-red liquidy lipstick applied with a brush.

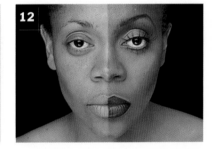

Top off the luscious look with a creamy, cream-colored eye shadow that you apply directly to the center of the top and bottom lips. (Make sure the eye shadow is no wider than a finger, and put it on with a sponge applicator.) Blend the edges of the cream-colored eye shadow into the cherry-red lipstick with a clean lipstick brush.

HALF-FACE MAKEUP

RICHARD MARCUS
BARBRA STREISAND

Barbra Streisand, that funny girl who blossomed into one of the biggest stars on the planet, has several distinguishing features, most notably that nose! She's kept it, as she sings, to spite her face. Without it she just wouldn't be Barbra. Whether you've got it or not, here's how your mirror can have two faces:

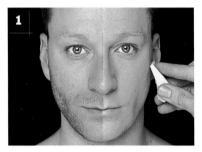

1 With a sponge apply a medium brown foundation to the face, and set it with translucent powder with a powder puff.

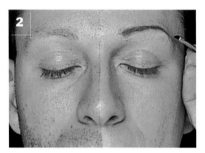

4 Now, with medium brown shadow and a thin beveled shadow brush, fill in the crease of the eye from the nose to the outer end, taking it slightly into a Cleopatra V shape as shown.

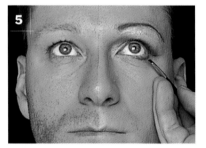

2 To get Babs's brow, use a small eye brush and medium brown shadow and draw in a thin, arched brow over your own. If you have bushy brows you can partially paste down any excess you don't need. (See Devon's Recommendations, page 19.)

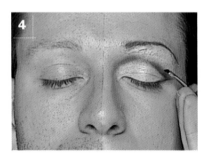

5 Now, with medium brown shadow and the same brush, draw a very thin line under the eye from the outer corner to the middle of the eye. This changes the shape of the eye, if needed. (See Devon's Recommendations, page 19.)

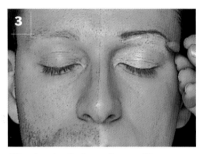

3 After drawing in the eyebrow, with a sponge applicator use a cream-colored eye shadow on the brow bone. Use it to completely cover under the brow and extend it down all over the eyelid.

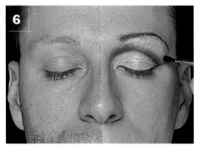

6 Next, take a thicker eye shadow brush with a coppertone-colored shadow and follow the brown line in the crease of the eye. This creates a softer blend to the lid. (See Devon's Recommendations, page 21.)

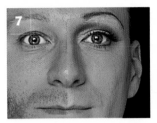

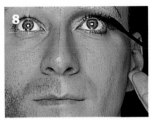

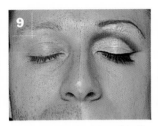

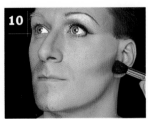

Now, attach a small natural false eyelash tip to the outer edge of the natural eyelash. You can use a full natural lash if desired. (See Devon's Recommendations, page 20.)

Mesh the false tip into the natural eyelash with mascara. Lightly apply mascara to the bottom lashes as well.

With black liquid eyeliner, line the lash line starting with a thin, light line near the nose. Then make it thicker as you move to the middle, and thin again as you blend it into the Cleopatra V at the outer edge of the eye, as shown.

Now, using a contour brush and a medium brown contour shadow, draw a half-moon shape under the cheekbone starting near the top of the ear and stopping about an inch away from the nose. Also, be sure to contour the jawline and temple.

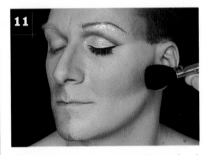

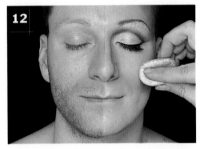

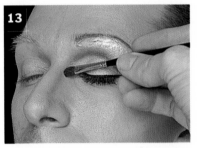

With a blush brush and coppertone-colored blush, blend in all the contour lines you've made. Remember to blend the jawline and temple contour lines, too. (See Devon's Recommendations, page 22.)

Subtly highlight the apple of the cheek with a cream-colored frost shadow applied with a powder puff. Be sure to smile or smirk to see the "apple" better. This will give you Barbra's full cheek.

For the nose, use a medium brown shadow and eye shadow brush. Draw a thin line starting close to the inner edge of the eye and work down, making the line wider as you move, to the tip of the nose.

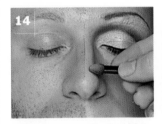

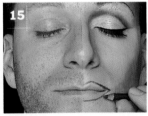

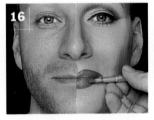

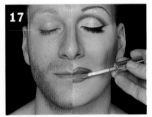

With a sponge applicator, put the same cream-colored frost shadow on the tip of the nose to accentuate the look.

Now, use a medium brown lip liner pencil and draw in Bab's kissable lips (see Devon's Recommendations, page 24.)

Fill in the lips with a creamy praline or light-colored lipstick. Use a lip brush for the best results. (See Devon's Recommendations, page 24.)

For the final touch, Barbra always uses a silver or gold shimmery lip gloss.

HALF-FACE MAKEUP
NATALIE BLALOCK
MADONNA

Being a new mother may change Madonna's image, but the looks that the world has come to know and love are indelibly etched in our minds. Madonna's made a great many physical changes in her appearance, but when it comes to makeup, even she sticks with what works.

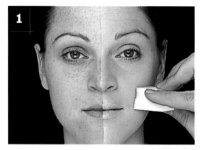

1

Cover the face with an ivory foundation using a sponge.

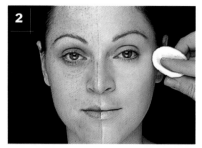

2

Highlight the cheek, forehead, and chin with a light-colored powder using a powder puff.

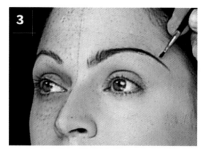

3

With black eye shadow and an eyebrow brush, create Madonna's long, half-moon shaped brow as shown. Fill in and darken as necessary. (To hide bushy brows, see Devon's Recommendations, page 18.)

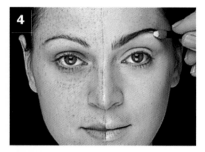

4

Now, take a white eye shadow and with a sponge applicator apply it to the brow and over the entire eyelid.

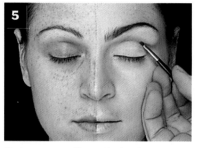

5

Next, use a small eye shadow brush and a coppertone-colored shadow to fill in the crease of the eye from the bridge of the nose to the outer edge of the eye and up toward the temple.

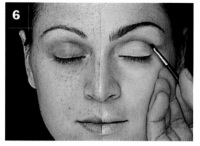

6

With a medium brown shadow and small eyebrow brush, draw a thin line directly under the coppertone-colored line in the crease of the eye.

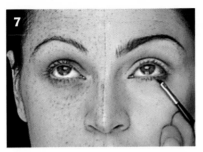

Using the same brush and medium brown shadow, draw a line under the eye starting at the outer edge of the bottom lash line and working your way in, stopping in the middle of the eye.

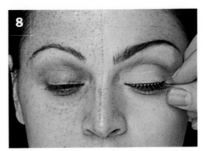

Apply full, black false eyelashes to the top natural eyelashes. (See Devon's Recommendations, page 20.)

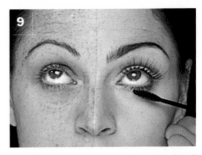

Use black mascara to mesh the natural and false eyelashes on top (see Devon's Recommendations, page 21). Lightly coat the bottom natural eyelashes, too.

With a black liquid eyeliner, draw a line across the upper eyelash line. Start with a thinner line near the inner edge of the eye, make the line thicker as you move out toward the middle, and then thinner again as you move toward the outer edge of the eye, as shown.

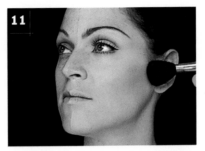

Now, with a blush brush and a coppertone-colored blush, lightly make a line from near the upper edge of the ear to the hollow of the cheek, and blend color into the skin.

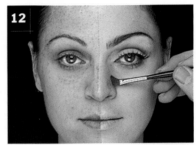

Next comes Madonna's nose. With an eye shadow brush and a light brown eye shadow, draw a line down the side of the nose from top to tip as shown. (For a wider or thinner nose, see Devon's Recommendations, page 22.)

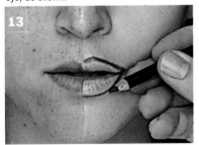

Draw on Madonna's medium-size, arched lips with a dark burgundy lip liner pencil.

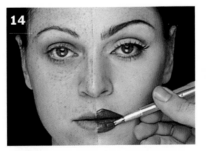

Fill in the lips with a cherry-red lipstick applied with a lip brush.

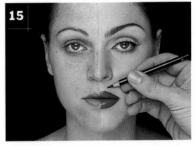

Finally, use a black eyeliner pencil to draw Madonna's beauty mark on the right side of the face between the nose and mouth. (Shown here on the left side of the face to fit format.)

HALF-FACE MAKEUP
JO ANNE MEEKS
MARILYN MONROE

L ike the song says, "Your candle burned out long before your legend ever did." We have her movies, her songs, and her photographs, but they are not the only things keeping that legend alive. Marilyn Monroe impersonators can nearly bring her back to life when they do it right. You can make yourself look like Marilyn. Keep reading.

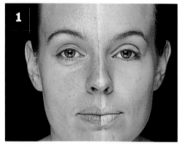

With a sponge, apply a creamy ivory foundation over the face. Translucent powder applied with a powder puff holds it in place.Partially paste down the outer end of the eyebrow if needed. (See Devon's Recommendations, page 19).

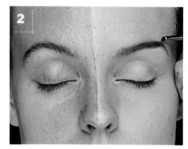

Create Marilyn's thin, arched eyebrow with a light brown eye shadow using a brow brush.

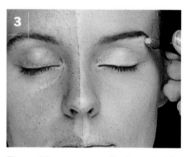

Then, with a sponge applicator and white eye shadow, cover the entire eyelid and brow bone. Also use white eyeliner on the lower lash line.

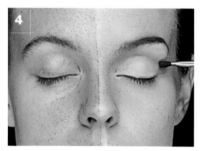

Using orange eye shadow and a small eye shadow brush, fill in the crease of the eye starting from the nose and working your way out and up toward the temple.

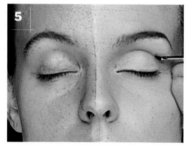

With a small eyebrow brush and brown shadow, make a light line in the crease of the eye from near the center out to the end of the eye. Apply this light brown line directly over the orange shadow.

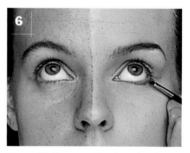

Then with the same fine brow brush and brown eye shadow, draw a thin line under the bottom eyelash. This will emphasize the white eyeliner applied in step 3.

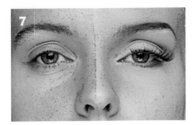

Next, place a false black lash tip on the outside edge of the natural eyelash. (See Devon's Recommendations, page 20.)

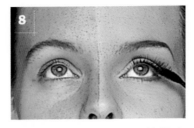

Mesh the false and real lashes with black mascara. Apply to both the top and bottom lashes, but coat the bottoms lightly.

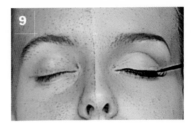

With a black liquid eyeliner, draw a line along the lash line.

Lightly extend this line out toward the temple as shown. This semicircular eye line is important for creating the shape of Marilyn's eye.

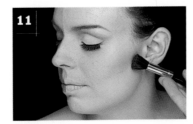

Now it's time to contour the face. With a light brown shadow and a contour brush, draw a soft line from the ear to the middle of the cheek.

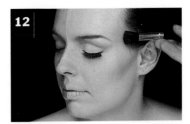

To create Marilyn's somewhat large forehead, using a contour brush draw a line from the eyebrow to the hairline at the temple.

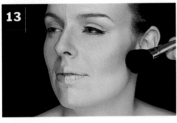

Then, with an orange blush and a blush brush, blend in the contour lines. (See Devon's Recommendations, page 21.)

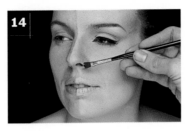

For Marilyn Monroe's nose, use a tan shadow and a medium-size eye shadow brush. Draw a soft line down the nose,

starting from the inner eye then moving toward the tip, where you make a little circle to create her bulb tip. Now, draw a very subtle line across the upper tip of the nose (lower bridge) to enhance the bulb effect. Using a sponge applicator, you can also put a dab of white shadow on the tip of the nose for more definition.

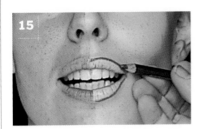

With a dark burgandy lip liner pencil, draw on Marilyn's fifties-style lips.

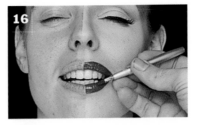

Using a lip brush, fill in the lips with cherry-red lipstick, and don't forget Marilyn usually wore lip gloss.

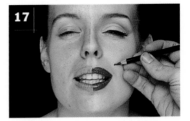

Now, for the final touch, Marilyn Monroe's beauty mark. This can be applied with a black liquid or pencil eyeliner. Place the dot an inch between the nose and mouth on the left side of the face.

HALF-FACE MAKEUP

MICHAEL JACKSON

Michael Jackson is arguably the greatest entertainer of the last half of the twentieth century, perhaps the greatest entertainer of all time. So it's no wonder he has so many fans and so many people who want to impersonate him, or at least some fashion statement he started. (Remember the one-glove look?) Keep reading to see how you can start with the man or woman in the mirror and make history.

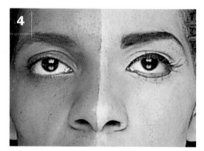

If you have a dark complexion, start with a clown white foundation, and with a sponge add an ivory foundation on top of it to make for a more natural-looking skin tone. If you have a light complexion, the ivory foundation alone should create Michael's stage look. Be sure to powder it all in place. Remember to always use a translucent powder applied with a powder puff.

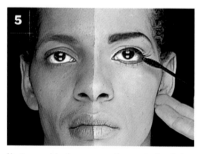

Michael has an arched yet tapered eyebrow. Use a black eye shadow and a brow brush to draw the shape as shown.

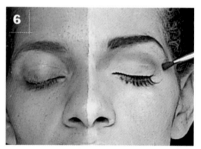

Now, with black liquid eyeliner, completely circle the eye to make Michael's rounded eye.

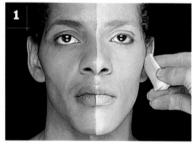

Add a false eyelash tip to the outer real eyelashes. (See Devon's Recommendations, page 20.)

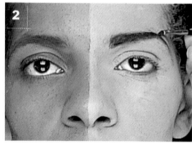

Next, use black mascara to mesh the false tip with your natural lashes and to enhance the lashes in general. Use the mascara on both the upper and lower lashes.

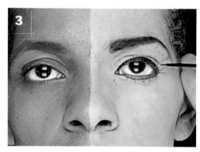

With an orange eye shadow and eye shadow brush, shade in the brow bone and the crease of the eye, starting from the nose and working your way out and up toward the temple.

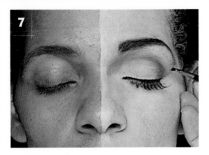

With a dark brown eye shadow and an eye shadow brush, partially cover the eyelid on the outer corner of the eye, working the shadow only into the crease. Press harder in the crease and lightly on the lid.

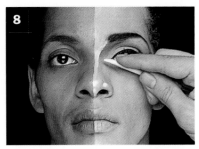

Now it's time to do the nose. First, take clown white foundation and, using a cuticle stick, create a triangle between the eyebrows, tapering it down to the tip of the nose, almost ending in a point. Put a tiny white dot on the tip of the nose. This creates the illusion of a very pointy nose. Also, put a little white dot on the side of the nostril close to the tip, as shown.

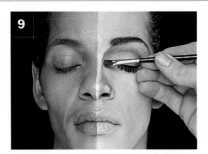

Next, with an eye shadow brush and light brown eye shadow, draw a line down alongside the white triangle line you just created. Extend the shadow around the white dot on the side of the nostril.

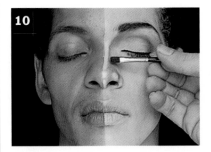

To soften these lines, follow the brown line with a tan shadow line and blend them together with an eye shadow brush.

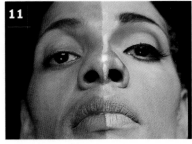

Now, with black liquid eyeliner, create a small V shape at the top of the nostril.

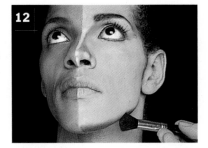

With a contour brush and dark brown contour shadow, draw a line from the chin back along the jawbone. (See Devon's Recommendations, page 22.)

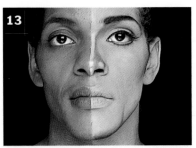

To create Michael's squared-off chin, use an eye shadow brush and the same dark brown contour shadow and draw a straight line an inch up from the chin toward the edge of the mouth. Lessen the pressure applied as you move away from the chin, as shown.

Now, with a blush brush and orange blush, soften all of the contour lines. Also apply blush from the ear to the middle of the cheek.

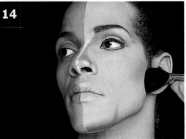

Next, use a natural tan lip liner pencil to draw in Michael's medium-size lips (See Devon's Recommendations, page 24).

Using a lip brush, fill in the lips with a praline-colored lipstick.

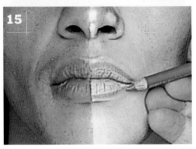

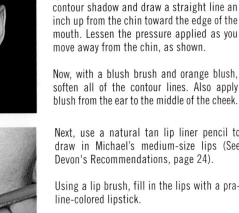

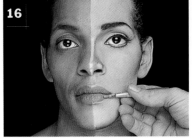

HALF-FACE MAKEUP
DEVON CASS
CHER

For the past thirty years Cher has been an American pop icon. Thrust into the limelight of the music scene as a teenager, she was the sensational half of Sonny and Cher. Her singing and comedic talent took the duo to television. After conquering the small screen, and with Sonny out of the picture, Cher took on the silver screen and walked away with an Oscar and a solid new career: actress! Today, she also has a successful mail-order catalog company and can pretty much do whatever she wants.

Here are the steps that can turn you into a flattering imitation of one of the living legends of our time.

1. Cher has arched eyebrows, so paste down part of the eyebrow if yours are too thick. (See Devon's Recommendations, page 18.)

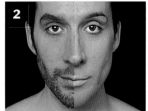

2. Using a sponge, cover the face with a deep beige foundation. Be sure to put foundation over the pasted down portion of the eyebrow.

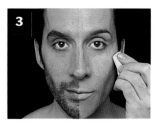

3. Now, take a lighter ivory foundation and, using a sponge, apply it to the cheekbone area just under the eye and up toward the upper part of the ear. Also place some ivory foundation on the center of the forehead and cleft of the chin.

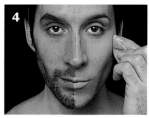

4. Using a powder puff, set the ivory foundation with ivory powder and beige foundation with matching powder.

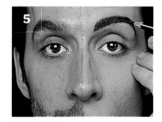

5. Next, take a black eyeliner pencil and create the arched eyebrow.

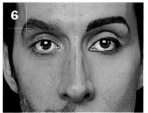

6. With the same pencil, create Cher's almond-shaped eyes. (See Devon's Recommendations, page 20.)

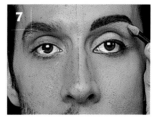

7. Use a white or gold eye shadow and a sponge applicator to apply the eye shadow to the brow bone, directly beneath the eyebrow.

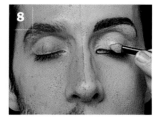

8. Be sure to put some of the same eye shadow on the top of the inner eyelid with a sponge applicator.

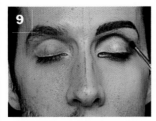

9 With a small eye shadow brush and dark brown eye shadow, fill in the crease of the eye starting at the nose and working your way out to the end of the eye. This will create Cher's deep-set eyes. Now, add brown to the outer corner of the eyelid with the same eye shadow brush.

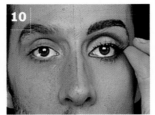

10 Next, glue on a normal or spiky black false eyelash to your upper natural lashes.

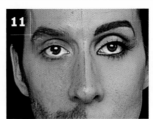

11 Use black mascara to mesh the false eyelashes with the natural ones (see Devon's Recommendations, page 21). Be sure to use mascara on both the top and bottom lashes (the bottom ones should be heavily covered with mascara).

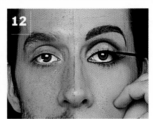

12 With a black liquid eyeliner, go over the lash line and the original thinner pencil eye line to deepen the effect.

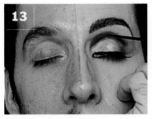

13 Using the same liquid eyeliner, create a thin line over the brown shadow line in the crease of the eye. This also makes the deep-set eyes even more dramatic.

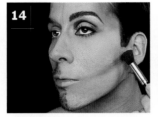

14 Next, contour the face using a contour brush and a medium brown shadow. Draw a half-moon shaped medium line from the ear to the mouth. Also, contour the temple and the jawline. (See Devon's Recommendations, page 22).

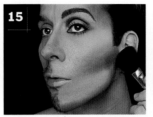

15 Use an orange or a rust blush to blend in the contour lines. Use a blush brush for this step, which softens the look. (See Devon's Recommendations, page 22.)

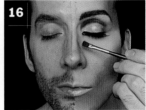

16 With an eye shadow brush and a tan shadow, draw a soft line down the nose from the edge of the inner eye to the end of the nose. Make a small circle at the tip to create a bulb effect on the end of the nose. Draw a subtle line across the upper tip of the nose (the lower bridge) to enhance the bulb effect.

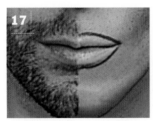

17 With a dark brown or burgundy lip liner pencil, draw in larger or smaller lips, accordingly. (See Devon's Recommendations, page 24.)

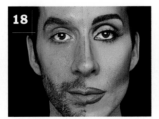

18 Now, use a praline-colored lipstick (or any desired Cher color) to fill in the lips. Use a lip brush and creamy lipstick for best results.

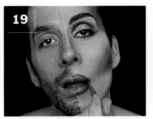

19 Darken the corner of the mouth with a dark brown lipstick, again applied with a lip brush. You can also use a dark brown eyeliner pencil to color in the corner. Press harder on the edge of the mouth and lighter as you move toward the center. Remember, the dark portion should only be about half an inch from the corner of the mouth.

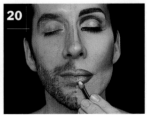

20 To top off Cher's pouty mouth, take a silver, gold, or cream-colored shadow and dab it on the middle of the top and bottom lips, then blend it into the lipstick.

HALF-FACE MAKEUP
MARK PAYNE
LIZA MINNELLI

Energetic, bubbly, and flashy even when her makeup is concerned—that's Liza Minnelli! A woman who constantly exercises her right to be who she is without compromise. To perfect a Liza Minnelli illusion, follow these easy guidelines.

If you don't have brown eyes, put in nonprescriptive brown contact lenses.

Apply ivory foundation to the face with a sponge, and using powder puff add a translucent powder to hold it in place.

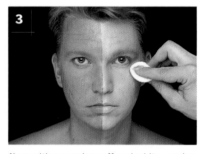

Now, with a powder puff and white powder, highlight the cheek, forehead, chin, and tip of the nose. (You highlight the nose to help create Liza's bulb tip.)

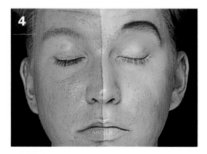

Take an eyebrow brush and black shadow and draw a brow, starting about half an inch from the nose and working straight out to the end of the eye; then arch the brow down about half an inch, ending in a point. (This creates Liza's droopy brow bone.)

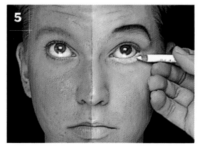

With a white eyeliner pencil, open the eye up by drawing a semicircular white line under the bottom eyelash line as shown. Don't follow the natural lash line. (See Devon's Recommendations, page 19.)

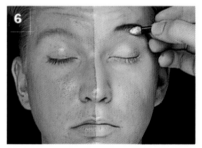

Next, use white eye shadow and a sponge applicator to cover the entire brow bone under the brow. Also cover half of the eyelid starting as close to the nose as possible and working your way towards the middle of the eyelid.

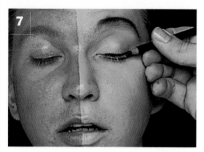

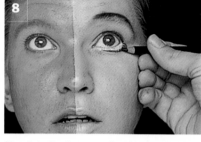

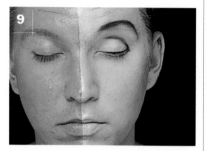

With black eyeliner pencil, draw a thin line along the upper eyelash line, starting in the center and working out to the corner of the eye.

Then take the line around and under the white line you drew beneath the bottom lash line in step 5.

Now, use a charcoal shadow on a beveled eye shadow brush and draw a line in the crease of the eye from the outer edge to the middle.

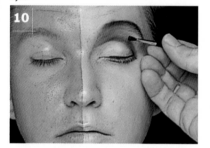

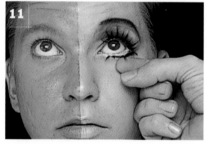

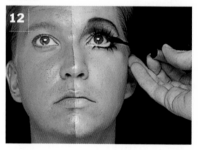

Take a coppertone-colored shadow using a small shadow brush blend it into the charcoal shadow, extending the coppertone-colored line past the charcoal and over to the nose. Swoop this extension up to the brow and blend it slightly into the brow, moving toward the middle about half an inch.

Glue on full, top spiky black false eyelashes to your top natural lash, then glue bottom false lash to line drawn under natural lash.

Next, go back and mesh the top false eyelashes into the natural ones with black mascara. Apply pressure only at the foundation of the lash line to prevent caking on the outer spikes when you bring the mascara brush up and out. There's no need to mesh the bottom lashes together with mascara. (See Devon's Recommendations, page 21.)

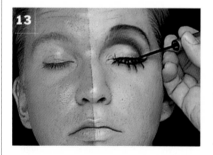

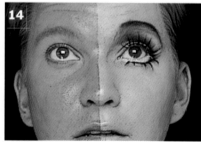

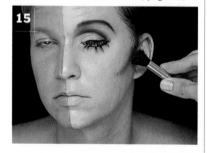

With black liquid eyeliner, create a more rounded eye by not following the upper lash line exactly. Instead, start at the lash line near the nose where the false eyelash band begins. Draw a thin line that gets thicker as you move toward the center of the lash line and up a bit in a semicircular motion. Start to make the line thin again as you bring the curve back down toward the outer end of the eye and lash line.

With the same black liquid eyeliner, draw a very thin line under the bottom false lash line you created.

Now, with a contour brush and a medium brown shadow, start at the middle of the ear and draw a crescent-shaped line under the apple of the cheek, ending in the middle of the cheek. Be sure to contour the jawline for a stronger jaw. (See Devon's Recommendations, page 22.)

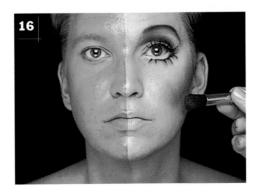

Take a contour brush with a rose-colored shadow and blend it into the medium brown contour lines you just made.

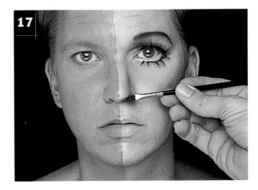

With an eye shadow brush and a light brown shadow, create a wide-looking nose by drawing a line down the side of your nose, beginning near the inner eye and ending at the nostril. Shade under the tip of the nose to create Liza's bulb tip. (See Devon's Recommendations, page 23.)

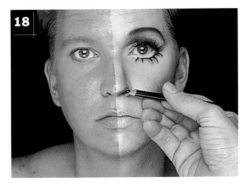

With a black eyeliner pencil, outline the nostril to make it appear larger.

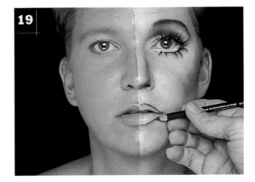

Use a red lip liner pencil to draw on Liza's lips, making sure the bottom lip is larger than the top. This helps create a pouty effect.

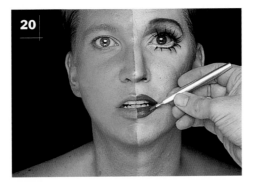

Fill in the lips with a cherry-red lipstick. Apply with a lip brush.

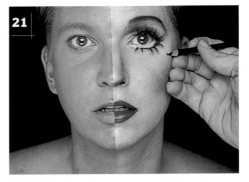

Using a black eyeliner pencil, draw on Liza's beauty mark by making a dot about a half an inch below the corner of the left eye. (necessary)

I met my Michael Jackson on a plane to Chicago. Jose Luis had his hair slicked back, and at first I didn't see it when he told me he did Michael. Later, back in New York, I did his makeup and sure enough, he was a realistic-looking Michael Jackson.

When Jose wears his hair down he looks more like Michael because they have very similar hair, but when it's back the illusion isn't there. He has a larger nose than Michael, and his chin is bigger too. It's interesting though that the minute he puts the white face on you start to see Michael seeping through.

But the greatest thing about Jose Luis, even more than the look, is the spirit he has for the character and the way he captures Michael's movements and dancing. He's one of the most professional people I've ever worked with on that level, and his wardrobe is unbelievable. I chose to use this particular outfit— a pair of black pants, loafers, white T-shirt, black hat, and glasses—because it's so easy for anyone wanting to look like Michael to find. Most of Michael Jackson's clothes are rhinestoned to death, beaded, and very expensive. But this is one of the more subtle, yet recognizable, outfits that he's worn.

SQUARE TO OVAL FACES
DO MICHAEL BEST!

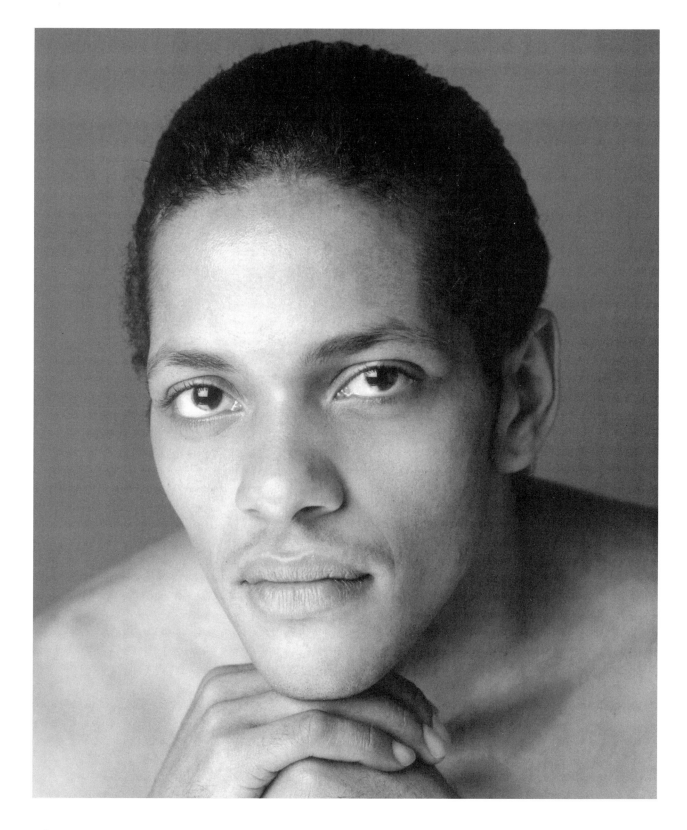

STARTING WITH THE
MAN IN THE MIRROR!

To transform into an incredible likeness of Michael Jackson, Jose Luis Jorge Benitez, better known as Jose Luis, always starts with the man in the mirror. Jose resembles the "King of Pop," but says it's the magic of makeup that makes Michael really pop out! This Sagittarian, who was born in Puerto Rico, now lives in New York City. He has a similar body and bone structure to Michael, which helps make the illusion easy, but once he hits the stage it's almost impossible to tell if you're watching Jose or the real Michael. The impersonation is that perfect.

MANNEQUIN
MICHAEL JACKSON

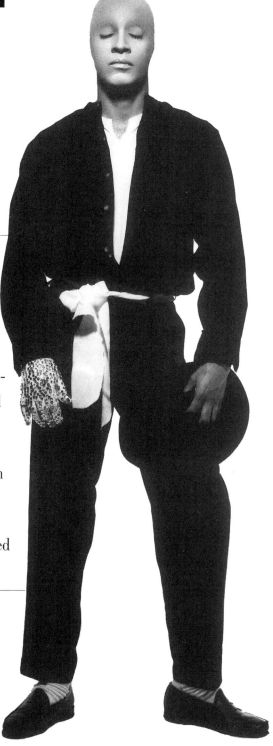

Michael Jackson translates his love for fantasy right down to the outfits he wears. His bejeweled military look is one the world has come to know. But Michael does have more simple looks, especially in his videos. Try some of these clothes on for size, but do stay mild-mannered and soft-spoken.

CLOTHING

- Stovepipe straight-leg black pants.
- White T-shirt torn in the middle from the neckline to the chest.
- Button-down black shirt worn over a white T-shirt and opened to the waist.
- Pleated white ribbon-tie belt.
- Black fedora hat.
- White socks.
- Black penny loafers.
- Rhinestone-studded right glove.
- Mirrored glasses.

EYELASHES

- Short, spiky black lash tips.

WIG

A long, spiral, and curled look with spiral bangs hanging in the face. The two sides of the wig are pulled back and pinned up.

WIG TIP

Dot face with spirit gum, then place strand of hair on dot and press. Let dry for ten to fifteen seconds. This will hold bangs in place.

BODY-MAKEUP TIPS

1 Streak clown white foundation topped with light ivory foundation across exposed skin on chest, then blend with a sponge.
2 Same as above but on hands.

OPTIONS

- Bandage tape around fingers.
- Beaded or bejeweled military suit.
- Torn white T-shirt worn with white button-down overshirt.
- Black pants.
- Black patent-leather jumpsuit.
- Knee-high combat boots with silver instep guards.
- Michael's best colors include red, royal blue, gold, silver, black, and white.

EXPRESSIONS

Wide, toothy grin.
Angry clenched teeth and a clenched fist.
Innocence.
Hurt and sorrow.
Joy and elation.

FAMOUS QUOTES

"Leave me alone!"
"Stop pressurin' me!"

BEST SONGS TO PERFORM

"Billie Jean"
"Beat It"
"Don't Stop 'Till You Get Enough"
"Bad"
"Thriller"

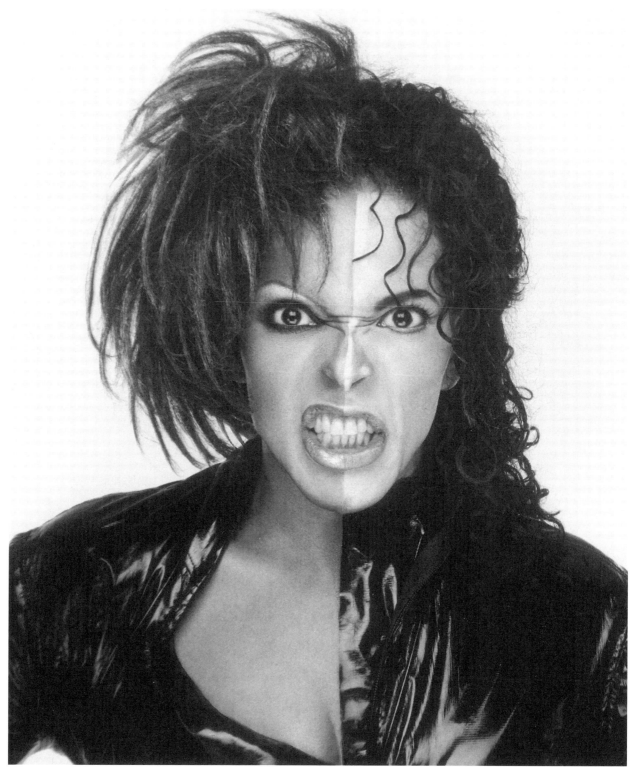

JANET JACKSON/MICHAEL JACKSON (INSPIRED BY "SCREAM")

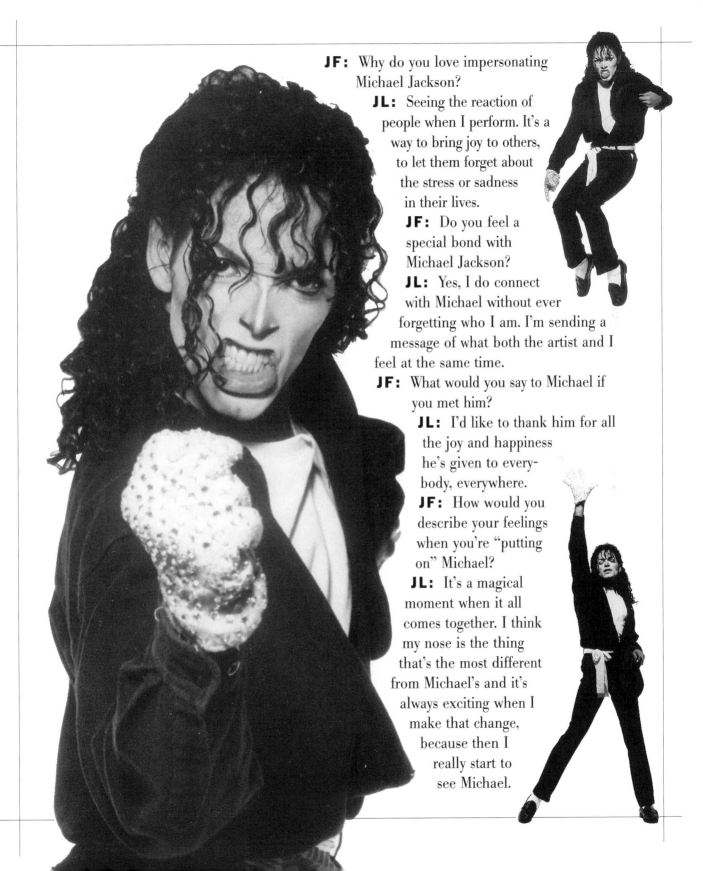

JF: Why do you love impersonating Michael Jackson?

JL: Seeing the reaction of people when I perform. It's a way to bring joy to others, to let them forget about the stress or sadness in their lives.

JF: Do you feel a special bond with Michael Jackson?

JL: Yes, I do connect with Michael without ever forgetting who I am. I'm sending a message of what both the artist and I feel at the same time.

JF: What would you say to Michael if you met him?

JL: I'd like to thank him for all the joy and happiness he's given to everybody, everywhere.

JF: How would you describe your feelings when you're "putting on" Michael?

JL: It's a magical moment when it all comes together. I think my nose is the thing that's the most different from Michael's and it's always exciting when I make that change, because then I really start to see Michael.

IMPRESSIONS OF
JULIE SHEPPARD
JUDY GARLAND

I met Julie about eight years ago when she was in her critically acclaimed one-woman show doing Judy Garland. It was called *Julie, Julie, Julie.* The moment I saw the show I knew I wanted to try to improve her Judy look. I was amazed at the incredible likeness once I got her made up, but I've also been so impressed with her ability to do Judy's talking and singing. It's amazing, even down to imitating Judy spitting into the microphone. Her impression is that exact.

Julie shares some facial features with Judy naturally. Her eyes are similiar, but I saw that they could be transformed into something more Judy. Her bone structure is close as well. She has a square jawline that's more like Liza's, but with the makeup and contouring she can do both Judy and Liza. Julie's cheekbones are actually higher than Judy's were, but again, makeup corrects that. As for the nose, Julie's is similar to Judy's. When I photographed her as Liza, I just had to create a bulb at the tip of the nose to make her more Liza. Julie's mouth is similar to Judy's, but it's a lot smaller so I have to draw in the pouty lips underneath her natural lip line, and I make it a little bigger on the top.

HEART-SHAPED TO ROUND FACES
DO JUDY BEST!

MANNEQUIN

JUDY GARLAND

O ften dramatic, sometimes vulnerable, always the legend, Judy Garland had a simple, elegant, and, above all, feminine style of dressing. Copy that style and add her wit and laughter for a winning impression.

CLOTHING

- Knee-length, sequined black tank dress.
- Matching sequined black jacket with wide shawl collar and short sleeves.
- High-heeled black patent-leather pumps.
- Clip-on rhinestone cluster earrings.

EYELASHES

- Short, spiky black lash tips.

WIG

Short, dark brown, messy layered, spiked wig.

OPTIONS

- Same wig in black.
- Same tank dress and jacket in white, with intricately patterned jewels.
- Evening gown with matching jacket.
- Black capri pants with white flat shoes.
- White blouse with wide collar.
- Three-quarter-length men's black jacket, worn with black sheer tights or black fishnet stockings, black high-heeled pumps, and a men's black fedora. (This is the "Get Happy" look.)

EXPRESSIONS

Looking out searchingly.
Uncertainty.
Quivering lip.

FAMOUS QUOTES

"I know, I'll, I'll sing 'em all! And we'll stay all night. I don't ever want to go home. I never want to go home!"
"There's no place like home."

BEST SONGS TO PERFORM

"Over the Rainbow"
"Get Happy"
"The Man That Got Away"
"Chicago"

HALF-FACE MAKEUP

JULIE SHEPPARD
JUDY GARLAND

Judy Garland is one of the most popular impersonations to do. Nearly thirty years after her death audiences still thrill to her music, and even more so when an impersonator can bring her magically back to the stage. To recapture some of that magic for yourself try these easy makeup steps:

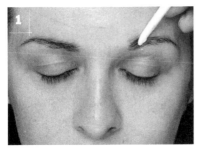

If you have big or bushy eyebrows, paste down about a half inch of the eyebrow starting closest to the nose and coming in. This creates a wide-eyed look because Judy Garland's eyebrows were far apart (see Devon's Recommendations, page 19).

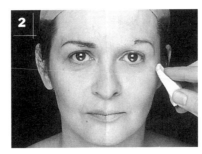

Now, cover the face with an ivory foundation, applied generously with a sponge. Be sure to apply foundation to the covered part of your eyebrow to help conceal it even more. Using a powder puff and translucent powder, set the foundation in place.

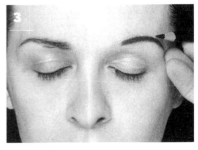

Next, shape your eyebrow into a rounded, arched brow using a black eyebrow pencil.

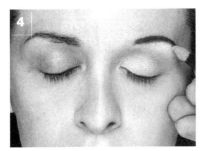

To bring out Judy's tell-all eyes, use a frosty snow-colored eye shadow applied with a sponge applicator directly over the brow bone, underneath the brow itself, and on the entire eyelid.

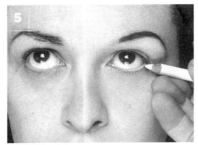

Draw a white semicircular line under the eye with a white eyeliner pencil. This makes the shape rounder (see Devon's Recommendations, page 19).

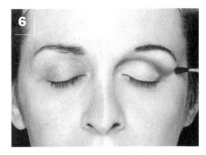

Put medium brown eye shadow in the upper crease of the eye, starting from the bridge of the nose over to the outer end of the eye. The line should extend down to the corner of the lid and then up toward the temple, almost as if making a check mark. Use a small eye shadow brush.

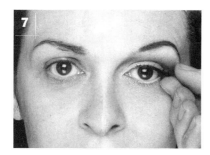

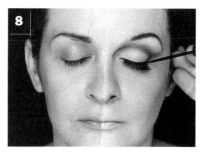

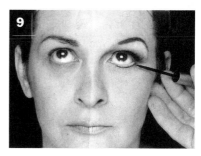

Take a false eyelash tip and place it on the outside end of your real lash, from the arch of the eye over to the outer end. Now it's time to add black mascara to both the top and bottom lashes. The mascara will help mesh the false lash tip with your own lash, creating a more natural look (see Devon's Recommendations, page 21).

With black liquid eyeliner, draw a line along the lash line of the eyelid, from about the center of the eye to the outer end, and, again in a check-mark motion, extend the line up toward the temple.

With the same black liquid eyeliner, outline under the white eyeliner used earlier under the eye. This adds emphasis to the roundness you want to create.

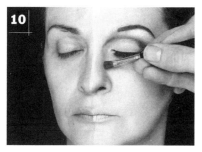

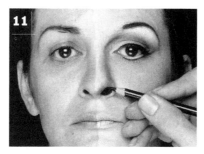

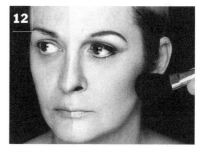

To contour the nose, use a small eye shadow brush and make a subtle thin line starting from the top of the nose next to the eye and drawing straight down to the nostril with tan shadow.

Since Judy had wide nostrils, outline your own nostril with a black eyeliner pencil.

With a blush brush, apply a muted red blush from the middle of the ear, extending down to just under the cheekbone. Contour the jaw and temple if necessary (see Devon's Recommendations, page 21).

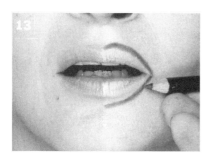

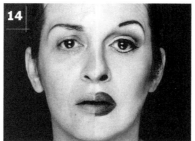

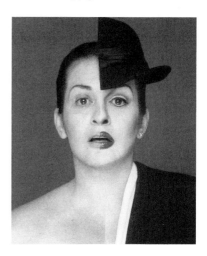

Now it's time to create those pouty lips. With a deep burgundy lip pencil draw in top and bottom lips over your own.

With a lip brush and soft cherry-red lipstick, fill in the lips. Add gloss to give those pouty lips a sexy Judy Garland shine.

JULIE'S GARLAND
OF DELIGHTS!

She says she knew from age five that she could talk and sing like Judy Garland, ever since seeing her idol on *The Ed Sullivan Show*. She believes she's a mirror image of Garland. Sheppard's a Virgo with a Gemini moon; Judy was a Gemini with a Virgo moon. She's right-handed; Judy was left-handed. She says even her real last name, Stefanelli, means "wreath or garland" in Italian. So how exactly did this nice Italian-French girl from New Jersey (who does thirty different impressions) grow up to be one of the most amazing Judy Garland impersonators of all time?

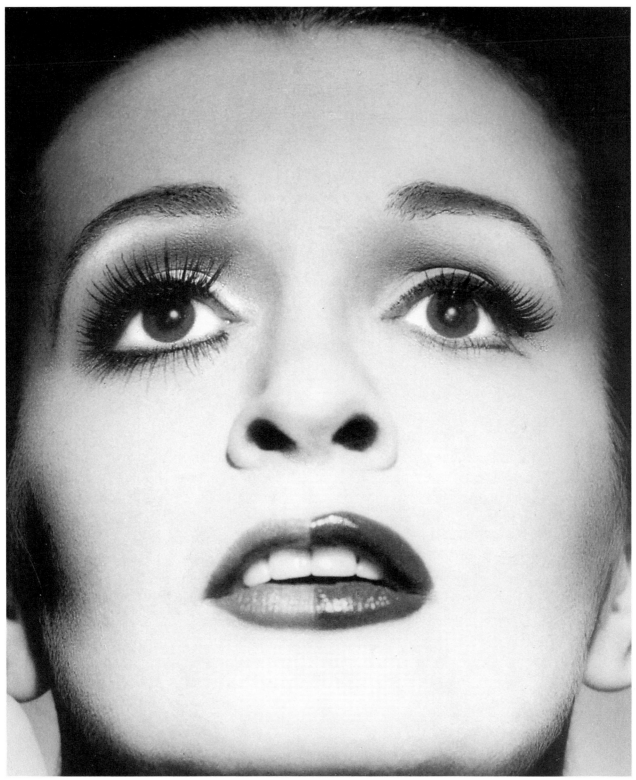

TO VIEW: COVER THE RIGHT SIDE OF FACE TO SEE LIZA; COVER THE LEFT SIDE OF FACE TO SEE JUDY.

JS: I was about five and used to watch *The Ed Sullivan Show* regularly and whomever I liked best on the show I would become for the entire week. And one week he had Judy Garland on and that was it for me. I said that's the voice, there are no others.

JF: What's been one of the most unusual reactions you've gotten to your impersonation of Judy?

JS: I was in Paris and this young Parisian man came up to me and said, "Oh, my God, you were so wonderful. I did not know you were still alive!" He bought it. I was in hysterics.

JF: If she were alive would you want to meet her?

JS: Boy would I. I'd say thank you. I don't think any woman has ever moved me as a performer as much as she does. She's riveting, she's beautiful, she was multitalented, and was never given enough credit for her ability in her day, especially as an actress.

JF: What do you think is your greatest similarity to Judy?

JS: The first thing that comes to mind is her overpowering love for her children. I'm a mother and I feel emotion for her as a woman and a mother more than on any other level, more than on a performing level.

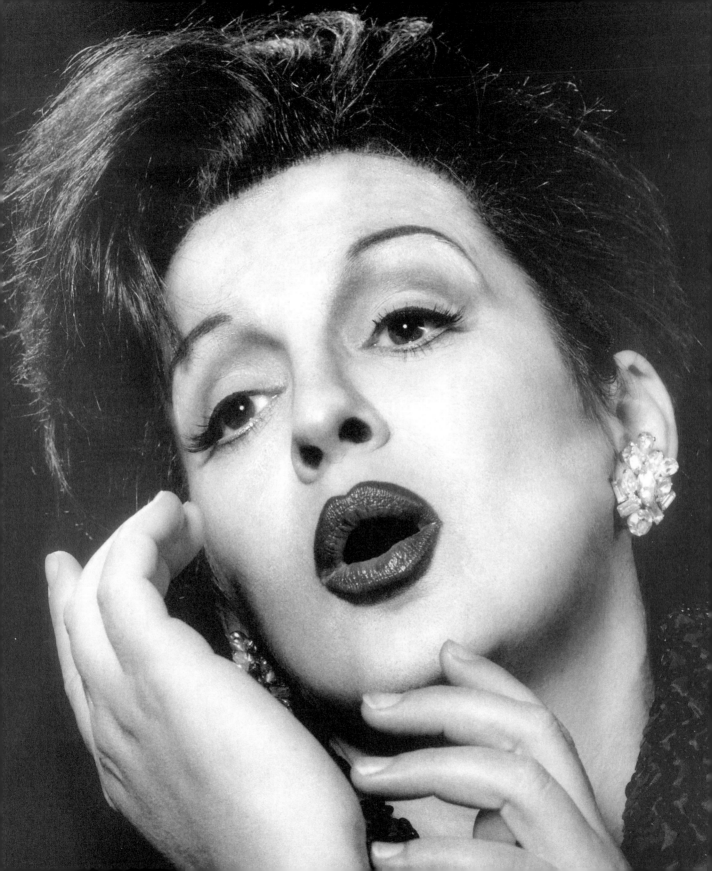

I met Mark Payne when we were both seventeen and in high school in Houston, Texas. I'm sure it was fate that brought us together, because it was Mark who introduced me to the world of celebrity illusion. I'm still fascinated with it and always will be.

Mark was the first illusionist I ever photographed. At the time, he impersonated Judy Garland, Liza Minnelli, Diana Ross, and Barbra Streisand, but it was always his Liza that stood out. She was his strongest character, mostly because Mark's bone structure is similar to Liza's. I create a rounder eye and a thicker nose with makeup. Mark needs just a little help for the pouty mouth because his mouth is the feature that most resembles Liza's. I chose this outfit, the sequined jumpsuit and jacket, because it's signature Liza!

As for RuPaul, fate once again, stepped in to help me in a last-minute dilemma. Ironically, I was on a plane going to Houston about a week after it was decided that a RuPaul look-alike should be included in the book. As the deadline for production of the book was approaching fast, I was trying to think of someone I knew who was thin, had great legs, and big teeth. Then, all at once it hit me—I thought of Mark Payne! He just happens to live in Houston. I realized that he may not be a dead ringer for RuPaul but I wanted to take this opportunity to show that with the right ingredients anyone can create the image that RuPaul personifies.

I would say that the most recognizable feature is her platinum blond, big hair. Whether it's styled in an up do, cascading down around her shoulders in a seventies look, or done up in one of her high-fashion fantasy coifs, it screams RuPaul.

The other feature most associated with RuPaul is her toothy grin. If you don't have large teeth I discovered the perfect remedy: vampire teeth! Just file down the fangs and you've got that instant, dazzling, luminous smile that's sure to light up any room you enter. It helps to have the body type, but if you follow the RuPaul rule—be extremely creative, outrageous, with a great sense of humor—you too can feel the phenomenon that is RuPaul!

HEART-SHAPED TO ROUND FACES
DO LIZA THE BEST!
ROUND TO SQUARE FACES
DO RUPAUL THE BEST!

MANNEQUIN
LIZA MINNELLI

Liza always dresses with that dash of panache. She likes outfits that get attention. If you want to get attention as a Liza Minnelli look-alike you'll need to be out-going, peppy, and ready to have a good time.

CLOTHING

- Long, black sequined halter jumpsuit with matching jacket. (This is a favorite Liza look.)
- Long, flowing chiffon scarf.
- Strappy high-heeled sandals.
- Simple rhinestone earrings and bracelet.
- French manicure.

EYELASHES

- Spiky top and bottom lashes.

WIG

Short, black spiky look.

OPTIONS

- Liza's favorite colors include red, purple, white, and yellow.
- She prefers sequins and beads.
- Liza often will wear a halter mini-dress teamed with a long scarf.
- For a simple Liza look, wear a black turtleneck tunic over black tights and black ankle boots (no scarf, please).

Present look

EXPRESSIONS

Wide-eyed pleading look.
Excited.
Smirky mouth.
Smiles a semicrooked smile and gulps at the same time.

FAMOUS QUOTES

"You're really terrific!"
"Swell."
Hysterical giggle.

'80s look

BEST SONGS TO PERFORM

"New York, New York"
"Some People" from Broadway's *Gypsy*
"Cabaret"
"Maybe This Time"

TAKING PLEASURE
IN PAYNE!

It's truly a sight to behold. His tanned face slowly takes on a luminous glow. Black liner defines instantly recognizable doe eyes. His baby blues go brown, compliments of colored contacts. Long eyelashes get longer. The eyebrows darken and thicken as if by magic, and his blond hair becomes black. In fact, he becomes she, and what once was mild-mannered Mark Payne has been turned into superstar Liza (with an "M," for *Mark*) Minnelli.

Payne is a thirty-one-year-old jazz singer who started performing as a child. He says he was dressing up at age four, and by the time he was nine he knew what he wanted to do: perform. Four years later, he was transforming himself into Barbra Streisand, Diana Ross, and, of course, Liza.

He took his impersonating show on the road down under and came up with a singing career all his own. Today he's a successful recording artist and entertainer on the fast track to musical triumph.

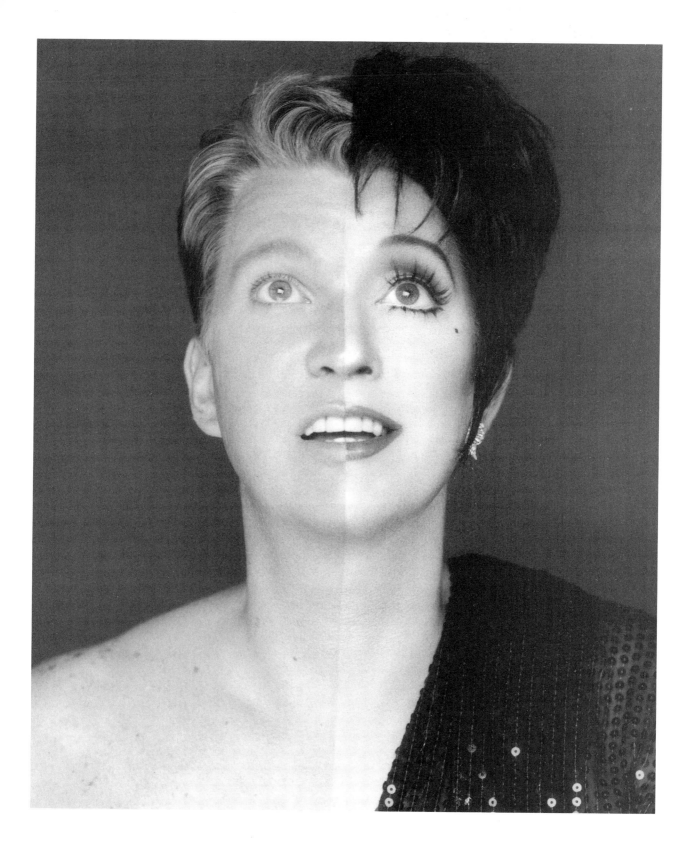

MP: When I was nine I went to visit an aunt in San Francisco, and Liza was there performing in a show called *The Act*. I desperately wanted to see it, but my family said it was an adult show, and I couldn't go. It was about that time that I guess I became obsessed with Liza, but the impersonation didn't really start until just before high school when I saw Jim Bailey, who impersonates Liza's mother, Judy Garland. That's when I started, and I began with Barbra Streisand because my mother had the same hair color as Barbra and I could use her wigs.

JF: How did your mother feel about that?

MP: Oh, my mother was fine with it. She gave me my first makeup kit to play with. It was a tackle box with all her old makeup in it.

JF: What is it about being transformed into Liza that you like most?

MP: Being able to sing and dance onstage. She's so theatrical and has all this energy, and it really gives me a high to re-create that in front of an audience. I guess I also enjoy connecting with the female side of my personality.

JF: Is there any fascination at all with the fact that you don't look anything like her until you get into full makeup and costume?

MP: Yes, it's a trip becoming someone else who's completely removed from Mark Payne, and learning to take on that personality, the mannerisms, and the facial movements.

JF: You've met Liza several times and consider her a friend. What was the first meeting like?

MP: I met her before a concert through a mutual friend, and it was great, but after meeting her I realized she was a normal, wonderful human being and not the character she portrays to the public. I mean her personality offstage is pretty close to the one onstage, but she's performing onstage so there's bound to be theatrics involved.

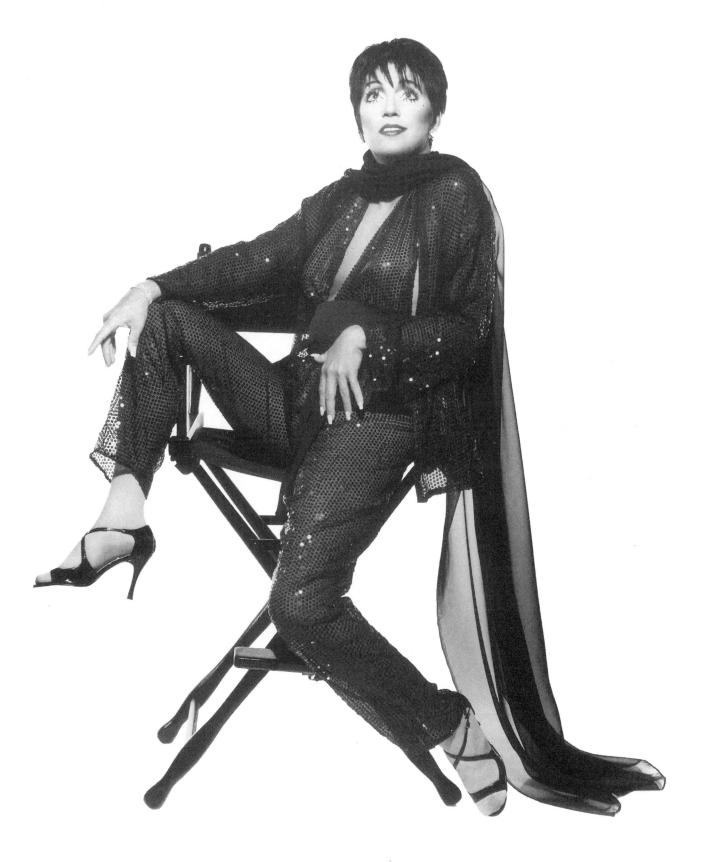

MANNEQUIN
RUPAUL
RUPAUL

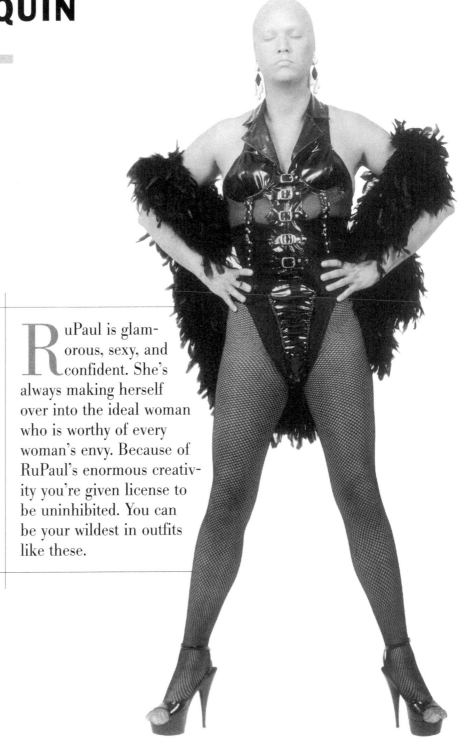

RuPaul is glamorous, sexy, and confident. She's always making herself over into the ideal woman who is worthy of every woman's envy. Because of RuPaul's enormous creativity you're given license to be uninhibited. You can be your wildest in outfits like these.

CLOTHING

- Black, French-cut, patent leather body suit.
- Black fishnet stockings.
- A long, full black feather boa.
- Black and silver rhinestone dangle earrings.
- Black patent leather, open-toed, ankle strap, super high stilettos.

EYELASHES

- Full, spiky black lashes.

WIG

A long layered, loose curled, full cascading platinum blond look as inspired by RuPaul's hit "Snapshot."

OPTIONS

- Platinum blond hair in any over-the-top, big style.
- Aside from black, RuPaul can wear any vibrant color; when it comes to clothes they just have to show lots of shoulder and leg.
- You can wear any kind of feather—ostrich, maribou, etc.

EXPRESSION

Wide-eyed, toothy grin.

FAMOUS QUOTES

"Heeeyyy Y'all!"
"You better work (Bitch)"
If you want to be nasty!
"I am the supermodel of the world!"
"You go girl!"
"Everbody say 'Love'!"

BEST SONGS TO PERFORM

"Supermodel"
"Snapshot"
"Back to My Roots"
"House of Love"

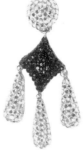

HALF-FACE MAKEUP

RUPAUL
MARK PAYNE

Exceptionally expressive, always alluring, and dynamically dramatic—RuPaul is a showstopper who constantly proves that beauty is more powerful than bigotry. She's a household icon, accepted around the world for her inner, as well as her outer, beauty. She uses her beauty, as well as her songs and laughter, to break down the barriers caused by stereotypes. If you want to follow in her stilettos, here are some easy makeup tips:

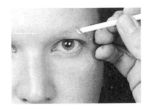

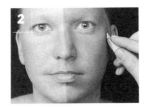

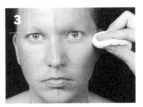

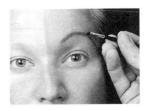

Paste down entire eyebrow using glue from a glue stick applied with a cuticle stick (see Devon's Recommendations, page 18).

Use a cappuccino-colored foundation to cover the entire face and brows, applying it with a sponge. Set in place with a translucent powder using a powder puff.

Take a light highlight powder, and, using a powder puff, apply to cheekbone, center of forehead, and chin.

With a beveled eyebrow brush and a light to medium brown shadow, draw in a semicircular eyebrow above the pasted down brow.

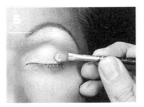

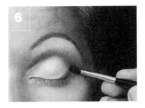

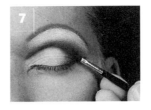

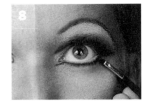

Take a white frosty eye shadow and cover the pasted-down brow using a sponge applicator. Also cover the entire eyelid.

Using a small eye shadow brush, with a coppertone-colored shadow, create a line in the upper crease of the eye starting at the outer edge of the eye and moving toward the nose.

Now, with a black eye shadow and a small beveled brush, follow the line you just created in step 6. This creates more of a Cleopatra V shape.

With the same brush and black eye shadow, draw a thin line under the bottom natural eyelash line. Follow the lash line from the outside edge of the eye to the inner V near the nose. (If you need to create an almond eye, see Devon's Recommendations, page 20.)

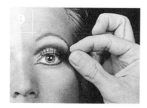

Attach a full black spiky false eyelash to the top natural lashes (see Devon's Recommendations, page 20).

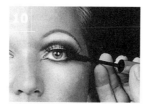

Mesh the false and natural lashes together with black mascara. Be sure to lightly apply mascara to the bottom lashes too (see Devon's Recommendations, page 21).

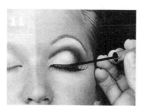

With a black liquid eyeliner, draw a line from the V at the innermost edge of the eye nearest your nose across the upper eyelash line. Make the line thin near the nose, and thicker as you move toward the outer edge of the eye, ending in a point.

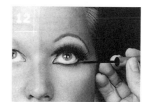

Now take the same black liquid eyeliner and connect the top and bottom lash lines at the V near your nose. Then draw a very thin line across the same lower lash line you drew with eye shadow in step 8, to create an ombre effect.

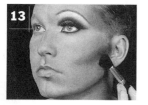

Take a contour brush and medium brown contour shadow and draw a line from the middle of the ear to the mouth, but stopping about half an inch from the edge of the mouth. Be sure to contour the temples and jawline too.

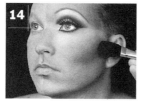

With a blush brush and coppertone-colored blush, blend in the contour lines you just created (see Devon's Recommendations, page 21).

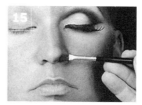

Now it's time to create RuPaul's nose. With a small eye shadow brush and coppertone-colored shadow draw a thin line connecting the line you've drawn in the upper crease of the eye, nearest the nose, to the top of the nostril, as well as across the ball of the nose.

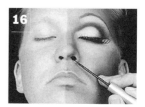

Now, take the black liquid eyeliner and create fuller nostril by outlining the real nostril as thickly as needed.

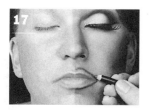

To create RuPaul's full mouth, use a dark brown lip liner pencil and draw in RuPaul's lips (see Devon's Recommendations, page 24).

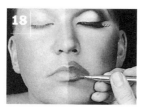

Fill in lips using a desired RuPaul-colored lipstick and apply with a lip brush. Be sure to blend in lipline as much as possible.

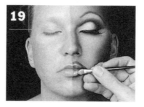

Take a silver highlight powder, and, using a sponge applicator, dab on center of top and bottom lips to create a poutier mouth. Be sure to blend into lipstick.

Now, take vampire teeth and using scissors cut off fangs on both top and bottom to make an even set of large teeth.

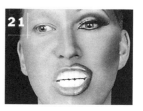

Place in mouth as shown.

PAYNE ON RUPAUL

MP: I worked with RuPaul in Australia when I was performing there but I never dreamed I'd ever be impersonating her. When Devon said he wanted to try and make me over as RuPaul, I was a little skeptical but I said, "Why not?"

JF: It's very in keeping with the philosophy of the book, meaning anyone can try and impersonate a celebrity and see how it goes, right?

MP: Yes. It was such a learning experience for me. I don't perform as RuPaul, I just did these photographs, but it was exciting because it was a new character for me. It was different from doing Liza, I guess because I've been doing her for so long.

JF: What was the most exciting part?

MP: Seeing less of my own face in RuPaul than I do in Liza. That was really unexpected. I thought I'd just see "me" in a big blond wig and dark makeup, but I didn't see myself at all really.

JF: You saw RuPaul?

MP: In the black-and-white pictures I did. In the color shots I have to say I thought I looked more like a bronzed Dolly Parton or Pamela Anderson.

JF: Was there anything different about your shoot for RuPaul, as opposed to your shoot with Devon for Liza?

MP: I was surprised at how smoothly it went despite my doing it at virtually the last minute. I shot the Liza pictures early on with Devon and it took longer, even though I've been doing her for years. The RuPaul shoot went like clockwork although I must say it took some getting use to the high platform stilettos and the corset. I'd never worn a corset before.

JF: So, you're a real RuPaul fan now?

MP: I've always liked her. I like what she's done for impersonators everywhere. Thanks to RuPaul we're being accepted into people's living rooms around the world and we're getting more respect for the talent it takes to do what we do.

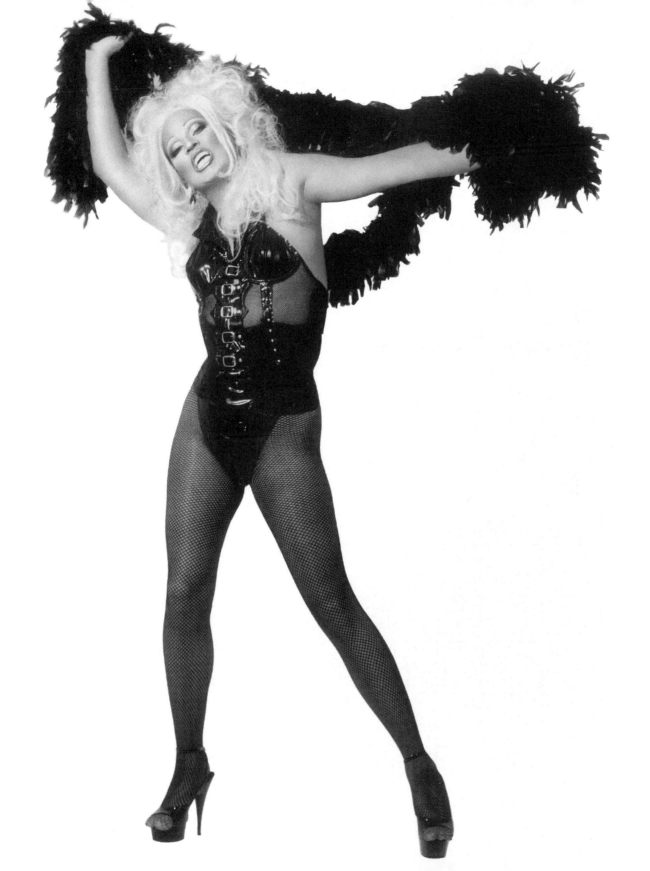

I met Anne through a look-alike agent, and I must admit when I saw her at first I was not sold on the idea of her as Roseanne. She looks like her, but the eyes were wrong. You really have to have the eyes to do Roseanne. Anne's are a little droopier, and more sleepy-looking; Roseanne's are more catlike, but then I thought about creating the almond-shaped eyes with makeup.

When I first shot Anne, we did the glamorous Roseanne as she appeared on the *MTV Music Awards*, because I thought people would have more fun getting dressed up than doing Roseanne's waitress or white-trash looks. But once we shot it, people just didn't see the Roseanne in her, so we went back to the drawing board. She got the waitress outfit with the name tag and pad and pencil, I used lighter makeup, and she just sang Roseanne. I also did a lot with her nose and cheeks, which better transformed her the second time. Anne has a round yet somewhat sculpted face that looks like Roseanne's after all her plastic surgery. Anne's nose is straighter, but the mouth and jaw area are exactly like Roseanne's. That's what really works—and, of course, the similar bodies. She's like Roseanne is now, not the heavy Roseanne. The thing that's even more remarkable is her voice. It's the same. It's weird to me how some look-alikes naturally have the same voice as the person they impersonate. She also does the nasal whine for emphasis.

You can choose several wigs to do Roseanne because she has changed her hair so many times. For this look her hair is straight and dyed black, but it even works with the waitress outfit, though in the character's waitressing days she had lighter brown curly hair. And, buy plenty of chewing gum.

ROUND TO HEART-SHAPED FACES
DO ROSEANNE BEST!

MANNEQUIN
ROSEANNE

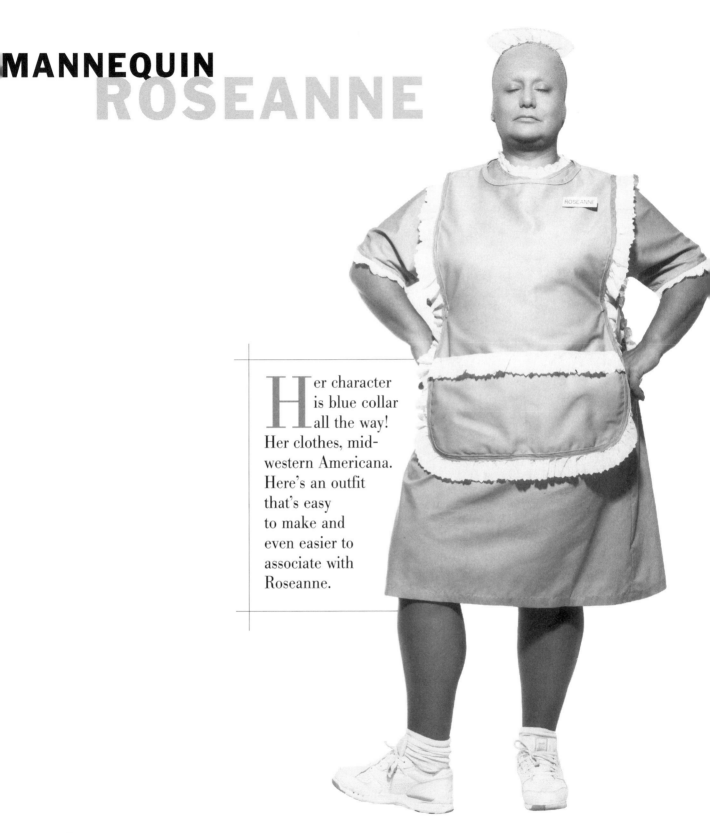

Her character is blue collar all the way! Her clothes, mid-western Americana. Here's an outfit that's easy to make and even easier to associate with Roseanne.

CLOTHING

- Basic blue waitress dress with white-ruffled pink apron.
- White socks.
- White sneakers.
- Ruffled waitress cap.
- Roseanne name tag.
- Wedding ring.

EYELASHES

- Short, spiky black lashes.

WIG

A straight, shoulder-length black wig with layered bangs.

OPTIONS

- Brown curly wig.
- Red flannel shirt worn with blue jeans.
- Baseball shirt, baseball cap, and blue jeans.
- Lycra tights worn with glitzy overshirt.
- For a more glamorous Roseanne look, follow the same makeup steps for the waitress look, but make all the lines heavier and be sure to use full false eyelashes. (Big hair and glamorous outfits are a must.)

- Favorite lip colors for Roseanne include frosty pink, peach, and reds.

FAMOUS QUOTES

"Daaaannnnnn!"
"Duh!"

EXPRESSION

Surprised.

BEST SONG TO PERFORM

"The Star-Spangled Banner" (done badly for laughs)

HALF-FACE MAKEUP

ANNE KISSEL

ROSEANNE

Roseanne has gone through more changes than most since she struck gold on the comedy circuit in the eighties and catapulted to success with her sitcom. She's changed husbands, her name, and even her face. But here's a Roseanne look that's guaranteed to get you looks when you wear it:

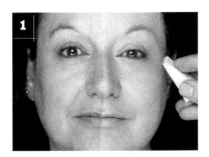

Using a sponge, start by putting a light beige foundation on your face and keep it in place with a translucent powder applied with a powder puff.

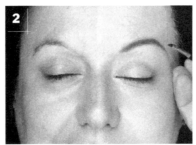

Now, use an eyebrow brush and dark brown to black eye shadow to draw in Roseanne's short, V-arch eyebrow.

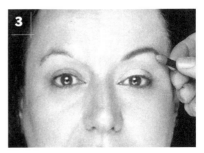

With a cream-colored or white eye shadow and sponge applicator, fill in the brow bone under the brow and all of the eyelid.

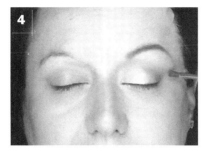

With a small eyeshadow brush and a medium brown shadow create a sideways V in the corner of the eye. Start in the crease from the middle of the eye, bring the line out to the outer corner, and then extend it back across the lash line. Follow the line back to the corner, then up and out toward the temple. (Push harder in the corner of the eye, lightly in all other directions.)

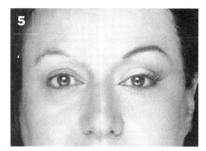

Now, glue a short, spiky black false eyelash tip to the outer real eyelashes.

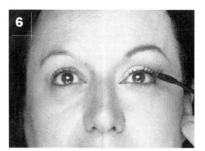

Mesh the top false and real lashes with black mascara. Be sure to lightly mascara the bottom lashes as well. (See Devon's Recommendations, page 21.)

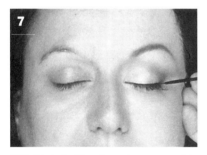

With black liquid eyeliner, draw a very thin line across the entire lash line and extend it out to a point past the outer edge of the eye.

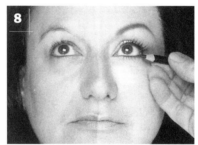

Use a black eyeliner pencil to line the bottom inner lash line.

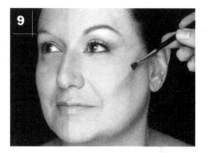

Next, take a thin eye shadow brush and a medium brown shadow and draw a straight line on an angle from the upper edge of the ear to just under the cheekbone. Use a contour brush and the same color shadow to contour the jawline (see Devon's Recommendations, page 21).

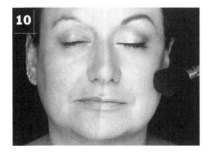

With a blush brush and light red blush, lightly go over the lines you've just made without totally softening them. (Dab the apple of the cheek with this blush too.)

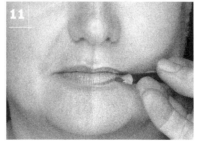

Now, use a red lip liner pencil to create Roseanne's thin lips. (To make smaller or larger lips, see Devon's Recommendations, page 24.)

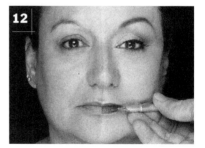

Fill the lips in with a cherry-red lipstick, using a lip brush.

DOMESTIC GODDESS
ANNE—
IS ROSEANNE!

Anne Kissel comes from Connecticut. She's Married with Children and says while there's no need for Home Improvement, there is Something So Right about wanting to be an entertainer. Right now she's impersonating Roseanne, and doing Roseanne's routines. Even when she has to put up with Men Behaving Badly in her audience, she knows it's all part of paying her dues.

Anne is Almost Perfect at what she does. She knows if she takes things Step by Step she'll avoid Jeopardy and one day be walking on EZ Streets, doing her own comedic work. And who knows, maybe she'll even have a TV series of her own.

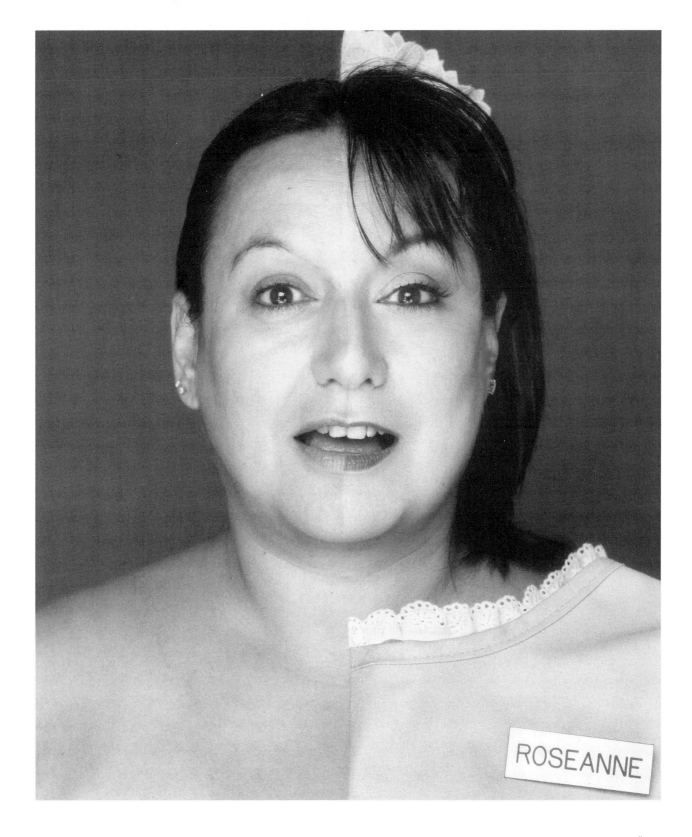

AK: We've both got that wonderful body [*Laughs*], and I think we share the same sense of humor. I mean you can go through everyday life and have the same ol' crap all the time, or you can look at it from another point of view, and that makes things a lot easier. Life is cooler that way. I actually met Roseanne on the set of her show, and Roseanne did a double take when she saw me in the audience. That was great. We talked, and Roseanne was gracious. She loved that I sound and laugh just like her too.

JF: You have similar voices, and you really can do the exaggerated nasal whine.

AK: When Devon and I were doing the shoot for this book I would do the voice—you know, "DAAAAAAAN!"—to get the facial expressions down. Roseanne's got some really good ones, like her "get real" expression when she looks at people like they're nuts. She wrinkles her forehead and gives you that "Uh-uh." To capture Roseanne you kind of just have to keep talking—half under your breath— just keep the chatter going. And the single most important thing to do while impersonating Roseanne is to always be chewing gum, and be annoying about it—snap it and talk with the gum going.

JF: Do you relate to Roseanne?

AK: I think I understand her. I can see she's more centered and spiritual now, and so am I. I also relate to the mother thing, the kids and the struggling. I like the whole concept for her TV show too. She believed that TV didn't really represent the real American family, with a mother and father working to make ends meet, taking care of the job, the kids, the house, and doing it well. Now at least after her show, it's a little more realistic. You know everybody does not live in the lap of luxury.

JF: Do you have any favorite jokes from Roseanne's stand-up routine?

AK: "Yeah, ladies, you may think you married the man of your dreams, but fifteen years later you're married to a recliner that burps!"

IMPRESSIONS OF
RICHARD CRUZ
MARLENE DIETRICH

I've known Richard Cruz for many, many years. We worked together in Houston before coming to live in New York, and we were roommates when we first arrived. I always thought Richard had the face to do Claudette Colbert, but I also saw Marlene Dietrich in him. He has a square face like Marlene, and I decided to go with that.

Richard was very excited to try the impersonation, but didn't think he looked like Marlene because he's Latin. But Richard has Marlene's deep-set eyes and a lot of eyelid like she had, and he has her bone structure and a similar nose shape. His mouth isn't right, but that can be adjusted with makeup. Richard has such a different skin type than Marlene and a very masculine chin that needs to be softened through contouring, but his transformation shows you that you can make dramatic changes and still have the "real" look.

Of course, to complete the illusion, you need the right costume—the tuxedo. Marlene was one of the first famous women to wear pants, and it caused a public scandal. She styled her hair in a finger wave and wore a top hat. You need a white rose for your lapel too, and then you're really doing Dietrich.

WIDE, HEART-SHAPED
TO SQUARE FACES
DO MARLENE BEST!

MANNEQUIN

MARLENE DIETRICH

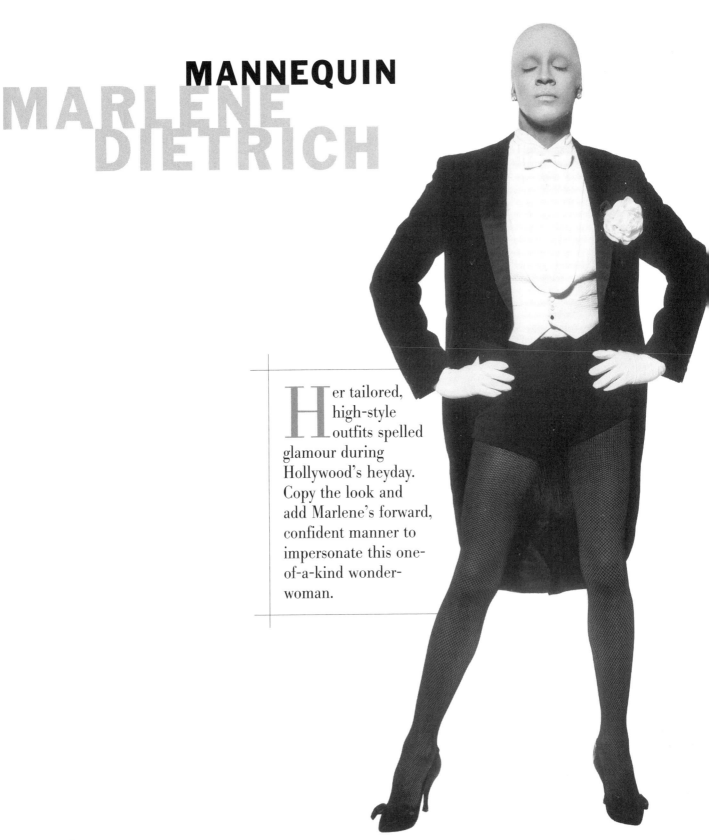

Her tailored, high-style outfits spelled glamour during Hollywood's heyday. Copy the look and add Marlene's forward, confident manner to impersonate this one-of-a-kind wonder-woman.

CLOTHING

- Black short pants worn with fishnet stockings.
- Black top hat.
- White tuxedo shirt, white vest, and white bow tie.
- Black tuxedo jacket with tails.
- White rose in lapel.
- Black satin pumps with ribbon bow on instep.
- Simple rhinestone stud earrings.
- Wrist-length white gloves.

EYELASHES

- Short, spiky black lashes.

WIG

Blond wig with front finger wave and curls all around the back, always worn with a top hat.

OPTIONS

- Cream-colored men's suit with wide shoulders and matching fedora. (Remember, hats make the wig work better.)
- Baggy black tuxedo pants.
- Feather boas, or feathers in hat.
- Best colors to use are white, black, and metallics.

EXPRESSION

Sultry look.

FAMOUS QUOTE

"Pour me a whiskey baby, and don't be stingy!"

HALF-FACE MAKEUP

RICHARD CRUZ
MARLENE DIETRICH

S he made men swoon and women envious without ever being afraid to show both her masculine and feminine moods. Marlene Dietrich's tough attitude and deep voice made her the talk of the town, not only in Hollywood but also around the world. See if you can make the magic happen with these tips:

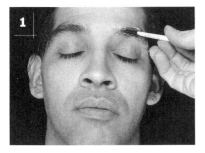

Paste down most of your natural eyebrow, leaving just a thin line along the top of the brow. Or paste down the entire brow and draw the thin line on as in step 5 (see Devon's Recommendations, page 18).

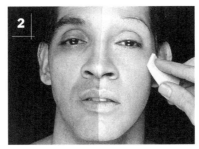

Using a sponge and a light ivory base, cover your face, including the pasted-down portion of your brow. This conceals the covered part of the eyebrow better.

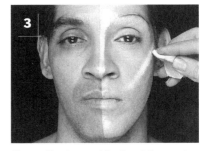

Now, with clown white foundation and a sponge, draw a line starting near the upper edge of the ear down to the mouth on an angle. Also draw a line down the middle of the nose from top to tip.

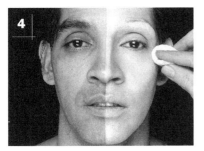

Blend the foundations with a sponge and set in place with translucent powder using a powder puff.

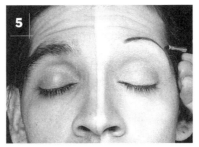

Now, draw in Marlene's thin, rounded brow using an eyebrow brush and black shadow. You can also use black liquid eyeliner to create the brow.

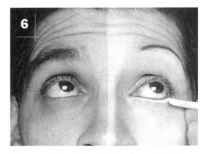

Use a cuticle stick and the clown white foundation to apply a thin line to the inner and outer bottom lash lines.

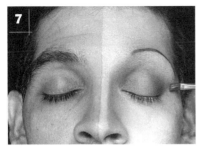

With charcoal shadow and an eye shadow brush, cover the eyelid. Start at the inner corner of the eye near the nose and work out and up to the brow bone, moving down to the outer corner of the eye. Be sure to press lighter on the brow bone and harder in the corner, making the shadow darker there.

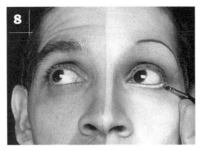

Next, take a medium brown shadow and, using a beveled eyebrow brush, underline the white line you made along the bottom outer lash line in step 6.

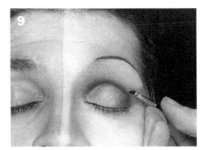

With the same brush and a black shadow, draw a line in the crease of the eye starting about half an inch out from the nose and ending about a quarter inch from the outer end of the eye.

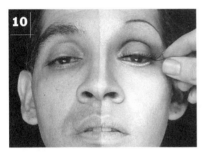

Glue on a black, full false eyelash to top natural lashes. Be sure to mesh the top false and natural lashes together with black mascara (see Devon's Recommendations, page 21). But don't use any mascara on the bottom lashes.

Now, take a contour brush and a medium brown shadow to draw a line under the white line on your cheek that you drew in step 3. This will create a high cheekbone effect. Contour the jawline and temple too (see Devon's Recommendations, page 21).

With a blush brush and red blush, blend in the contour shadow without extending into the white highlighted area to avoid diminishing the high cheekbone effect. Also, blend the contour lines at the jaw and temple.

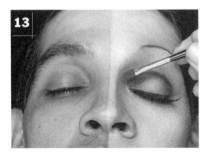

Take an eye shadow brush with light brown shadow and draw a line along the outside of the white line that you drew down the nose in step 3. If you have a larger nose that you want to look smaller, extend this brown line out and around the nostril (see Devon's Recommendations, page 22).

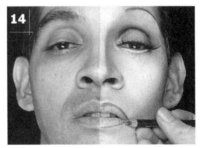

Use a burgundy lip liner pencil to create Marlene's medium-size, semi-arched lips (see Devon's Recommendations, page 24).

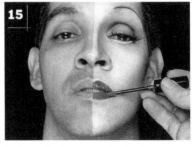

Using a lip brush, fill in the lips with a cherry-red lipstick, then top them off with lip gloss.

DETECTING DIETRICH!

That Richard Cruz does an impersonation of Marlene Dietrich is as unusual and unique as the character herself. Cruz says he never considered the possibility that he could look like her. First of all, Cruz is of Spanish descent and several shades darker than Dietrich. Secondly, he'd never really paid attention to Dietrich's work. But Cruz allowed the transformation to happen. It was a surprise and delight for him, and a perfect example of what this book is all about.

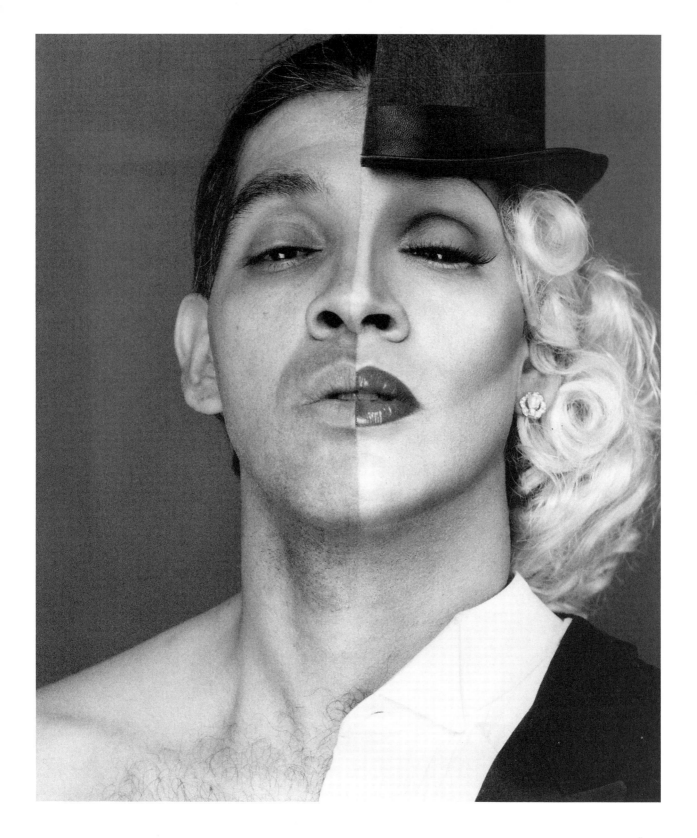

RC: I didn't believe I looked like her because of my dark olive complexion, and I'd never really given impersonating her any thought. Devon said that that's the whole idea of this book: if someone tells you you look like someone else, or you think you might be able to look like someone else, then try it. Even if you don't do such a great job of putting it together, at least it's still a lot of fun.

JF: Do you have to be a good actor to be Marlene Dietrich?

RC: I had to find that certain attitude Dietrich had or has onscreen and pick up the essence of her being and re-create that. I never did her before, so it was a mental thing to capture and portray her aura.

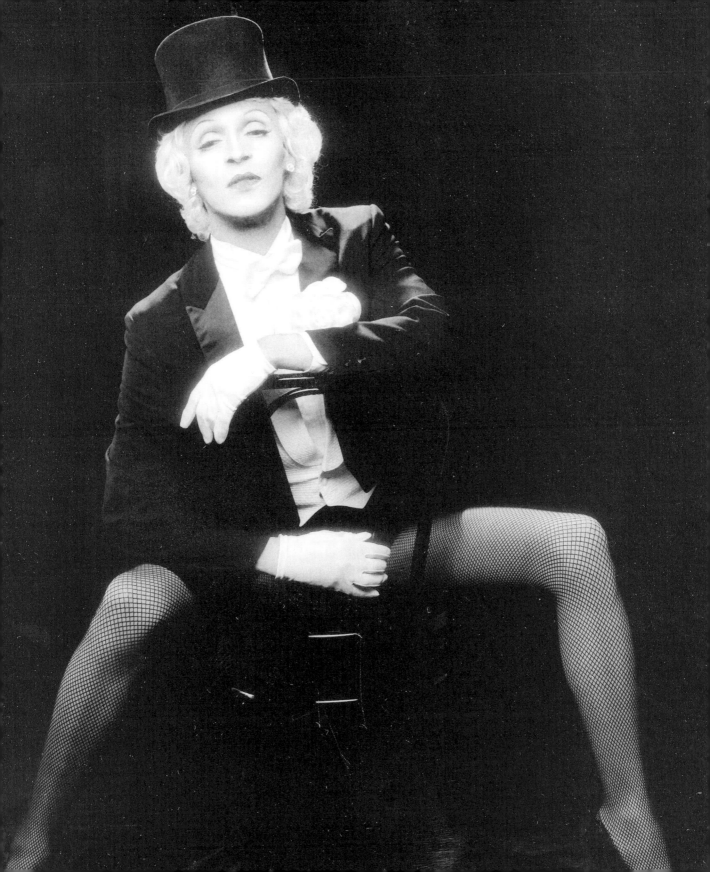

Jacquie Kendall first came into my life about eight years ago, around the same time that the idea for this book came to me. She's an actress and was a client who needed photos for her career. As the years went by we kept shooting publicity photos, and when she smiled during one of our sessions, I saw something there. She had Oprah's profile, but straight on—other than the smile—I didn't see much of a resemblance

When we did the shoot with the right clothes and the right wig, I was still a little hesitant, until I saw it come together. The wig is really important here. I learned that black textured hair is necessary because even if the wig has the right shape and coloring it won't create the illusion I want. Jacquie naturally has almost the same hazel eye color as Oprah, but Oprah wears contacts and Jacquie doesn't. I gave her nonprescription contacts because I wanted to capture the same look—the gleam that Oprah has in her eyes. It wouldn't be the same without it. Jacquie's eyes are closer together than Oprah's, but the shape is pretty much the same. Their noses are completely different, and I had to create the nose with makeup. Jacquie's mouth is close to Oprah's so they do have the same smile.

Oprah is very stylish and changes with the fashion trends, so something identifiable is necessary. Because she's visible every day on TV and has changed so much herself, I had to do an updated look: the after-the-weight-loss look with the modern suit, modern shoes, and the shorter hair with pared-down makeup. Actually, it would have been easier to do Oprah's eighties makeup because she wore so much of it and always had the big earrings and things, but it would have been the wrong look since Oprah's so different now. I decided on a turtleneck sweater and jacket—Oprah wears lots of turtlenecks—slightly flared pants, and either patent-leather or regular leather square-toed black shoes. Jacquie is such an actress that once she did the smile, put her arms up and out, and cocked her head just right, there were moments that were dead-on Oprah.

ROUND FACES DO OPRAH BEST!

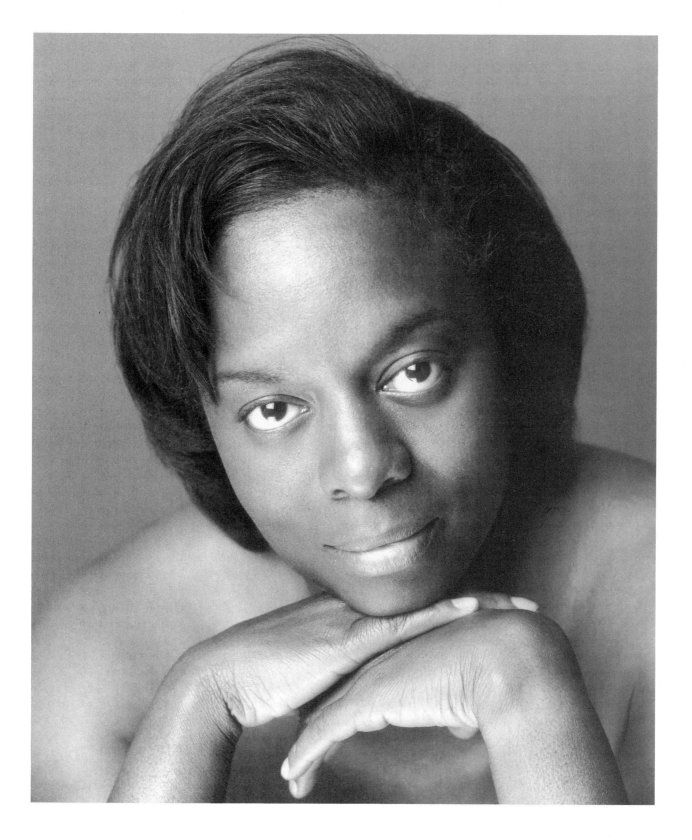

MANNEQUIN

OPRAH WINFREY

Oprah's style is always tops as she changes with the times. She likes quality and luxury, but never loses her down-to-earth attitude, even in the way she dresses. You should be honest and straight-forward, imitate her fair and extremely intelligent aura, and then Oprah's On!

CLOTHING

- Retro-looking, wide-lapeled bell bottom pantsuit with matching belt.
- White turtleneck sweater.
- Patent-leather, square-toed, medium-heeled, black ankle boots.
- Silver, heart-shaped dangle earrings.

EYELASHES

- Full black lash tips.

WIG

A black, short, layered shag, shoulder length in the back.

OPTIONS

- Long-sleeve tank dress with matching shoes.
- Wide-lapeled shirt with pantsuit.
- Glamorous, floor-length evening gown that reveals cleavage.
- Oprah's best colors are brown, wine, red, and fuchsia. For excitement add gold or silver highlights to Oprah's makeup.
- For camp, carry around a microphone.

EXPRESSIONS

Big, toothy grin.
"I'm a winner!" look.

OPRAH'S FAMOUS OPENING THEMES

"Get with the Program"
"I'm Every Woman"
"Oprah's On!"

HALF-FACE MAKEUP
JACQUELINE KENDALL
OPRAH WINFREY

America fell in love with Oprah Winfrey when her syndicated talk show hit the broadcast airwaves in the mid-eighties. She was a real woman's woman. She was overweight, down-to-earth, and easy to relate to. She shared the same everyday problems, hopes, and dreams as her audience—and more than anything, she wanted to help people. More than a decade later she still has the number one talk show in America and in some way has helped millions. A lot has changed though: Oprah is no longer overweight, she follows a rigid diet and exercise regimen, and makes herself over as often as she likes. You can make yourself over as Oprah. Here's how:

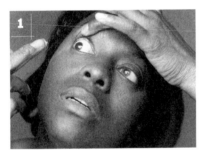
Start with hazel contacts, if desired.

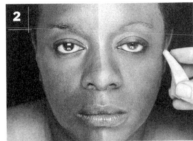
Oprah's complexion is dark to medium brown, so choose a foundation that best gives you her skin tone and apply with a sponge.

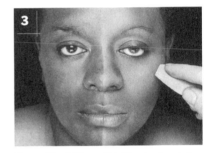
Now, add a lighter café latté color foundation to the cheekbone, chin, forehead, and bridge of the nose. Be sure to apply a light touch of this lighter color on the sides of the nostrils and the tip of the nose. Blend it into the darker foundation with a sponge.

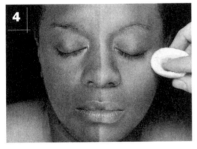
Use a translucent powder to hold it all in place. If you don't have a translucent powder, be sure to use a dark powder on the darker areas of the face and lighter powder on the highlighted areas. Apply with a powder puff.

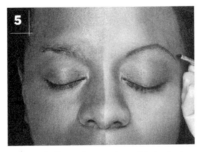
Next, arch the eyebrow using a black shadow and an eyebrow brush.

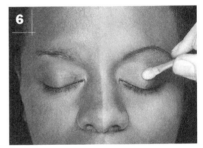
To create Oprah's wide-eyed look, use a cream-colored shadow applied with a sponge applicator. Start close to the nose; fill in the brow bone under the brow and cover half the eyelid, pressing hard near the nose and lighter toward the middle of the eyelid and brow bone.

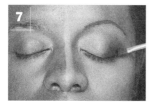

Now, use a brown shadow and a small eye shadow brush, starting where you stopped with the cream eye shadow on the eyelid. Blend where they meet and cover the rest of the eyelid in brown.

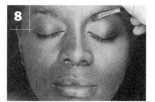

Do the nose now, because the look depends on the relationship between the eye and nose. With a small shadow brush and a light brown shadow, start next to the edge of the eyebrow and draw a line following the brow bone down to the top of the bridge of the nose, making it narrow there and wider as you move down to the nostril.

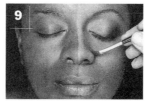

Without covering the lighter mix of foundation on the sides of the nostril and the tip of the nose, use a small eye shadow brush to outline the foundation of the nostril with the light brown shadow.

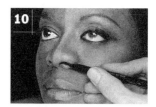

To create a wider nostril, use a black eyeliner pencil and draw a half-moon shape to outline the outside edge of the nostril.

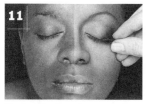

Now, go back to the eye and put a thick black false eyelash tip on the outer edge of the natural lash (see Devon's Recommendations, page 20).

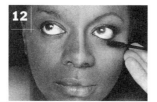

Use black mascara to mesh the top false and natural eyelashes (see Devon's Recommendations, page 21), and then apply mascara lightly to the bottom lashes.

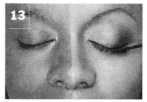

With a black liquid eyeliner, create a medium line following your lash line, starting near the nose all the way to the curve of the eye. Continue this line, making it thinner as you extend it to the end of the eye.

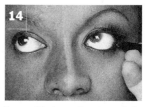

Use a black eyeliner pencil to color the bottom inside lash line.

It's time to contour the face. With a medium brown shadow and a contour brush, draw a line from the top of the ear out to the middle of the cheek. Also contour the jawline and temple to create a softer forehead and strong jaw.

Next, take a blush brush and tangerine blush to blend in all the medium brown contour lines for a more natural effect (see Devon's Recommendations, page 21).

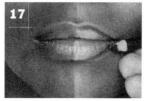

Now, for Oprah's expressive mouth, use a dark brown or burgundy lip liner pencil to draw in medium-size lips.

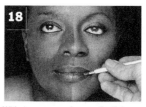

With a creamy brown lipstick or desired "Oprah" color and a lip brush, fill in Oprah's lips (see Devon's Recommendations, page 24).

JACQUELINE KENDALL GETS WITH THE PROGRAM!

Actress, Sky Goddess (translate as flight attendant), and Oprah! That's right, Jacquie K. is an Oprah Winfrey look-alike. Jacquie lives in Virginia Beach, Virginia, where she was born, and as yet has never met the queen of daytime TV. She says they do have certain things in common. They were both in Miss Black America contests (not at the same time). Oprah was Miss Tennessee, Jacquie was Miss Virginia, and both went to school at predominantly African American universities. But when it comes to turning herself into Oprah, Jacquie says it's all smoke and mirrors.

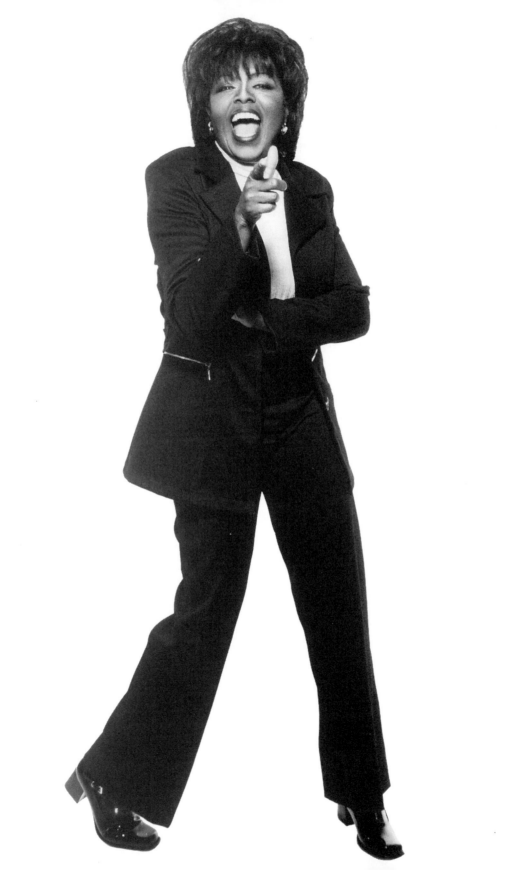

JK: I really didn't think I looked like her at all. But Devon did things with my nose, hair, and even used contacts in my eyes, though actually they aren't mine. I had to get an optometrist to show me how to put them in.

JF: So it's makeup magic that makes you look like Oprah?

JK: Oh yes. Her eyes are more droopy than mine; I'm very wide-eyed. My nose is thinned out just like her makeup artists do for her on TV, and I have very high cheekbones so they had to be contoured a bit. My mouth is thinned out a little to do Oprah, but we have the same complexion. My hair is also different.

JF: You have experience as a talk show host. With your acting ability, do you think you could pull off substituting for Oprah on her show?

JK: Next caller please! Seriously, I substituted for Joan Rivers after winning a life-swap contest from her show. I got to be a talk show host while Joan went flying.

JF: Were you shocked by the final result of your photo shoot?

JK: Amazed. I'm amazed at the power of makeup, the illusion you can create with makeup. It's really funny now when I look at people. It makes me think, Is that really them or is it makeup?

JF: Do you feel an obligation to uphold Oprah's image when you portray her?

JK: I do. I think I can carry it off. She's a fabulous woman, an entertainer, a philanthropist, and a good person, so I'd never do anything to shame or disgrace her. Harpo, I need a job!

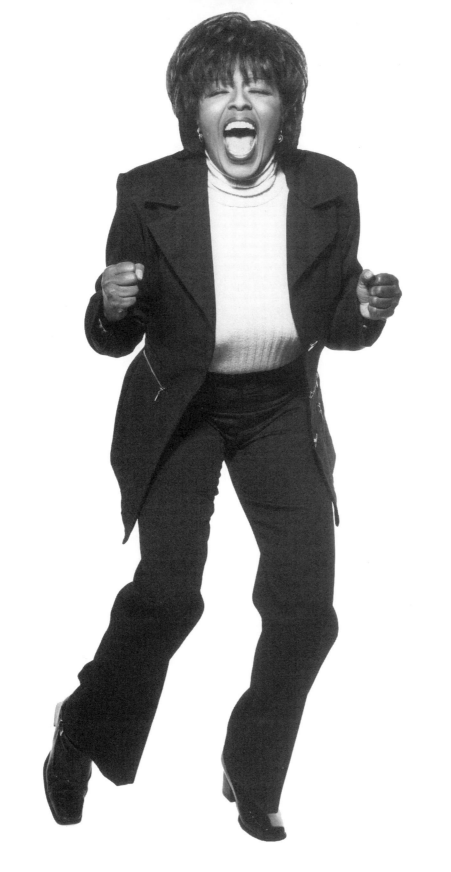

IMPRESSIONS OF
DEBORAH
CLAIRE TAGLIENTI

MARIAH CAREY

Deborah has such an interesting face. She can look like so many different people besides Mariah. She has angles that are dead-on Mariah, but at other times she looks like Dana Delany, who was in *Cliffhanger*. But with the long curly wig she's truly Mariah. Almost anybody can put on a wig like this and look like Mariah Carey.

As far as face shape, Deborah has Mariah's nose, mouth, and even her teeth and smile. The eyes are a little different but easily adjusted. I make them a little smaller actually. The rest is really angle and attitude.

I think Mariah's an easygoing person. Even though she can get hip, she does wear a lot of slip dresses that are simply elegant. That's why I chose this dress. It's not expensive—you can find a slip dress anywhere—and if you get the wig and some earrings, you can pull it off too.

MEDIUM-LENGTH NARROW
FACES DO MARIAH BEST!

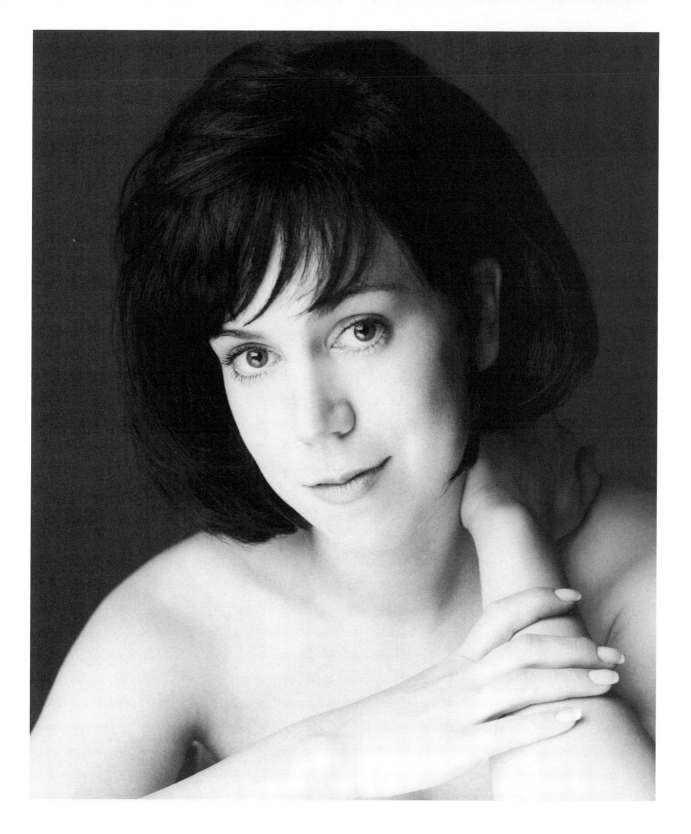

MANNEQUIN
MARIAH CAREY

Mariah Carey may have a powerful voice and a distinctive style, but her clothes are fairly simple and always sexy. She loves slip dresses and funky seventies looks with hats. You'll need to be a little understated, quiet, sweet, and shy to pull off this impersonation.

CLOTHING

- Ankle-length, spaghetti-strap black slip dress.
- Black patent-leather strap mules with wide heels and a medium-high platform.
- Simple teardrop rhinestone earrings.
- Two diamond wedding bands along with an engagement ring.
- Short fingernails with French manicure.

EYELASHES

- Short, spiky black lash tips.

WIG

A long, layered dirty-blond look with light blond highlights and Mariah's recognizable spiral curls.

OPTIONS

- Same color straight wig with bangs.
- Cutoff shorts.
- White cropped tank top with the midriff exposed.
- Hip-hugger bell bottoms.
- Seventies-style funky applejack hat.
- Platform shoes.
- Mariah's favorite colors include light praline, orange-frost red, and burgundy.

BEST SONGS TO PERFORM

"Make It Happen"
"Dream Lover"
"One Sweet Day"
"Hero"
"Honey"

HALF-FACE MAKEUP

DEBORAH CLAIRE TAGLIENTI

MARIAH CAREY

Mariah Carey could easily call the nineties her decade. She stormed on the music scene with a multioctave range reminiscent of seventies diva Minnie Ripperton, and like Ripperton, Carey can serve up a sad ballad as easily as a saucy beat. Mariah's look is as distinctive as her voice. Here's how you can copy it:

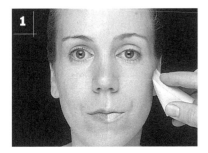

With a sponge, apply a medium dark beige foundation on the face and set it with translucent powder using a powder puff.

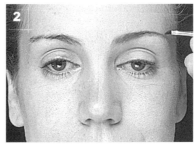

Draw in an arched brow that's thicker near the nose and thinner at the arch and out. Use a dark brown shadow and a small eyebrow brush.

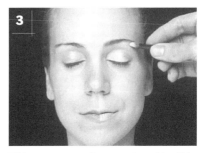

With a sponge applicator and a white highlighting shadow, cover the brow bone under the brow and all of the eyelid.

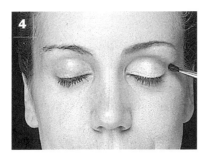

With a small eye shadow brush put medium brown eye shadow in the crease of the lid, making it softer as you move out toward the temple.

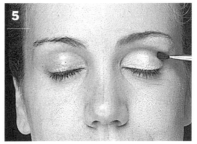

With an eye shadow brush and a coppertone-colored shadow, blend with the medium brown shadow in the crease.

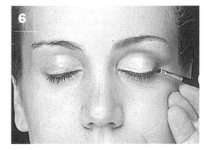

Next, use a small, beveled brow brush and charcoal shadow to enhance the lash line. Starting in the center of the lash line, draw a very thin line, making it thicker as you move toward the outer edge of the eye, and then thin again as you move out and up toward the temple. End the line in a point.

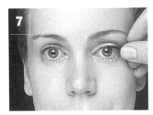

Glue a black, false spiky eyelash tip on the outer edge of your natural lashes.

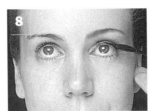

Mesh the lash tip with your natural lashes using black mascara. Be sure to apply a thin mascara coat to your bottom natural lashes as well (see Devon's Recommendations, page 21).

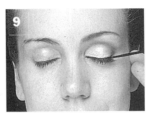

Now, with black liquid eyeliner, draw a very thin line across the entire lash line.

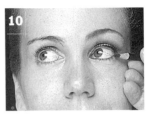

With a black eyeliner pencil, line the bottom inner lash line.

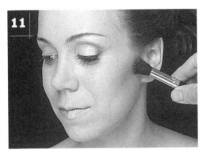

Take a contour brush and a medium brown shadow to draw a thin, light line from the upper edge of the ear to the middle of the cheek. Contour jaw if necessary

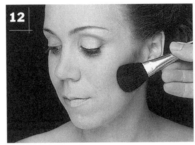

With blush brush and a coppertone-colored blush, blend all brown contour lines for a more natural look (see Devon's Recommendations, page 21).

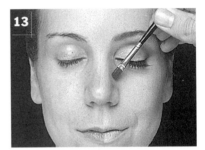

With a medium brown shadow and small eye shadow brush, draw a line straight down along the outer side of the nose bridge. (For a wider or narrower nose, see Devon's Recommendations, pages 22–23.)

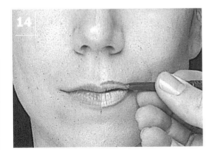

Next, use a medium brown lip liner pencil to draw on Mariah's thin lips (see Devon's Recommendations, page 24).

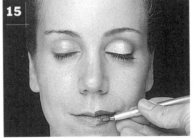

Using a lip brush, fill the lips in with a medium brown matte lipstick or other "Mariah" color.

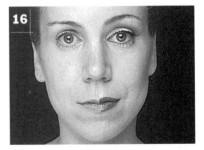

For Mariah's beauty mark, take a medium brown eyeliner pencil and simply draw in the little dot on the left side of the chin.

MY, MY MARIAH!

Deborah Claire Taglienti (the "g" is silent) lives in Silver Spring, Maryland. She's originally a West Coast girl from Walnut Creek, near San Francisco, California. She's married and is an actress, who, believe it or not, says she doesn't sing. That's too bad because she is an amazing double for Mariah Carey. Picture the face that graced the cover of *People* magazine and you have Deborah. Taglienti says impersonating Mariah Carey is a new challenge for her, but it's a challenge that she's meeting with a little help from her friends.

DT: I was visiting New York, walking down the street and minding my own business when this guy, a perfect stranger, walks up to me and says, "Has anyone ever told you that you have a mouth and a nose similar to Mariah Carey?" I was like, "Only in New York! Who is this guy?" I used to have short dark hair and I thought he was absolutely nuts. Well, this guy was Devon, and he explained what he

was doing and asked me if I wanted to be part of this book project. The actress in me said, "Go for it," and now I have a whole new career.

JF: Are you a Mariah Carey fan?

DT: Oh, yes. I do collect pictures of her because now I'm trying to perfect my impersonation of her. I do have a couple of her CDs, but I'm not obsessed. [*Laughs.*]

JF: What have you learned about Mariah since becoming more interested in her? Do you share any similarities that aren't physical?

DT: I think she's half Irish and half Venezuelan, while I'm French American. We both love animals. Her parents are divorced and so are mine. She was very poor growing up, while my family wasn't so bad off. Her former husband's Italian, as is my husband.

JF: Has anything exciting happened since you started impersonating Mariah Carey?

DT: I was a semifinalist in an MGM Grand look-alike contest in Las Vegas. We just kind of paraded around for the judges; we didn't have to sing or lip-synch, but I would like to perform as Mariah. Since I don't sing it would have to be a lip-synch performance, but it would be thrilling to experience what a singer feels onstage before crowds of people.

IMPRESSIONS OF
JOSEPH HOPE
EDDIE MURPHY

I was going to see a movie in New York, when I saw Joe and could not pass up the opportunity to talk to him. I went up to him and said, "Has anybody ever told you that you look like Eddie Murphy?" He was with his girl-friend going to see a movie and a stranger comes up to him as he's salting his popcorn! He looked at me like I was insane. But I could really see Eddie in his face, particularly when he smiles. He laughs like him too.

Joe can act like Eddie too. He's got great comedic timing and can create the expressions. Luckily, Eddie's a man who wears makeup. He wears foundation and always makes sure his facial hair, eyebrows, mustache, and sideburns are groomed. If you don't particularly have eyes like Eddie's, like Joe, then you can wear sunglasses. Joe's lips are a little bigger than Eddie's, but Eddie has a very large mustache so I extend Joe's mustache down on the lip with makeup. I draw in the little V-shaped fly under the center of the mouth and draw in the sideburns too. I also arch the eyebrow more to look like Eddie's.

I picked a *Boomerang*-inspired look because it's easy. It's just a black suit with a black mock-turtleneck shirt.

NARROW TO SOMEWHAT WIDE, MEDIUM-LONG FACES DO EDDIE BEST!

MANNEQUIN

EDDIE MURPHY

Tailored, cool, classy, sophistication. That's how to sum up Eddie Murphy's style. This sarcastic, funny man is sometimes raw, sometimes charming, but he's always animated and can be flamboyant when he wants to. You can be like Eddie in this outfit.

CLOTHING

- Black suit with black turtle-neck sweater.
- Sophisticated, heavy, black dress boots.
- Black leather belt with silver buckle.
- Silver sunglasses.
- Silver earring in left ear.

OPTIONS

- Red jacket with black shirt and black pants.
- Black suit with purple shirt.
- Black leather pants with red leather bomber jacket.
- Lycra workout wear. (If you have Eddie's body!)
- Sneakers or dress shoes.
- Silver or gold rings.
- Silver or gold chain bracelet.
- Rolex watch.

EXPRESSIONS

Suave and debonair.
Surprised.
Wide smile.
Annoying, loud laugh.

BEST SONGS TO PERFORM

"Party All the Time"–his one big hit
Lip-synch to monologues from stand-up routines such as "Raw"

HALF-FACE MAKEUP
JOSEPH HOPE
EDDIE MURPHY

He's a well-groomed class act with a wild imagination, razor-sharp wit, and an outrageous sense of humor. Eddie Murphy has it all with his winning smile and that signature laugh. Imitate Eddie by following these suggestions:

With a sponge, use a medium brown foundation to cover the face and translucent powder applied with a powder puff to hold it in place.

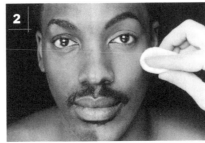

Using a powder puff and light brown powder, highlight the cheek, forehead, and chin.

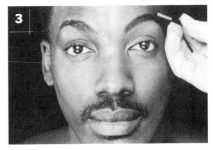

With an eyebrow brush and black eye shadow, create Eddie's high, arched eyebrow. Partially paste down your natural brow if necessary (see Devon's Recommendations, page 19).

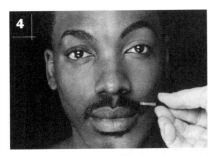

Paste down, or trim, a small V-shaped portion of the mustache directly under the nose. (If you don't have a mustache, buy a false one at a costume shop.) Be sure that the mustache reaches down past the corner of the mouth. Now, with black eye shadow and a brow brush, shape and thicken the mustache (refer to Devon's Recommendations page 18 for paste down technique).

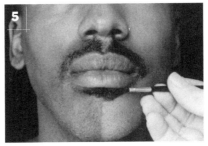

Using black eye shadow and a beveled shadow brush, create a small V-shaped hairline under the lower lip.

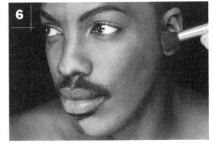

With a contour brush and a medium brown shadow, draw a line from the edge of the upper ear straight to the corner of the mouth. Be sure to contour the jawline and temple too, to strengthen the jawline and soften the forehead.

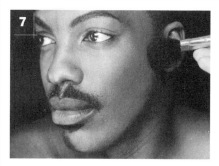

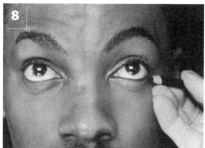

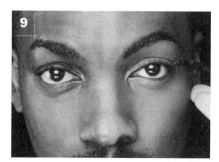

With a large blush brush and a coppertone-colored blush, blend in the contour lines for a more natural appearance (see Devon's Recommendations, page 21).

With a black eyeliner pencil, draw a line under the top eyelashes and line the bottom inner lash line.

Use black mascara for both the top and bottom lashes. The bottom lashes need only a light coating.

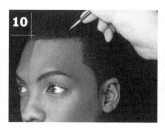

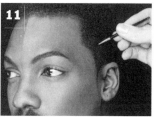

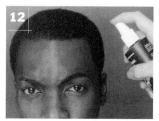

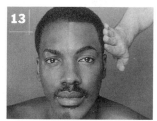

Create Eddie's sculpted hairline using an eyebrow brush and black eye shadow.

Repeat the procedure to create Eddie's sideburns.

Use hairspray to square off the hair on the side of the head.

Pat the sides down with your hand to flatten the hair, or use a hair trimmer to thin out the sides to create what's called a "fade."

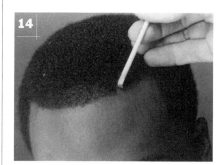

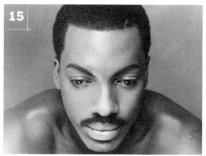

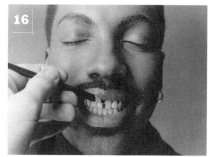

Make a fake short part in the hair by using a cuticle stick with a medium brown foundation. Draw a three-quarter-inch line onto the hair starting at the forehead and extending the line back, or create the part with a hair trimmer.

Compare with this demonstration photo.

For the space between Eddie's two front teeth you need to use a black eyeliner pencil. Be sure the teeth are dry and free from saliva, then simply outline both sides of the natural separation between the two. For a more lasting effect, get black teeth paint at a costume shop.

THERE'S "HOPE" WHEN IT COMES TO EDDIE!

Twenty-eight-year-old Joseph Hope hails from Jamaica, New York. That's Queens to locals. He says ever since he was a teenager people have been mistaking him for Eddie Murphy. He says it's flattering and all, but there have been times when he's been knocked down, pushed around, and even punched because he resembles the superstar. Hope is a cutup himself, but says there's nothing funny about getting beaten up. He's the first to admit that he laughed it off, chalking it up to experience that he can use when it comes time to impersonate a man he truly admires.

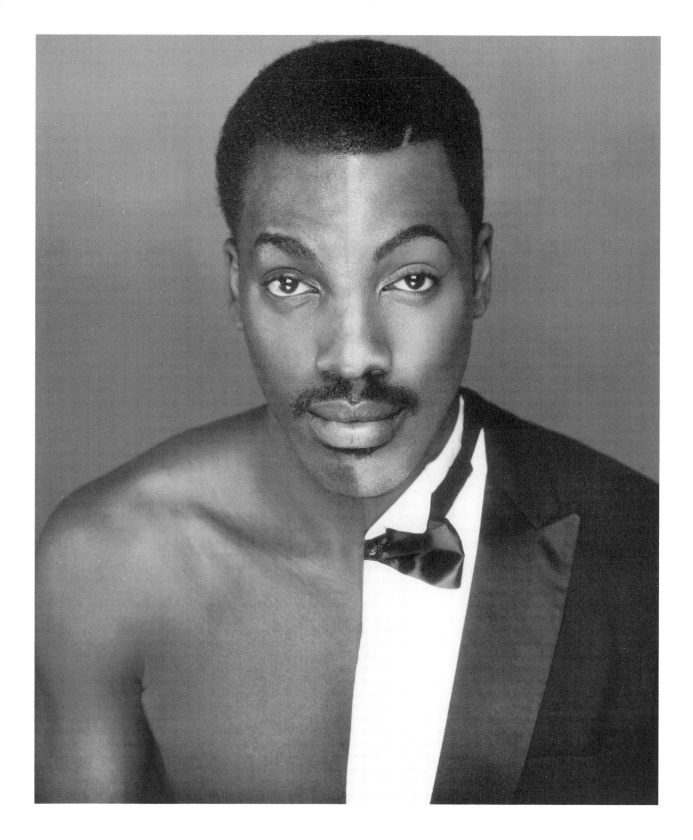

JH: I do admire him and would love to meet him, though we'd have to talk about all those times I was mistaken for him. The one time I'll never forget was when this guy came up to me and punched me in the face; then after he looked at me really close he apologized and bought me drinks. I asked him why he hit me and he said Eddie Murphy had stolen his girlfriend from him.

JF: Do you like getting made up as Eddie?

JH: Yeah, because then I really look like him, and I'm not embarrassed about it. I've always wanted to be in front of the camera and I think I sort of have his character in me anyway. My whole family has always said I'm pretty funny and a character myself, so I don't really have to do much acting.

JF: Do you think that you both have quiet sides?

JH: Yeah, like now he's a family man and he's with his wife and kids a lot, and I'm the same way. I have a son whom I love. I was married for five years, and I love to be home with my son if I'm not working. You know how they say everybody looks like somebody, that everybody has a double out there somewhere. Well, I think Eddie's mine.

IMPRESSIONS OF
MAE BONO
ROSIE O'DONNELL

Interestingly enough, a week before the book was to go into production Mae called me and said she was a Rosie O'Donnell look-alike. She said she wanted pictures so she could try to get impersonation work. I was very excited because up until this point I couldn't find a Rosie suitable for the book. So we scheduled an appointment and when she arrived on the day of the shoot, at first glance I had my doubts that she could pull it off. Mae's hair is a different color, and style, so we started by putting a wig on her and styling it the way Rosie wears her hair for her TV show. There was a resemblance but it was obvious that she wasn't Rosie. So, I decided to continue by doing the dressed-down Rosie look on Mae. We were getting warmer. Putting the beret-like hat on backward, with a casual outfit, started to bring Rosie to life. But it wasn't until Mae put on the dark sunglasses that I felt Rosie was standing right there with me. With the hat and glasses I was really able to see Rosie's facial features in Mae, especially her nose, mouth, and jawline. It always amazes me that in some circumstances props or accessories can make all the difference.

FULL, ROUND TO SQUARE FACES
DO ROSIE BEST!

MANNEQUIN
ROSIE O'DONNELL

She can be sophisticated, even glamorous, but says she feels most comfortable in casual, dressed-down clothes. Rosie O'Donnell is warm, witty, and wonderfully funny. She likes to wear a suit for work, but on Fridays she goes for jeans and a comfortable shirt. It's playtime attire and that's one way to describe what Rosie's all about, making her job seem like child's play. You can blur the line between Rosie's totally laid-back looks and her chic pantsuits by following these suggestions.

CLOTHING

- A black pantsuit, either single or double breasted.
- A white, wide-collared button-down blouse.
- Black lace-up oxfords.
- A black wool, short-brimmed beret-style cap, worn backward.
- Dark "Blues Brothers" shades.

EYELASHES

- Short, spiky black lash tips.

WIG

A dark brown, layered-to-the-shoulder wig worn behind the ears and under the hat.

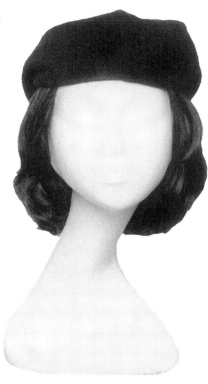

OPTIONS

- Same style wig but lighter with highlights.
- Every and any color pantsuit worn with coordinated blouse and black shoes.
- Jewel neck T-shirts under suit jackets.
- Black ankle boots.
- Jeans and baggy button-down shirts for the casual look.
- Any color sweat suit.
- Baseball cap worn backward.
- The Betty Rubble look from *The Flintstones*.
- A complete baseball outfit from *A League of Their Own*.
- Always carry little can of Altoids breath mints.
- Don't forget the "Kooszh" balls and sling shot.

- Carry the *Kids Are Funny* book and refer to it.

EXPRESSIONS

Puckers her lips.
Grimaces.
Wide toothy smile.
Silly faces.

FAMOUS QUOTES

Betty Rubble Giggle
"You rock"
"Rockin'"
"Right, right?"
"Nicole who?"

BEST SONGS TO PERFORM

"Tommy, Can You Hear Me"—From rock opera *Tommy*, for her "boyfriend" Tom Cruise
Any Broadway show tune, especially from *Grease*. (Rosie played Rizzo.)

HALF-FACE MAKEUP
ROSIE O'DONNELL
MAE BONO

Rosie doesn't have to rely on makeup to make her day. She's comfortable with a minimal amount of fuss. She's got great skin and thick hair to help her through. To polish the Rosie illusion follow these few steps:

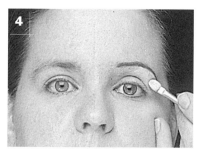

Partially paste down eyebrow with glue from glue stick applied with a cuticle stick (see Devon's Recommendations, page 19).

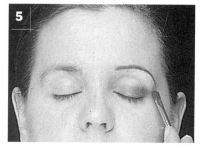

With a light beige foundation cover entire face and partially pasted-down brow using a facial sponge. Set foundation in place with a translucent powder applied with a powder puff.

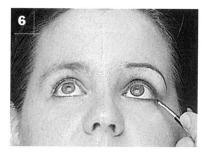

Create Rosie's thin and slightly arched brow using a dark brown eye shadow drawn on with a beveled eyebrow brush.

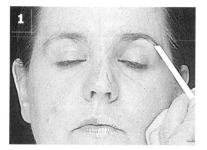

Using a sponge applicator, take a white cream shadow and cover the part of the brow you pasted down and the brow bone all the way down to the crease of the eye.

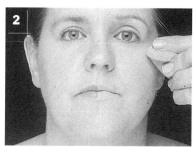

With a medium brown shadow, cover the entire eyelid into the crease of the eye, blending it into the cream color without extending the brown shadow onto the brow bone using a small eye shadow brush.

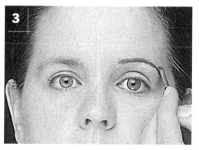

Use a small beveled eyebrow brush and the same medium brown shadow to draw a thin line following your natural bottom eyelash line.

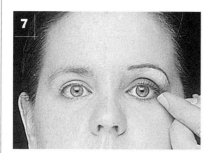

Apply a small, black spiked lash tip to the outer edge of your natural eyelashes.

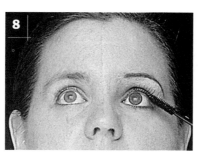

Mesh the false lash tip with your natural lashes, using black mascara. Be sure to lightly apply black mascara to your bottom natural lashes (see Devon's Recommendations, page 21).

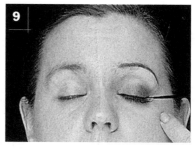

Using a black liquid eyeliner, draw a thin line across your upper natural lash line, starting from the inner eye near the nose and working toward the outer edge, ending in a point.

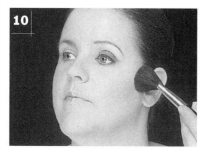

With a blush brush and coppertone colored shadow, dust the cheek from the ear to the apple of the cheek. Also dust under the chin.

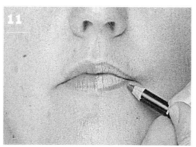

Create Rosie's wafer-thin lips by drawing them on with a burgundy lip liner pencil (see Devon's Recommendations, page 24).

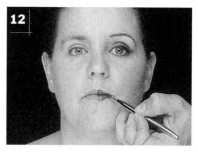

Now, using a lip brush, fill in the lips with a red creamy lipstick.

EVERYTHING'S
COMING UP
ROSIE!

And there's hardly a soul who knows that better than Mae Bono. This Connecticut deejay and talent booking agent is on a roll playing up anything and everything she has in common with the talented comedienne, movie star, and television talk show hostess. Bono, not related to you know who, is the same age and body type as Rosie, and has Rosie's winning smile, expressions, and stage personality. Like Rosie, Bono even did stand-up comedy in L.A. for several years before deciding the New York area is where she'd rather stay. Bono also came up with the heading for this little conversation. It seems she always has Rosie on her mind.

Bono was born in Norwalk, Connecticut, and now lives in Westport. She says that while the comparisons come at her daily now that Rosie is a hot commodity, she never thought she'd actually be impersonating the new star of daytime TV.

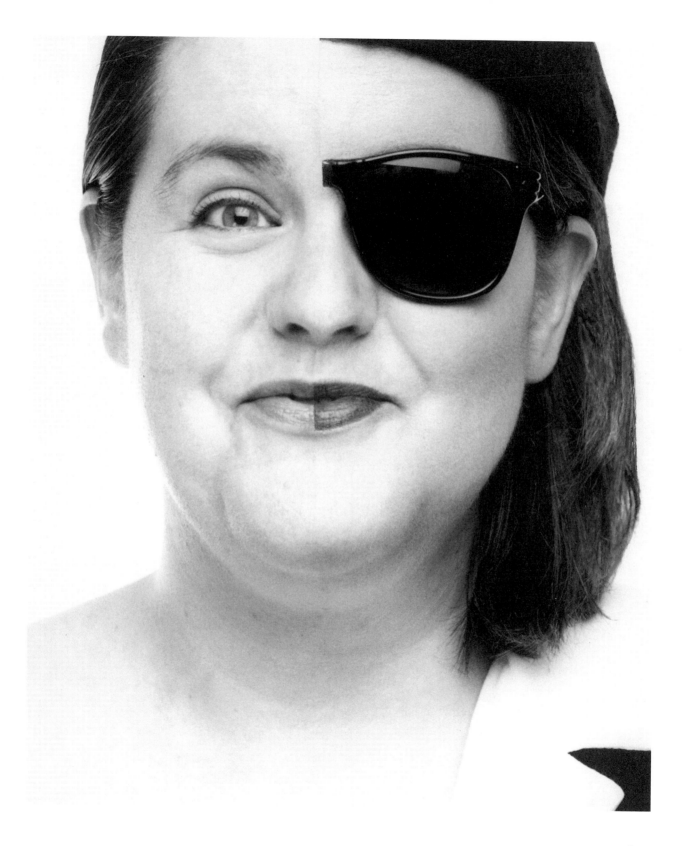

MB: I've been a fan of hers since I saw her on *Star Search* about nine years ago. We were both about twenty-six or twenty-seven then, and I mean there was just something very likable about her. Once I started deejaying, people began saying, "Oh, you look like Rosie O'Donnell," and you know to a certain degree I really didn't see it, but by the end of nearly every job everybody was saying, "Bye, Rosie"; you know,

"Thanks a lot, Rosie." So then I met up with a girl who does Roseanne Barr and she put me in touch with Devon just to get pictures so I could get work as a Rosie look-alike. Then about a week after we'd done the shoot, he called me to say he wanted me for this book. I was psyched. I think it's just so exciting because you're sort of immortalized in a way. I'm so happy.

JF: So it was fate?

MB: I always say everything happens for a reason, so it just worked out.

JF: It takes a little work for you to get the Rosie look really working, though?

MB: Yes, the makeup and wardrobe help me to look more like her. Our hair colors are different, hers is darker and the hairstyle is different too, so I wear a wig. The glasses and hat really help too. Physically we resemble each other but I have to wear brown contacts because my eyes are green. Her expressions are easy for me too—I have her sarcastic sense of humor, I think. I always have to have the last say.

JF: Rosie can be glamorous too?

MB: Oh yes. She was when she hosted the Tony awards, but I think, like myself, she's more comfortable being dressed-down. I mean everything she does onstage is very big and very physical, so if she was confined by her clothes she might feel more uptight.

JF: Anything you'd like to leave with the readers of the book about Mae Bono?

MB: Just that I really like to have a good time. I plan things so that I always have something to look forward to, and that I enjoy who I am and being with other people and making them laugh and making them happy. Also, that this started out as a goof. I'm not stalking Rosie or anything. I don't want her job, well, okay maybe that would be nice. . .

IMPRESSIONS OF
CHE-CHE ADAMI
FRAN DRESCHER

Fran Drescher has been popular for quite a while, but I was never a big fan of her show, *The Nanny*. Now, I'm hooked on the show and hooked on Fran. I was thrilled to find someone like Che-Che who can really be transformed into this hot actress.

I first talked to Che-Che on the phone and it was unbelievable. She sounds exactly like Fran Drescher. When I met her, I saw the resemblance but wasn't totally convinced she was Fran until I drew in the V-shaped hairline, that widow's peak that is so much a part of Fran's look. It actually changes the impression of the bone structure of the rest of the face. Che-Che has Fran's nose and her smile. I make Che-Che's eyes more catlike because Fran has somewhat slitty eyes.

I chose a little bit of an over-the-top outfit, kind of what The Nanny would wear. It includes a leopard print minidress and jacket, high heels, and big hair. Just get the whine down like Che-Che has done, and go out and have fun.

WIDE, HEART-SHAPED
TO SQUARE FACES
DO FRAN BEST!

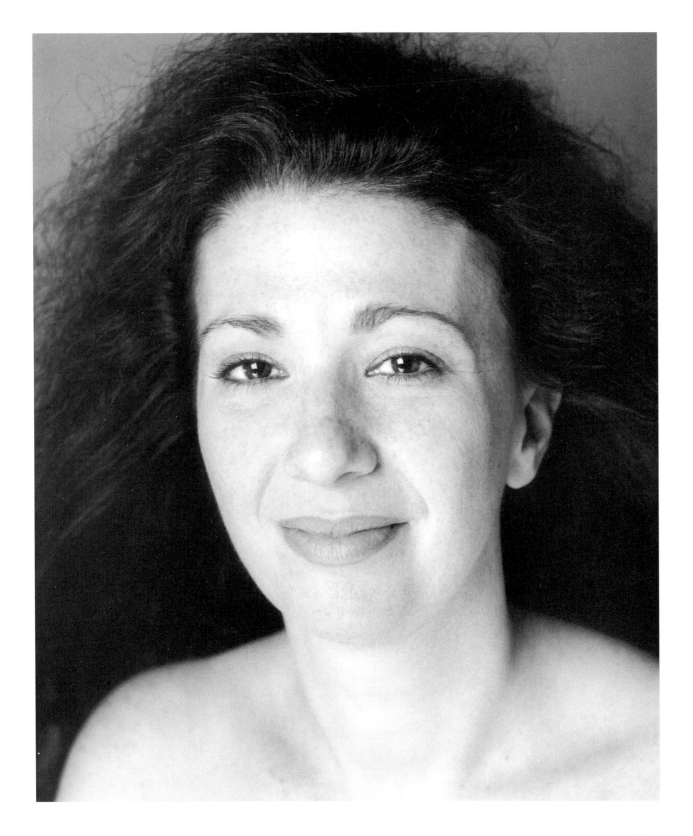

MANNEQUIN

FRAN DRESCHER

W hatever she wears, it's sure to make a statement, but you can't become Fran Drescher without acting a little irreverent. You'll have to whine quite a bit and talk through your nose, but above all have fun.

CLOTHING

- Leopard-print mini tank dress.
- Matching leopard-print jacket.
- Two matching bracelets worn on the same arm.
- Black patent leather high-heeled pumps.

EYELASHES

- Short, spiky black lash tips.

WIG

Long, semiwavy black hair that's layered at the bottom with pinned-up top layers and tendrils hair hanging down.

OPTIONS

- Any animal-print or wild-print short dress or skirt with blouse. (You can mix prints with vibrant solids too.)
- Spandex outfit in any wild print, animal print, or vibrant solid color.
- Day suit with animal-print collar and cuffs.

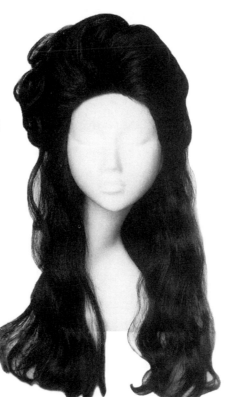

- Black leather (goes nicely with prints and bright colors).
- Mid-calf suede or leather boots.

EXPRESSIONS

Squints and sneers at the same time.
Wide-mouthed annoying laugh.

FAMOUS QUOTES

"You look good, you feel good."
"Mr. Sheffield!" (whine)
"Maahhhh!" (whine)
Any whine!

HALF-FACE MAKEUP
CHE-CHE ADAMI
FRAN DRESCHER

Vibrantly colorful and outrageously unique, Fran Drescher is one woman who stands out in a crowd. You'll stand out and be striking wherever you go if you follow these simple makeup steps:

Cover your face with a light beige foundation and set in place with translucent powder using a sponge then powder puff.

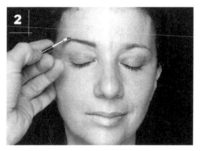

With an eyebrow brush and black shadow, draw a long brow that arches at the end. (If you have to paste down a portion of your brow, see Devon's Recommendations, page 19.)

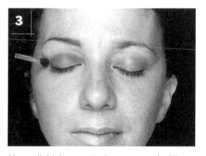

Use a light brown shadow now, and with an eye shadow brush cover the entire lid, ending in a point as you move out from the eye and up toward the temple.

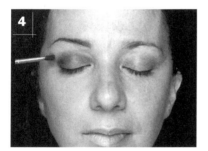

Take a dark brown shadow and eye shadow brush to apply the shadow to the outer corner of the eye. Make sure the shadow is darker in the corner and lighter as you move out and up toward the temple.

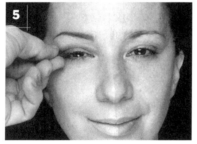

Glue a short, spiky black lash tip to the outer edges of your top natural lashes.

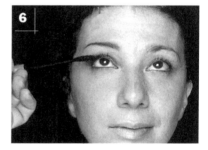

Use black mascara to mesh the false tip with your natural lashes (see Devon's Recommendations, page 21). Lightly put mascara on the bottom natural lashes.

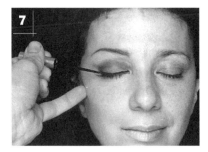

Draw a thin line along the upper lash line with black liquid eyeliner.

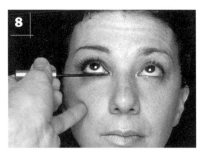

With the same black liquid eyeliner accentuate the natural V shape at the inner corner of the eye and extend a very soft, thin line all the way across the bottom inner lash line.

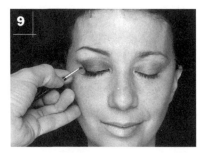

Take a beveled eyebrow brush and black shadow and draw a very small line from the outer edge of the upper lash line into the outer corner of the eye.

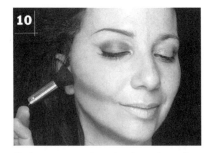

Next, use a contour brush and medium brown shadow to draw a line from the middle of the ear down to the mouth. Be sure to lessen the pressure as you move toward the mouth. Also, contour the jawline for a stronger jaw (see Devon's Recommendations, page 21).

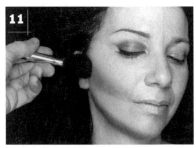

Using a blush brush and coppertone-colored or light red blush, blend all contour lines. (For the cheek don't extend the blush too far up past the contour line, because you want to keep a definite, full cheek.) If you need a wider nose, see Devon's Recommendations, page 23.

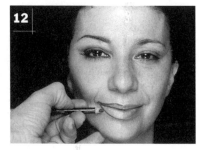

With a burgundy lip liner pencil, draw in Fran's full, arched lips.

Now, using a lip brush, fill in the lips with red lipstick.

To create Fran's widow's peak, use a black shadow and eye shadow brush to draw a V-shaped hairline down into the center of the forehead. (This is very important for a true impersonation of Fran Drescher.)

DISHING UP
DRESCHER!

They look alike, they walk alike, and, yes, they even talk alike. You can lose your mind because Che-Che Adami and Fran Drescher are two of a kind. They're even the same age and both are Jewish. Fran's from Queens and Che-Che was born and lives in Brooklyn, New York. Fran of course is a comedienne and TV star, and Che-Che is a housewife and mother of three who sells jewelry for a living. But that all could change now that the "Mommy" is looking more like the "Nanny" every day.

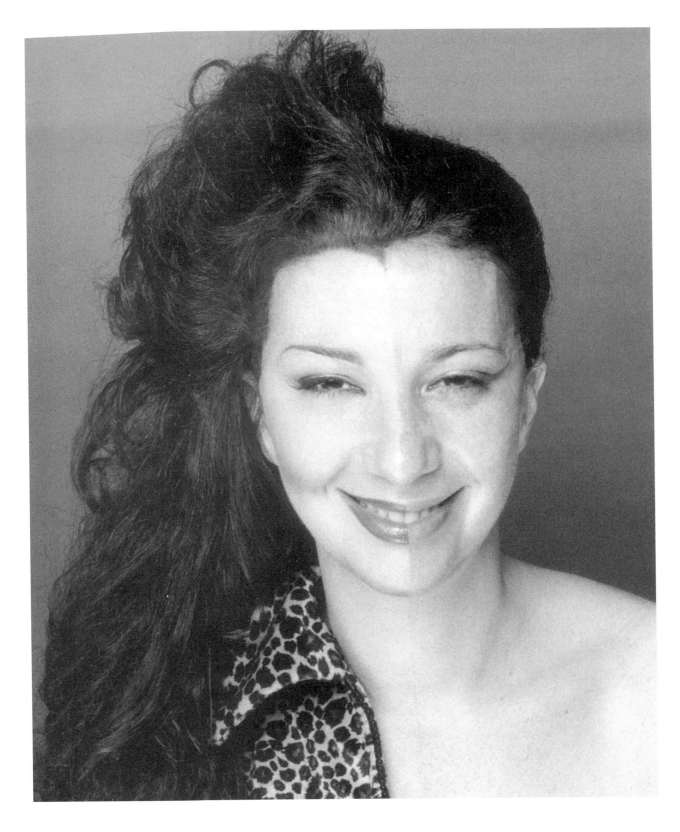

CA: I'd heard about her when I was in high school, that these two girls, Fran and her sister, sounded like me and looked like me, and do I know them and are they related. Then I was cooking dinner one night when my husband called me to see this woman on TV. He said she looks just like me. I said to leave me alone, that I'm busy. So, it took another month for me to watch the show, and once I saw *The Nanny* I realized that, yes, she does look like me.

JF: "She" looks like "you"?

CA: Yes, but if I ever met her I'd tell her to eat a little bit more. [*Laughs.*] I'd say, "You're so skinny, you make me look fat."

JF: Doesn't doing an impersonation mean more than just looking like someone?

CA: Oh yes, I mean I get the comparison at least five or six times a day when I'm just being myself—you know, people come over and say, "Oh my God, do you know you sound, no you look, no you look and you sound . . ." It's funny, the more popular she gets the more popular I get.

JF: So what is it you like most about the finished illusion?

CA: I get free pizza, I get into restaurants. [*Laughs.*] I know what it feels like to be a star without being one. I never knew New York was this friendly.

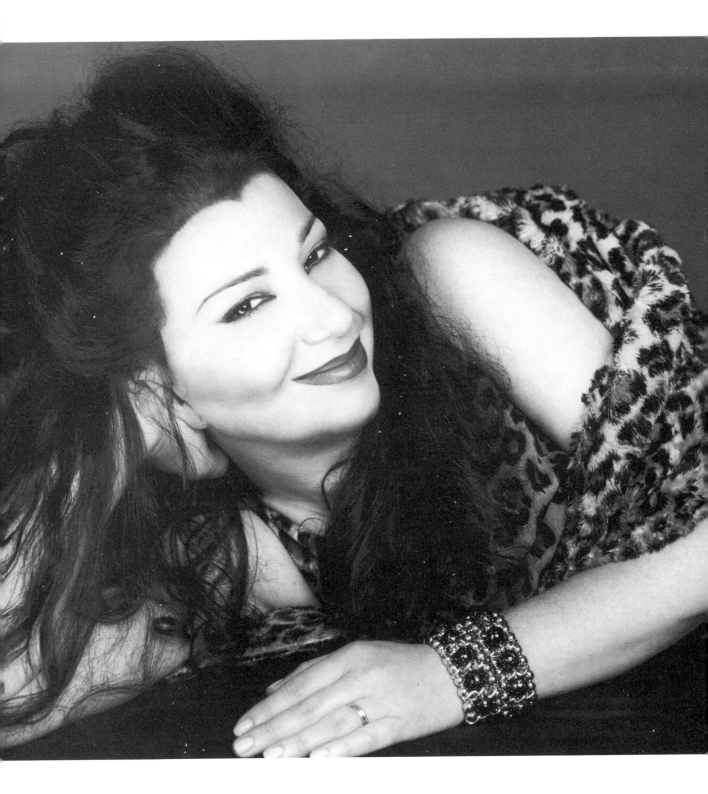

My first impression of Marlene was the most unusual, because she, of all the people whom I selected to work with, actually fooled me. I totally believed she was the real Gloria Estefan. I met Marlene about four years ago on *The Montel Williams Show*. I had met Gloria Estefan about four years prior to this TV appearance, and I went up to Marlene thinking that she was Gloria and booked for the show. I asked her if she remembered meeting me in Miami when my friend was performing in the *La Cage* show at Fountainebleau, and she said she didn't, so I thought she was just being rude because she didn't like drag queens or something. I walked away but kept listening to her talk to others on the show that day, and when I realized that she wasn't Gloria but was herself an impersonator, I was slightly embarrassed because I had never been fooled before that. Marlene is the closest I've ever seen to someone's having a double in life and not being an identical twin—or even related, for that matter. I mean right down to the same size, body shape, weight, hair, and eye color—you name it. The only thing that she doesn't have that Gloria Estefan has (aside from the money) is the mole—or beauty mark—underneath the eye, but that's easily rectified with just an eyeliner pencil.

Marlene's features are pretty uncanny. So, one of the reasons I went with the red hair and the silver dress was that I had shot another Gloria impersonator with this look, and it was one hundred percent Gloria!

HEART-SHAPED
OR ROUNDER FACES
DO GLORIA BEST!

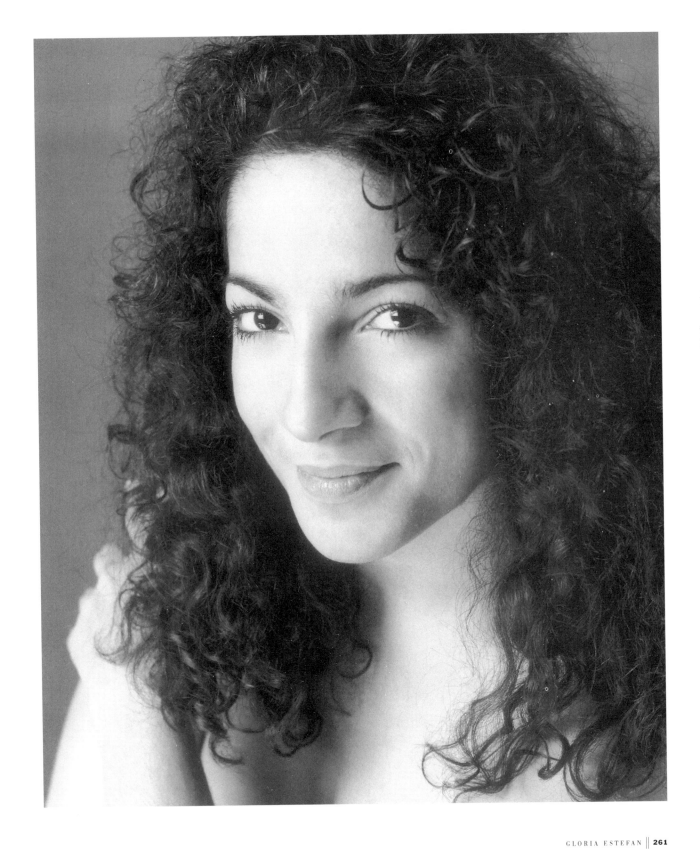

MANNEQUIN

GLORIA ESTEFAN

She's upbeat and perky with an understated style that goes from simple to salsa to glamorous. She's a family woman with love that overflows for her husband and children, yet there's plenty left for her millions of fans around the world.

Don't be afraid to be outgoing, and it wouldn't hurt to learn a little Spanish!

CLOTHING

- Fitted silver lamé evening gown with halter top and flared bottom.
- Silver ankle-strap high heels.
- Simple rhinestone stud earrings.

WIG

Long, straight, red, layered look that falls to the shoulders, and is parted on the top left side.

OPTIONS

- Curly brown wig.
- Forties-style curly brown wig, parted in the middle and pulled back for the "Mi Tierra" look.
- Bell bottoms and funky bare-midriff cropped top, for a seventies retro look.
- Tight blue jeans, cropped top, and bolero jacket for an eighties look.
- High-heeled pumps.
- Ankle boots.

BEST SONGS TO PERFORM

"Conga"
"Get on Your Feet"
"Rhythm Is Gonna Get You"
"Mi Tierra"
"Reach"
"1, 2, 3"
"Turn the Beat Around"

HALF-FACE MAKEUP
MARLENE SUAREZ
GLORIA ESTEFAN

Gloria Estefan is one of the most popular crossover artists in the world. One minute she's singing a sad ballad in Spanish, the next it's a pop song in English, with or without a dance-evoking salsa beat. Estefan transcends nationality and race the same way she defies music categories. She uses the universal language to bring people together. You can imitate this one-woman peace ambassador by following these guidelines:

A medium beige foundation will give you Gloria's silky complexion. Translucent powder keeps it in place. Apply the foundation with sponge; the powder with a puff.

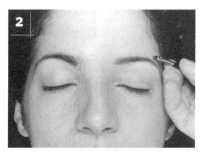

Next, with a dark brown eye shadow and eyebrow brush, create a clean, thin eyebrow.

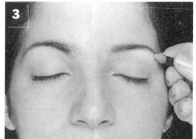

A cream-colored eye shadow will fill in the brow bone nicely when applied directly beneath the brow with a sponge applicator.

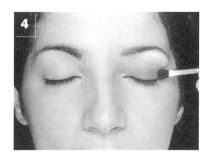

Now use a medium brown eye shadow with a small eye shadow brush to fill in the eyelid, starting from the inner part of the eye nearest to the nose and working your way out. Press harder across the lash line and lessen the pressure toward the crease of the eye. Be sure to carry the shadow up and into the cream eye shadow on the brow bone. The light pressure at this point will make for a nicely blended look.

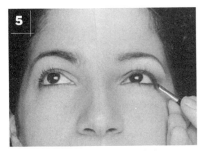

With an eyebrow brush and dark brown eye shadow, draw a thin line under the eye, following the shape of the eye.

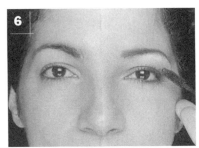

Black mascara for both the top and bottom eyelashes accentuates the eye. A subtle false eyelash can also be used to create a more dramatic eye, if desired.

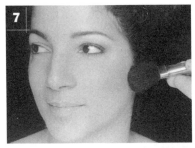

Use an orange or a coppertone-colored blush, applied with a blush brush, to add color to the cheeks, jawline, and temple.

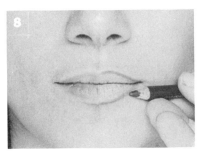

Now take a light brown lip pencil and draw in natural-looking lips—in other words, not too big, not too small.

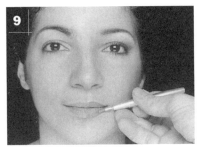

With a lip brush and creamy lipstick, fill in the lips with any color that Gloria commonly uses, such as red, orange, browns, and naturals.

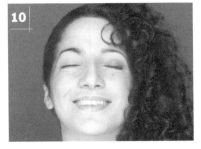

Gloria's face would not be complete without her sexy beauty mark. Use a dark brown eyeliner pencil and color in a tiny dot about an inch below the center of the right eye. (It's pictured under the left eye here because of the half-face format.)

MARLENE SUAREZ—
ON HER FEET AND SWAYIN' TO THE ESTEFAN BEAT!

Marlene says "Get on Your Feet" is her favorite Gloria Estefan song to lip-synch to. It excites her and she says people love it. I think she could win over any audience with her bubbly personality and boundless energy.

Marlene Suarez is a dynamo, one who shares a lot in common with Gloria Estefan. Like Gloria, Marlene comes from a Latin background. While Gloria is one hundred percent Cuban, Marlene is half Cuban and half Spanish. Gloria was born in Cuba and now lives in Miami. Marlene was born in New York City, lived in Miami for a couple of years in the early eighties, and now resides in New Jersey.

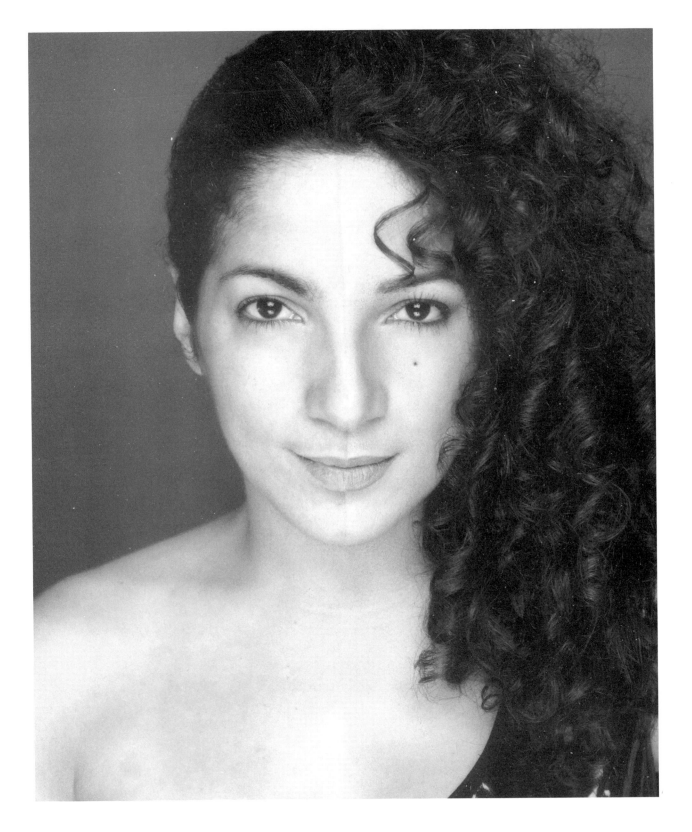

MS: It was during those Miami years that people started bringing it to my attention that I looked like Gloria Estefan. Miami Sound Machine was becoming really popular with the local Miami Cuban population but it was still only a regional band, and I didn't even know who Gloria was. Finally I went to a beach concert and actually met Gloria face-to-face. I was just kind of in shock. I didn't know what to say, and the first thing she blurted out was, "You look like me." Since then I've won several look-alike contests and I do get mistaken for her a lot.

JF: Even though you look like her, there's still a lot of work that goes into perfecting the impersonation. What do you like about making the full transformation?

MS: It's almost like seeing magic put on your whole body. For me it's a completion of some sort. I start out with the raw me and then end up convincing others that I'm someone else.

JF: Do you have any suggestions for someone who might want to try making themselves look like Gloria Estefan?

MS: Doing her from the inside is probably easy in a sense because she's a very down-to-earth person, like the girl next door. She acts like the average person and has no attitude.

JF: You two are the same size, height, everything. Were you a little upset when Gloria did the "Everlasting Love" video and you weren't in it?

MS: Actually, I'm probably a little chunkier now, but no, I wasn't upset. I loved the video—as a matter of fact one of the things that makes Gloria so likable is that she accepts her audience and isn't prejudiced, and that's what appeals to everyone. I love the idea that she used mostly men in the video to impersonate her. Gloria's very open-minded so that makes her look great and it's fun.

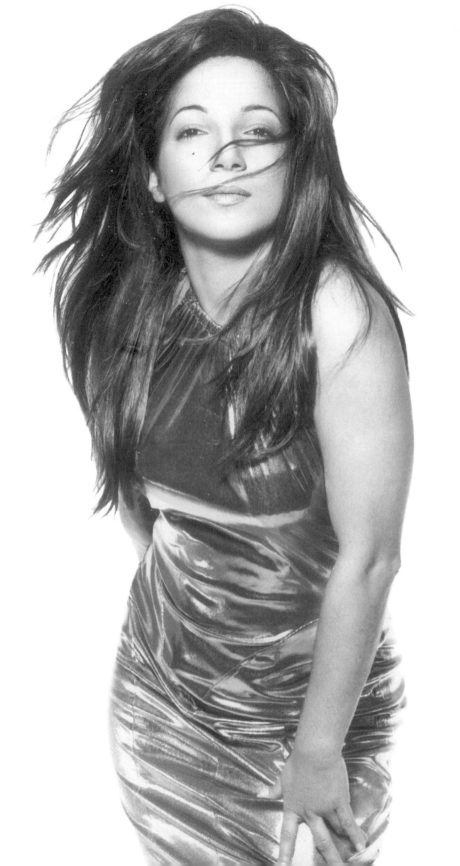

IMPRESSIONS OF
DEVON CASS
CHER

The first time I realized there was any resemblance at all between Cher and me was when I was thirteen. I would look at her picture on the *Take Me Home* album all the time and that's where I saw the similarities. Of course, I was a young boy at the time, and my features were even softer then than they are now, but today I use makeup to create the softer look. I saw similarities in the eyes and in the nose, but it's probably the eyes and mouth that are alike more than anything, because I don't have the distinctive nose that Cher had back then. The adjustments I have to make on my eyes are very, very minute. The space between my eyes is very much the same as Cher's. That's often a very important space to consider when creating an exact duplicate of somebody. Now that doesn't mean you can't do Cher if your eyes aren't exactly the same width apart, it just means that for somebody to look at a picture and mistake it for Cher, you have to have all the features in the same places. What I basically do, however, is redraw her face on mine because there are differences.

I chose the eighties costume because it's creative, easy to make, and the big curly hair, leather jacket, tattooed butt, and fishnet stockings are very Cher.

LONG, THIN FACES
DO CHER BEST!

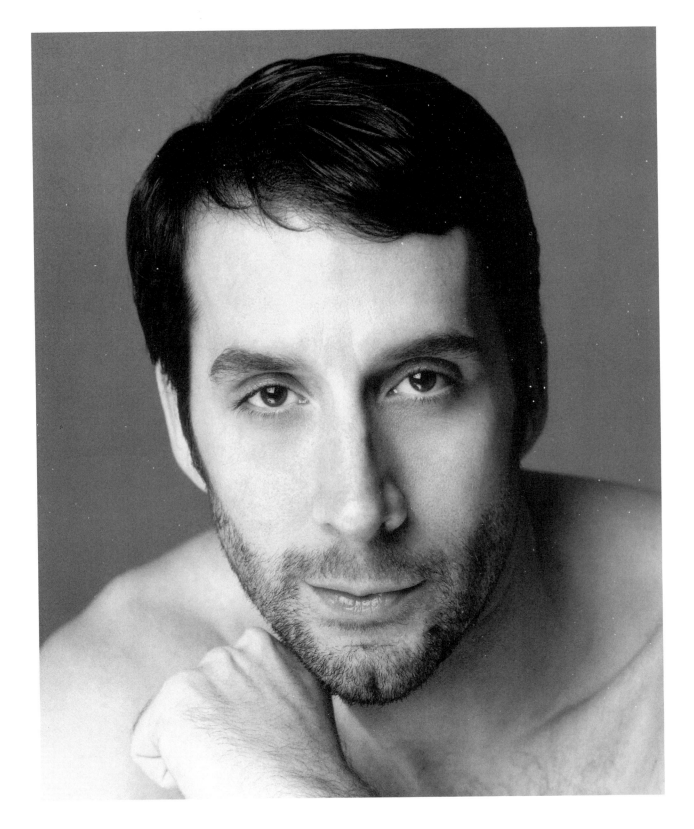

MANNEQUIN
CHER

Cher is often accused of being controversial, even outrageous, when it comes to her clothes. That she has a unique, individual style is an understatement, but it's something that her fans can't get enough of. Her bare, scanty outfits keep the paparazzi camera bulbs flashin' and the headlines hummin'. She's added a romantic, gothic feeling to her personal wardrobe, but people recognize the costumes from her music videos most.

Start with these suggestions and then experiment. Remember, to impersonate Cher the right way, you also have to be tactfully outspoken yet fair, strong-willed, and, above all, determined to succeed!

CLOTHING

- Full, skin-toned opaque body stocking with painted rose tattoos on butt.
- Full fishnet body stocking, worn over opaque one.
- One-piece, short, black Lycra bodysuit. This is the third layer. (Cut openings into bodysuit and place rhinestones around the openings.)
- Black opaque stockings (cut into a V shape at the top in front and back).
- Attach garters to the tips of the Vs on the stockings. Now cover with rhinestones as shown and attach to the bottom of the rhinestone bodysuit. (This creates the Bob Mackie bejeweled look that Cher loves.)
- Black leather motorcycle jacket. (Glue various sizes and shapes of rhinestones, in any pattern, to the lapels.)
- Black leather, studded race-car-driver gloves (they minimize larger hands).
- Black patent-leather lace-up boots with pointy toes and three-to four-inch heels (higher if you can stand it).
- Long, dangly rectangular rhinestone earrings.

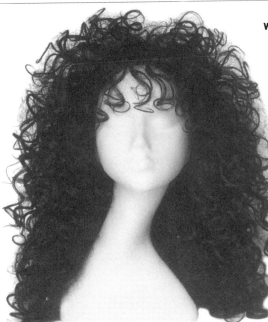

'70s look

Present look

WIG

Long, black wig with spiral curls and lots of volume on the top, parted in the middle. There should be less volume near the shoulders, and the back should be cut into a V shape that falls between the shoulder blades.

OPTIONS

- Popular colors for Cher's clothes include black, white, and silver.
- Keep two body stockings, but any scanty, skin-revealing bodysuit will work.
- For popular eighties Cher looks, use a white leather jacket or a silver sequined jacket. (The sequins give that bejeweled look.)
- For seventies Cher looks, colors are more rich and include red and purple, as well as magenta, white, crystal, and gold.
- Ostrich-feather boas and long gowns with the navel showing.
- Long, squared fingernails in any of Cher's favorite colors.
- Strappy high heels.

- Jeweled headdress with long curly hair coming out the back.
- A wig that will give you Cher's famous long, straight black hair.
- For a nineties Cher look, simple colors are cool, denim-blue, black, and white.
- Denim shorts with fishnet stockings and a cropped top.
- Patent-leather bodysuit.
- Black patent-leather or suede thigh-high boots with medium to high heels.
- Straight black or red wig that falls just past the shoulders (with bangs).
- Other makeup colors include purple, red, coppertone, and orange for eye shadow and blush.
- Lipstick shades can be deep purple (vamp), praline, or red (be sure to coordinate colors with costuming).

FAMOUS QUOTES

"Snap out of it." From *Moonstruck*
"I got you, babe." From Sonny and Cher days
"Sonny don't live here anymore."

BEST SONGS TO PERFORM

SEVENTIES

"Take Me Home"
"The Way of Love"
"Gypsies, Tramps, and Thieves"
"Halfbreed"

EIGHTIES

"I Found Someone"
"Turn Back Time"
"Jesse James"

NINETIES

"Love Hurts"
"Love and Understanding"
"One by One"

EXPRESSIONS

Charmingly disinterested.
Lick lips.
Push cheek out with tongue while licking side of cheek.
Cock head to one side and roll eyes to same side.

SHEER CHER!

As exceptional an impersonation as you'll ever see! When Devon Cass transforms himself into a look-alike of Cher, few can compare. It took him six years to perfect the makeup and costuming, but the results were well worth the wait. Even in the early stages, Cass came very close, but he's the first to admit that getting it right takes hard work. Now he uses what he knows to transform others into the celebrities they've always wanted to be, something he can now do in a day. In the ten years since coming to New York, via Las Vegas and Houston, Cass has amassed an impressive résumé. He's not only a successful photographer, but with his impersonation of Cher he appears in clubs and music halls around the world.

DC: The first two years that I began working on the impersonation, I didn't perform as Cher at all. In fact, only my roommate knew I was doing it. Then one Halloween I went out and said this is it, this is the test. I was really nervous and the minute I stepped out on the street someone screamed, "Cher," and I knew that I had accomplished what I wanted to accomplish right then and there. From that moment it's come a long way. I've performed at the Apollo here in New York, on Broadway at the Supper Club, and I've done motion pictures, TV shows—everything.

JF: What is it that you especially like about transforming yourself into the physical replica of Cher?

DC: It's an artistic high for me. I like the feeling I get knowing that people are observing me in a different way. I like that they see me as a beautiful woman as opposed to a man. I know what it feels like to be treated as a beautiful woman and now I respect women so much more. The way I'm treated is very interesting because inside I'm still a man, and sometimes I'll even forget I'm dressed as Cher and be lost in conversation with someone and have to stop and think, Oh, this person thinks I'm a woman or doesn't care. I've even mingled in crowds dressed as Cher, after a performance, and then gone home, changed, and gone back to the same club and mingled with the same people, and their reaction to me is so completely different.

JF: Do you feel connected to Cher in any way?

DC: In several ways, actually. We're both part Native American, although I think our ancestors are from different nations. Then, there's a number of coincidences that link us. For instance, she was friends with my aunt Suzy Creamcheese, who was a designer in the seventies. Cher knew my mother. In fact, I actually met Cher when I was sixteen, when we all went to see her at a concert in Las Vegas. That was the first time I saw female impersonation. Cher introduced Diana Ross, and I was convinced that what I was seeing was the real thing. But I'll never forget the feeling I had when my mother told me that wasn't Diana, that it was an impersonator. That magic has stuck with me ever since. Cher and I are both independent, and I think if I were a woman, I'd feel exactly the way she does about the way women are sometimes treated like second-class citizens in the world. Since I can take it all off I haven't really had to acknowledge that the way a woman does.

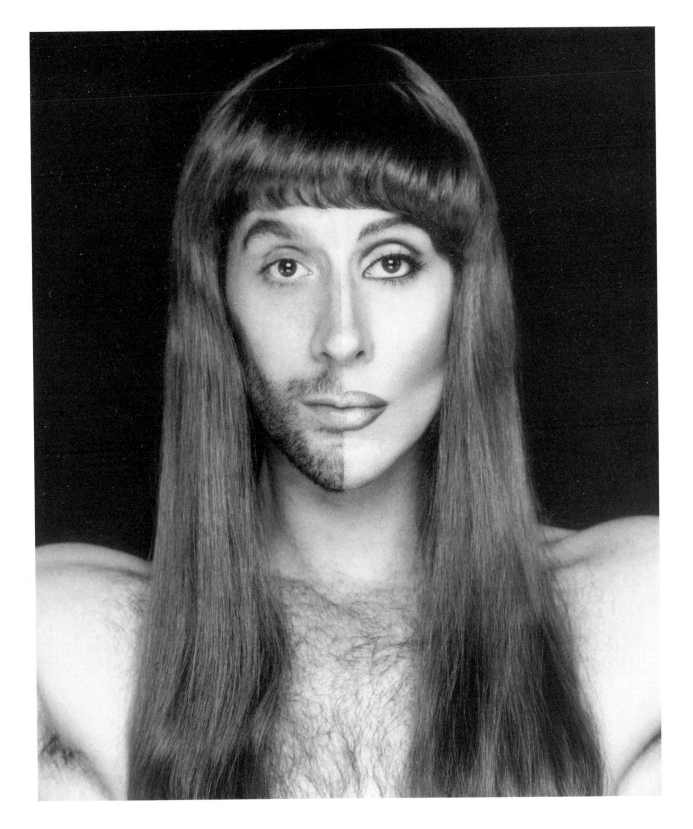

JF: Cher has overcome quite a lot of negatives in her life to become successful. Have you?

DC: Actually, three big ones. First, I guess while growing up I was very androgynous looking. People always picked on me and wondered if I was a boy or a girl. I don't remember ever relating to one or the other. One day, as an adult, I was reading an article and I really connected with the sentiment of the writer. The writer was a so-called drag queen who said that he was always ambiguous about gender and it never made sense to him to be considered either male or female all the time. He believes, as I do, that there's a certain magic in femininity, a shine as he called it. You can't

really put your finger on it, but it's very enchanting. He went on to say that when you grow up as a boy in our culture, that shine gets beaten out of you. Society does it to women too. Thank God that it never got totally beaten out of me because I feel that shine represents the strength of my imagination, which I believe is feminine. For me masculinity represents an aggressive way of being, while femininity is associated with sensitivity. I think imagination blossoms from sensitivity, hence it's feminine.

Second, I would say being abandoned by my father. It didn't really bother me when I was younger, but as I got older and realized what it really means to be responsible for someone you brought into this world, I got upset. But I believe things happen for a reason and I've been in touch with my father, and while I respect his views, we don't share many in common. I think had I grown up with him around, it would have kept me from becoming who I am, and I love who I am. I love everything about my life, so I don't think my father was meant to be in my life.

And the third thing is the death of my baby nephew from a heart ailment. This book is dedicated to him. He had my name, and seeing it there at his funeral was a weird experience. It made me realize that life is short and it gave me the drive to celebrate my life and the life he could have had. It made me want to leave a legacy and make him a part of that legacy.

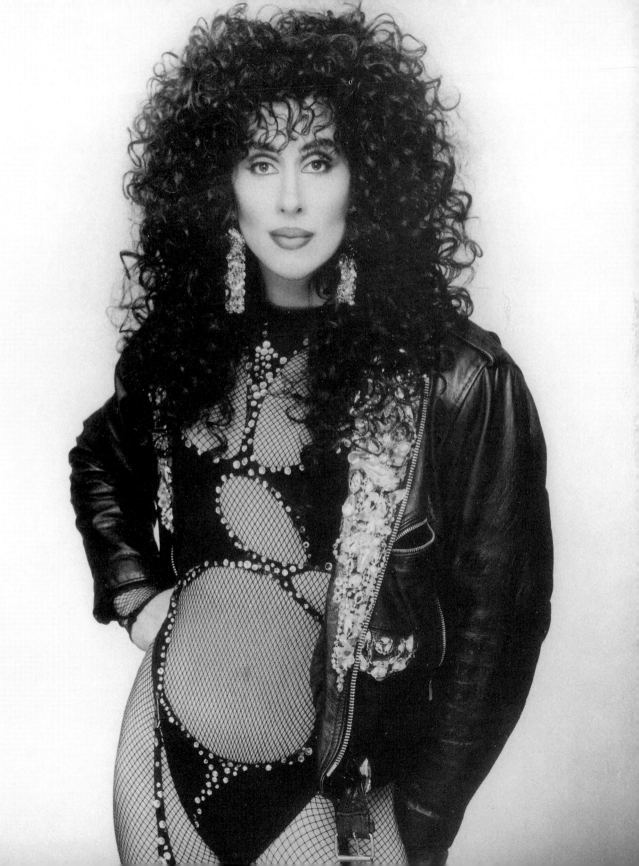

All the celebrity
impersonators in this book can be
contacted through the
Double Take Division of the
Elaine Chez Look-Alike Company,
P.O. Box 2242,
Astoria, NY 11102-3724.
(212) 989-6420